COOL

TYPE

Spencer Drate/Jütka Salavetz/Mark Smith

Forward by Carlos Segura

Backward by Rick Valicenti

NORTH LIGHT BOOKS
CINCINNATI, OHIO

Acknowledgments

Lynn Haller, Justin and Ariel (the Divine Inspiration), Roger Dean (the Guiding Light), Terri Boemker, Sandy Kent, Michelle Kramer, Amy Woodburn, Kathleen DeZarn and all of the people at North Light Books, Carlos Segura, Rick Valicenti, Chip Kidd and Scott Clum (the Dynamic Duo), the screens of i/o 360°, Emigre, The Font Bureau, [T-26], Plazm, Blur, HOW, U&LC, ID, Graphis, Eye, Raygun, Print, X height, Arie Kopelman (the Visionary) and N.Y. Gold, NARAS, the Visual Club, the One Club, Smithsonian, Lou Reed, Sylvia Reed, the Velvet Underground, Dennis Ascienzo and Sean (the Ghost in the Machine), Karen/John/Abigail/Erica/Jesse LOEB, Calo Rios and Brendan Walsh at GT Interactive, Steven Karas, Jeff Epstein, George and Elaine Salavetz, Judy Fraser, Anü and Apü, Kyle Cooper (the wonder child of the film credits), all typeheads of the world and typefaces.

Headings font: Epitaph (typeface designed by Tobias Frere-Jones)
Text font: Tasse Regular Wide (typeface designed by Guy Jeffrey Nelson)

Both fonts courtesy of Font Bureau
175 Newbury Street
Boston, Massachusetts 02116
Phone: (617) 423-8770
Fax: (617) 423-8771
Website: http://www.fontbureau.com

Other fine North Light Books are available from your local bookstore, art supply store or direct from the publisher.

01 00 99 98 97 5 4 3 2 1

Library of Congress Cataloging-in-Publication Data

Drate, Spencer.
 Cool type/Spencer Drate, Jütka Salavetz, Mark Smith.-- 1st ed.
 p. cm.
 Includes index.
 ISBN 0-89134-728-3 (alk. paper)
 1. Type and type-founding—United States. 2. Printing--United States--Specimens. I. Salavetz, Jütka.
II. Smith, Mark (Mark T.) III. Title.
Z250.D747 1997 96-44180
686.2´24--dc20 CIP

Edited by Lynn Haller, Terri Boemker and Amy Woodburn
Production Edited by Michelle Kramer
Interior designed by Jütka Salavetz, Sandy Kent and Spencer Drate
Front cover designed by Chip Kidd
Back cover designed by Scott Clum

The permissions on page 144 constitute an extension of this copyright page.

Spencer Drate

Spencer Drate, creative director, designer, CD consultant, and author, has created award-winning CD-packaging for many popular recording artists, including Bon Jovi, Lou Reed, U2, the Ramones, the Velvet Underground, Joan Jett and the Talking Heads. One of the first to recognize and take advantage of the graphic possibilities of CD special packaging, he recently curated the first CD Special Packaging Show at the One Club in New York City with Jütka Salavetz. He is the author of Designing for Music and Rock Art for

PBC International and coauthor with Roger Dean and Storm Thorgerson of Album Cover Album 6. Drate is an active member and committee participant of the National Academy of Recording Arts and Sciences and the Art Director's Club, NYC. He has been given many design awards, including ones from the AIGA and Art Directors Club, and has been interviewed by many leading publications and on MTV and VH-1.

Jütka Salavetz

Jütka Salavetz has freelanced for Justdesign for the past twelve years and has codesigned most of the packaging with Spencer Drate. Many of her pieces, in addition to being shown in a variety of books, have won awards. The language of design is what brought Salavetz and Drate together, and their vision for infinite fantasies and new creations is what keeps them together.

Mark T. Smith

Mark T. Smith received his B.F.A. from the Pratt Institute in Brooklyn in 1990 and works as a freelance illustrator and designer. He sports a distinguished client list that includes Absolut Vodka, MTV, Nickelodeon, AT&T, Newsweek and the Walt Disney Corporation. He has won awards from Print and the Society of Illustrators, New York City, and has had

exhibitions in galleries in New York, Washington DC, and Wilmington, Delaware. He teaches illustration and design at Parsons School of Design in New York.

ABOUT THE AUTHORS

CREDITS:
photo: Spencer Drate
color tinting: Jütka Salavetz

An assortment of habits throughout my life have created a career for me that is, at best, an accident.

When I would get a toy for Christmas, the first thing I would do is file the box—organization. Then I would look at the makeup of the toy, before I would notice the toy as a whole—observation. In other instances, I would not look for what was done with the toy but how it was done—technique.

Then, in 1965, it happened. On 8th Street, in Miami. An occurrence that has been taken for granted by almost everyone I've ever run into. My family and I were traveling east when the moment, engraved on my mind to this day, took place. It was caused by a revolving Sunoco gas station sign, not my first taste of "culture shock"; hours earlier, I had been handed a Coke and spit it out because it was full of bubbles, then, later, I swallowed a piece of Chiclets chewing gum, thinking it was candy. Having just come from Cuba, I had never seen any of these things in my life. And while I did not know it at the time, all of these forms of input shaped the life I was to have. The revolving Sunoco sign was greatness to me. It was moving in circles, was very big, had that odd yellowish diamond shape with a red arrow through it and, of course, great type. That sign contained a greatness that we are all surrounded by everyday of our lives, but unknowingly dismiss as clutter.

As the years went by, I was soaking in every-thing around me, asking questions and looking for free things to learn from since I could not afford to buy knowledge. Even while doing other things for a living, and way before I got into this field called communications, I was constantly looking for a source of inspiration under one roof, and by accident again, I found it while a drummer. For twelve years, drumming was my life, and I was sure it would be for the rest of it. During this period, however, our trips to local record stores were often, and I came to realize that it was there that I was happy.

I've always been an avid music fan and col-lector and when, years later, I became a designer, it all fell into place for me. A record store is what I call the "modern museum of design" where you can go to see "artwork": illustration, photography, special effects, typography, design, packaging, promotions, displays, kiosks, CD ROMs, cartoons, fashion, multimedia, limited edition releases and, of course, music. Everything there is under the direction of newness and culture, wrapped in assorted materials, and surrounded by levels of creativity unlike any other category. It is truly a wonderful place to soak in the sights.

This kind of designing talent can make a sud-den release an instant classic, become part of our culture, create larger-than-life icons, and link and capture memories like a time capsule, while always doing it in a refreshing way.

—Carlos Segura

NEAL ASHBY is the creative director of the Recording Industry Association of America. As the sole creative person on staff, Ashby is responsible for every aspect of designing and producing all published RIAA materials, including annual reports, newsletters, statistical books, brochures, press kits, posters and party invitations. He has practiced design since 1987 and is an adjunct faculty member at the Corcoran School of Art. Ashby has received honors from the Art Directors Club of Metropolitan Washington, the New York Art Directors Club, the Ad Club of Washington, the Ad Club of Baltimore, the AIGA, D&AD, Communication Arts, the Type Directors Club and the American Center for Design. His work has been included in numerous publications, including Graphis, Print, Communication Arts, Graphic Design USA, HOW and I.D.

N E A L

ASHBY

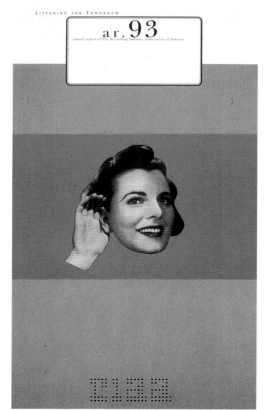

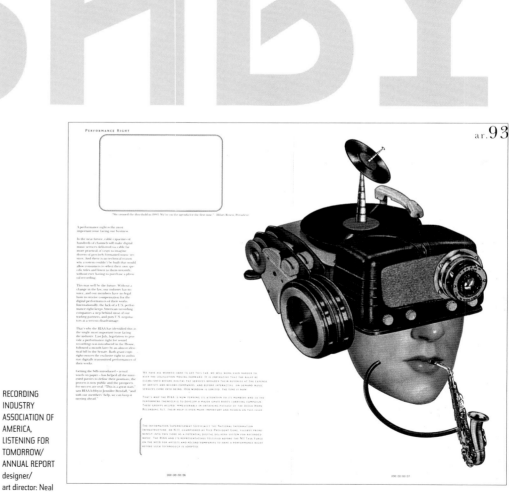

RECORDING INDUSTRY ASSOCIATION OF AMERICA, LISTENING FOR TOMORROW/ ANNUAL REPORT designer/ art director: Neal Ashby; client: Recording Industry Association of America; photographer: Steve Biver; illustrator: David Plunkert; typefaces: New Baskerville, Matrix

Inspired by the spirit of simplicity of a 1963 Annual Report, Ashby designed the visual theme of the book around "old vs. new": Only two typefaces were used—New Baskerville (old) and Matrix (new); Plunkert's illustrations use old images, rearranged to create something new; and the wrapper with the woman with her hand to her ear represents the "old" way of listening to music, while the cyborg-like illustration represents the "new" mediums of music delivery.

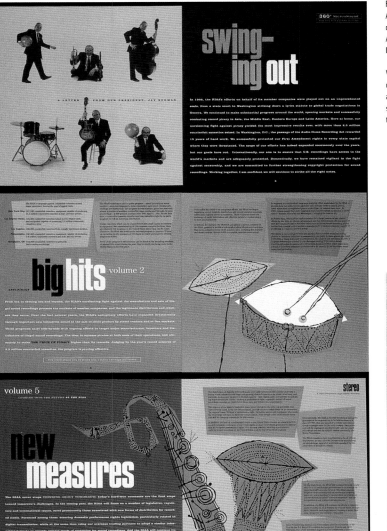

RECORDING INDUSTRY ASSOCIATION OF AMERICA, THE WORLD IS LISTENING/
ANNUAL REPORT
designer/art director: Neal Ashby; client: Recording Industry Association of
America; illustrator: David Plunkert; typefaces: Compressed Sans (heads),
Clarendon Bold

Wanting to pay homage to vinyl LPs, Ashby recreated the feeling of jazz album
cover art of the 1950s. He received guidance from William Claxton—a designer
and photographer for the Pacific Jazz label in the 1950s and 1960s. Ashby's
small tribute to Claxton is in the portrait of the company president, which is a
takeoff of Claxton's Chico Hamilton Quartet cover from 1955.

HEART OF MUSIC/INVITATION, PROGRAM, RSVP CARD
designers: Neal Ashby, Michele Clement; client: T.J. Martell
Foundation; art director: Neal Ashby; photographer:
Michele Clement; typeface: Letter Gothic

Jay Berman, president of the Recording Industry
Association of America, was the 1993 T.J. Martell
Foundation honoree. Because the award dinner is the focal
point of a fund-raising drive, Ashby wanted the invitation
and relating pieces to reflect the excitement and drama of
the evening. The flower imagery was developed by
Clement and Ashby as a way of telling the story of hope.
The flowers themselves represent life and the hope for a
cure for AIDS, cancer and leukemia, while the dancing
music notes represent the music industry and the many
people who donated generously.

the heart of

music 93

the TJ Martell Foundation

for leukemia, cancer

and AIDS research

humanitarian award dinner

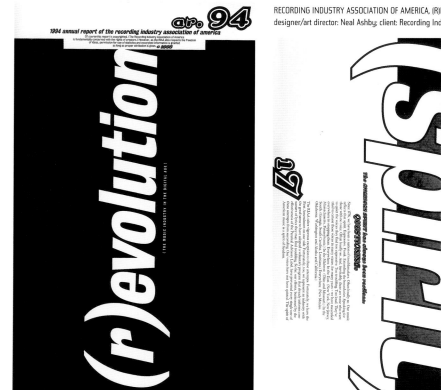

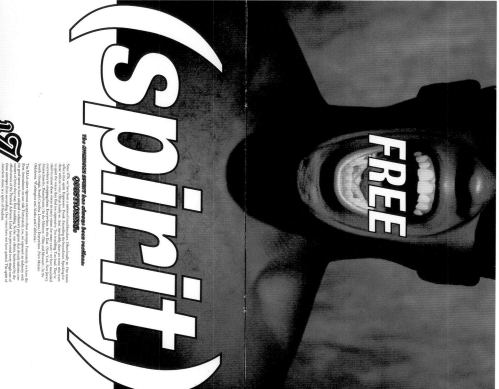

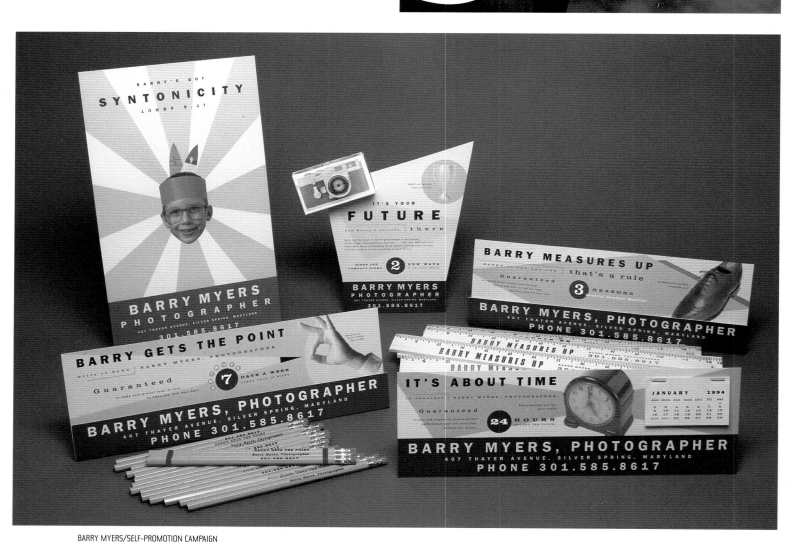

BARRY MYERS/SELF-PROMOTION CAMPAIGN

designer/art director: Neal Ashby; client: Barry Myers; photographer: Barry Myers; typefaces: Franklin Gothic Bold, Franklin Gothic Heavy, Clarendon Bold, Clarendon Regular

Rather than send art directors samples of beautiful photographs, Ashby and Myers wanted to send them something they could really use and make the pieces fun. The look of the pieces was inspired by samples of old direct mailers from hardware stores, plumbers and mechanics.

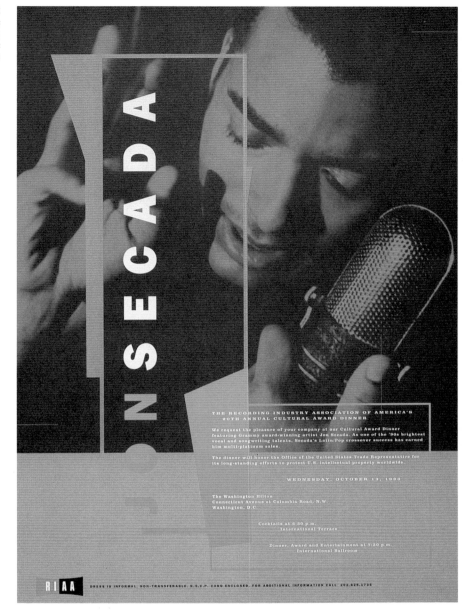

JON SECADA/CONCERT POSTER
designer/art director: Neal Ashby;
client: Recording Industry
Association of America; typeface:
Franklin Gothic Heavy ("Jon Secada")

JON SECADA DINNER/PROGRAM BOOKLET
designer/art director: Neal Ashby; client: Recording
Industry Association of America; typefaces: Ace Clarendon
Bold ("Jon Secada," "Bravo"), Compressed Sans Bold ("20")

When Jon Secada, a Latin artist, was scheduled to be the
feature artist at RIAA's annual Cultural Award Dinner,
Ashby designed a program to reflect a Latin feeling but
also to remain grounded in something purely American.
Using a 45 record sleeve as inspiration, the result was a
hybrid of retro-Americana with a Latin color scheme.

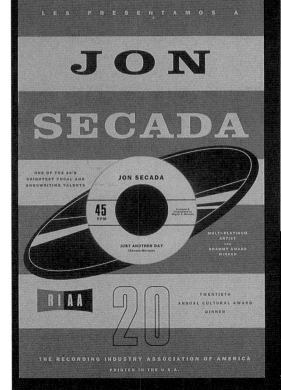

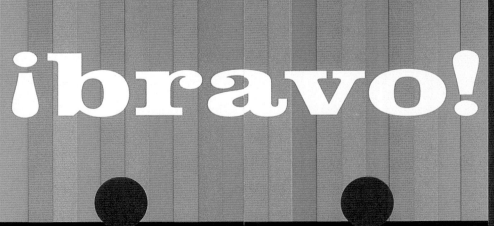

It is the Recording Industry Association of America's privilege to honor the USTR and celebrate Hispanic music in the same evening. During National Hispanic Heritage Month, it is only fitting to recognize the USTR for its efforts around the world to open markets for all music and, in particular, Hispanic music. The Hispanic music market in the United States is growing rapidly. In the past two years, it has experienced 40 percent growth from $100 million to $140 million – testifying to changes in demographics that reflect the evolving face and tastes of America. Much of this popularity can be credited to a new generation of Hispanic recording artists who are enjoying tremendous crossover appeal with non-Hispanic audiences. Whether their influences are traditional (salsa, meringue, ranchero) or contemporary (rock 'n' roll, rap, reggae, hip hop), these artists are discovering audiences hungry for the passion and warmth that is Latin music. The stars of this new generation include Luis Miguel, Gloria Estefan, Los Bukis and, this evening's guest performer, Jon Secada – all of whom certified gold or platinum within the past year. Never in the history of the RIAA's Gold and Platinum Program have so many Hispanic artists achieved this level of success in such a short period of time.

PHIL BAINES graduated from St. Martin's School of Art in 1985 and the Royal College of Art in 1987. He works as a freelance graphic designer mainly for small publishers and arts organizations. Personal work often includes letterpress, including the self-published StoneCUTTERS (1992). More recently, Baines has designed typographic sequences for several TV commercials. Since September 1991 he has taught typography part-time at Central St. Martin's College of Arts and Design in London. Two typefaces for Fuse #1 and Fuse #8, revisions of Can You?, were released as part of a Fuse Classics set in 1995. Baines is currently designing two "serious" sans serif typefaces.

PHIL
BAINES

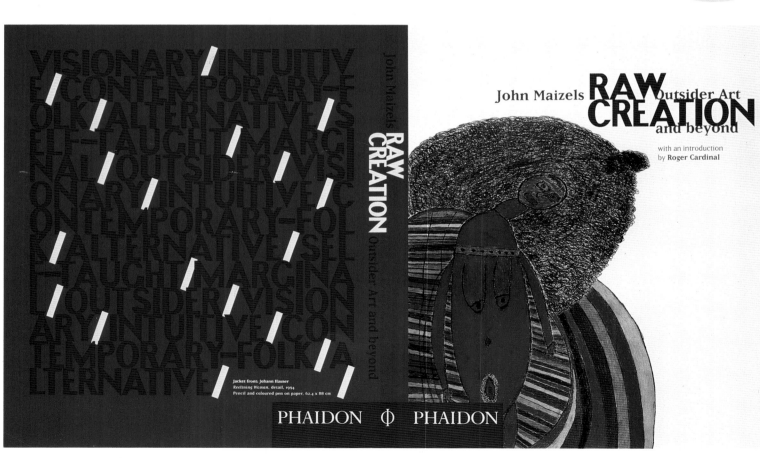

RAW CREATION/BOOK JACKET DESIGN
designer: Phil Baines; design studio: Phil Baines Design and Typography; client: Phaidon Press; illustrator: Johann Hauser; typefaces: Hauser (main title), Matrix (subtitle, author)

Though using Zuzana Licko's Matrix, Baines entirely re-specced the font for this book jacket; Hauser, created on Font Studio from scratch, is his own design based on Johann Hauser's drawing. This typeface, which was also inspired by Victorian enamel street signs, was named after the illustrator who died during the final design stages of the book.

PASCHAL CANDLE DESIGN 1996 (2 VERSIONS)
designer: Phil Baines; design studio: Phil Baines Design
and Typography; client: Various Roman Catholic Churches;
typefaces: hand-created lettering, Gill Sans

Baines created the primary typeface used for the phrase
"Lumen de Lumine" using Font Studio. Inspired by a
square and the movement of a compass, the face
contains five different characters and positive and
negative versions of each.

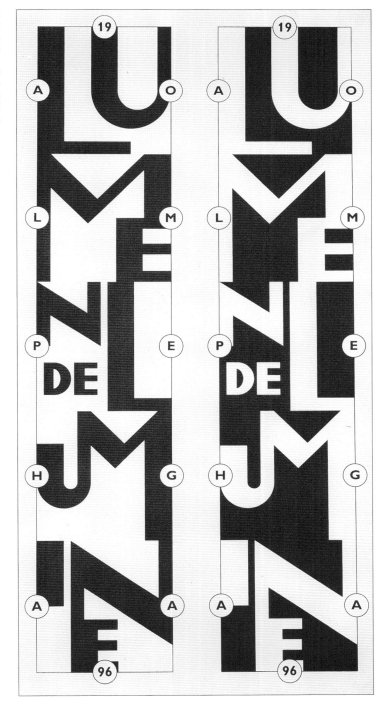

YOU CAN (READ ME)!/ANNOUNCEMENT POSTCARD
designer: Phil Baines; design studio: Phil Baines Design and
Typography; client: Font Shop International; typeface: You Can
(Read Me)!
　　Research in legibility by Brian Coe and college work by
Baines at St. Martin's School of Art in 1982 led to this amended
version of Can You (Read Me)? released in Fuse #1 in 1991. The
original was a digital manipulation of Clarendon.

JONATHAN BARNBROOK studied graphic design at St. Martin's School of Art and the Royal College of Art. He has worked as an independent graphic designer and font designer since 1990; in 1992 he joined Tony Kaye Films as a director. Barnbrook has worked extensively in television advertising for companies such as Nike and Toyota, and has had a number of his fonts released by Emigre. He is currently in the process of starting his own font company, called Virus, as well as working on a book with artist Damien Hirst and on the design of <u>Typography Now Two</u>.

Photographer: Tomoko Yoneda

JONATHAN
BARNBROOK

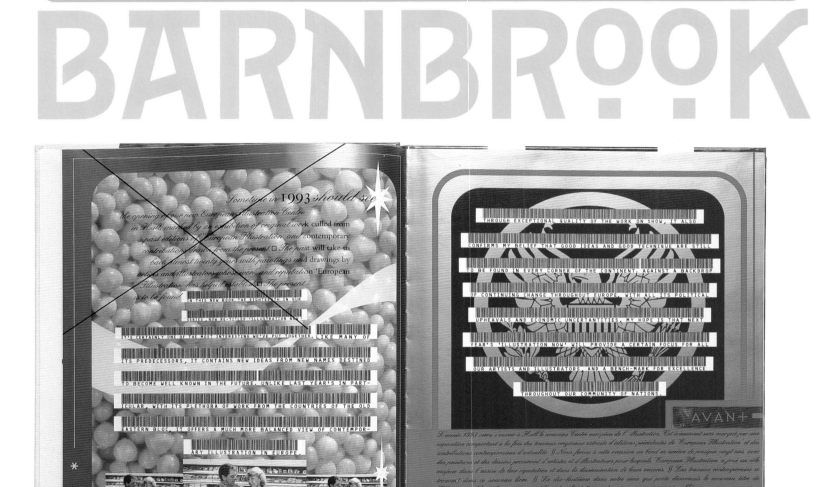

ILLUSTRATION NOW/SPREAD
designer: Jonathan Barnbrook; client: Illustration Now; photographer: Tomoko Yoneda; vegetable photographer: David Gill; stock photography: The Image Bank; Macintosh bar code font supplied by Computalabel

Based on layouts of the Koran, the introductory spread relates to the European obsession with doing trade in countries that have a lot of oil. The text is written in bar codes, and the Islamic text says "Petrol."

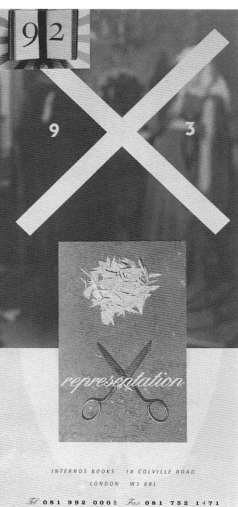

INTERNOS CATALOG/COVER
designer: Jonathan Barnbrook; client:
Internos; photographer: Tomoko
Yoneda; typefaces: Clarendon,
Kuenstler Script

THIS IS PROTOTYPE,

A TYPEFACE THAT

IS UPPERCASE,

LOWERCASE, SERIF

AND SANS SERIF

IN EACH

LETTERFORM

PROTOTYPE/FONT
designer: Jonathan Barnbrook; typeface: Prototype

The font was created from imported parts from at least
twelve other fonts that were combined and redrawn. Type
appears in uppercase, lowercase, serif and sans serif.

MELINDA BECK is a graphic designer and illustrator who works out of her studio in Brooklyn, New York. She has worked on a wide range of projects: a mural for a bar in Rome, animated spots for Nick at Nite and exhibition graphics for the American Institute of Architects. Other clients include MTV, Nike, Island Records, the Brooklyn Children's Museum, Rolling Stone, Time magazine and the New York Times. She has received awards from and publication in annuals, including American Illustration, The Art Directors Club, Communication Arts, Print's Regional Design Annual, The Society of Illustrators, The AIGA Annual, The Type Directors Club and I.D.

MELINDA
BECK

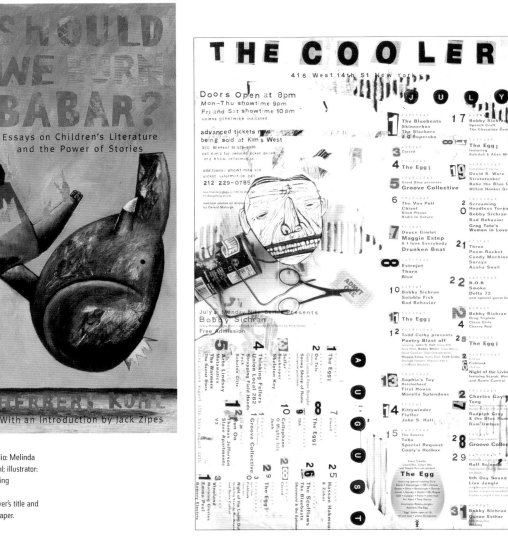

SHOULD WE BURN BABAR?/BOOK COVER
designer/art director: Melinda Beck; design studio: Melinda Beck Studio; clients: The New Press, Herbert Kohl; illustrator: Jordin Isip; typefaces: Meta, hand-created lettering

Ben Shawn inspired Beck to create the book cover's title and author name out of cut pieces of painted newspaper.

THE COOLER/CALENDAR JULY–AUGUST
designer/art director: Melinda Beck; design studio: Melinda Beck Studio; client: The Cooler; illustrator: Melinda Beck; typefaces: Zurich, Franklin Gothic, Trixie

Inspired by concert flyers in college, Beck used letters from a supermarket circular, old typewriter keys and rubber stamps for the title, club information and dates.

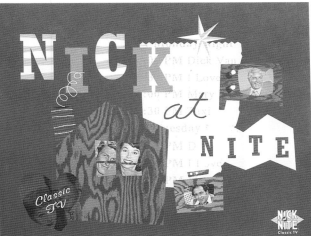

NICK AT NITE/PORTFOLIO
designer: Melinda Beck; design studio: Melinda Beck Studio; client: Nick at Nite; art directors: Melinda Beck, Laurie Hinzman, Kenna Kay; illustrator: Melinda Beck; typefaces: (cover) Rockwell, Poncho, Craw; (inside) Madrone, Richard Murray, Franklin Gothic

Inspired by 1950s packaging design, "Nick" is a manipulation of Rockwell in Adobe Illustrator, while "at" was hand-drawn.

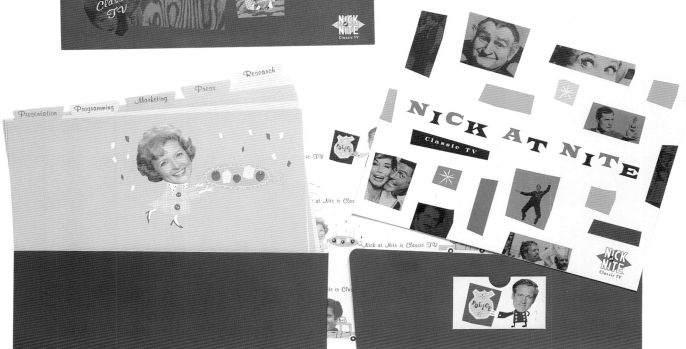

I WON'T LEARN FROM YOU/BOOK COVER
designer/art director: Melinda Beck; design studio: Melinda Beck Studio; clients: The New Press, Herbert Kohl; illustrator: Jordin Isip; typefaces: Meta, Trixie, hand-created lettering

The novel's title, I Won't Learn From You, was hand-drawn and scanned into a computer.

JOSHUA BERGER is a college graduate working in Portland, Oregon (it's not the end of the earth, but you can see it from here), on something he believes in. He is the last remaining founding member of Plazm Media and works for "famous advertising stars" Wieden and Kennedy.

JOSHUA
BERGER

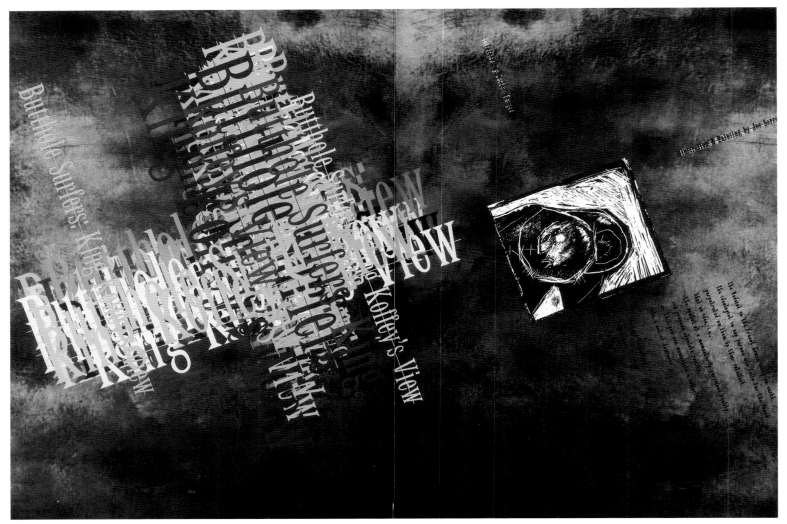

BUTTHOLE SURFERS/SPREAD
designer/art director: Joshua Berger; design studio: Plazm Media; client: Plazm; illustrator: Joe Sorren; typeface designer: Marcus Burlile (Stele Bevel); typefaces: Stele Bevel, Onyx

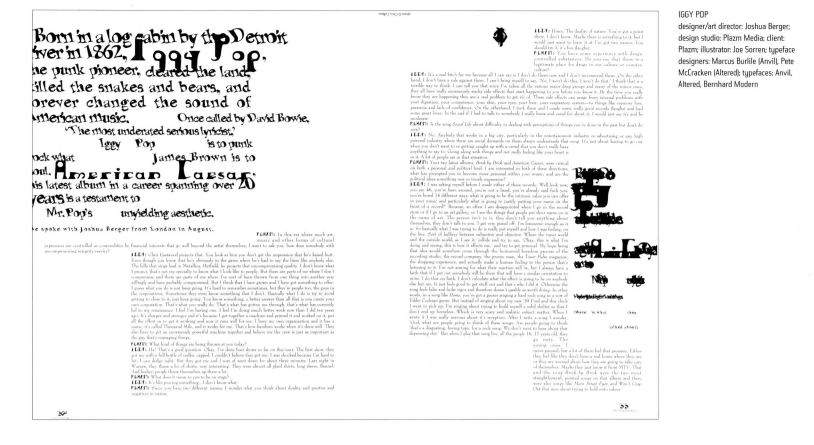

Born in a log cabin by the Detroit river in 1862, **Iggy Pop**, the punk pioneer, cleared the land, killed the snakes and bears, and forever changed the sound of American music. Once called by David Bowie, 'The most underrated serious lyricist,' Iggy Pop is to punk rock what James Brown is to soul. **American Caesar**, his latest album in a career spanning over 20 years is a testament to Mr. Pop's unyielding aesthetic.

We spoke with Joshua Berger from London in August.

PLAZM: In this era where much art, music and other forms of cultural expression are controlled as commodities by financial interests that go well beyond the artist themselves, I want to ask you, how does somebody with uncompromising integrity survive?

IGGY: Clint Eastwood projects that. You look at him you don't get the impression that he's kissed butt. Even though you know that he's obviously in the game where he's had to say the lines like anybody else. The fella that sings lead in Metallica, Hetfield, he projects that uncompromising quality. I don't know what I project, that's not my specialty to know what I look like to people. But there are parts of me where I don't compromise and there are parts of me where I've sort of been thrown from one thing into another very willingly and have probably compromised. But I think that I have grown and I have got something to offer. I guess what you do is just keep going. It's hard to remember sometimes, but they're people too, the guys in the corporations. Sometimes they even know something that I don't. Basically what I do is try to avoid getting to close to it, just keep going. You know something, a better answer than all that is you create your own corporation. That's what you really do. That's what has gotten me through, that's what has currently led to my renaissance. I feel I'm having one. I feel I'm doing much better work now than I did ten years ago. It's sharper and stronger and it's because I got together a machine and primed it and worked on it, put all the effort in to get it working and now it runs well for me. I have my own organization and it has a name, it's called Thousand Mile, and it works for me. That's how bandism works when it's done well. They also have to get an enormously powerful machine together and believe me the crew is just as important as the guy that's managing things.

PLAZM: What kind of things are being thrown at you today?

IGGY: Ha! That's a good question. Okay. I've done four shows so far on this tour. The first show, they got me with a full bottle of vodka, capped. I couldn't believe they got me. I was shocked because I'm hard to hit. I can dodge right. But they got me and I sort of went down for about three minutes. Last night in Warsaw, they threw a lot of shirts, very interesting. They were almost all plaid shirts, long sleeve, flannel. And bodies; people throw themselves up there a lot.

PLAZM: What does it mean to you to be on stage?

IGGY: It's like proving something...I don't know what.

PLAZM: Since you have two different names, I wonder what you think about duality and positive and negatives in nature.

IGGY: Hmm. The duality of nature. You've got a point there. I don't know. Maybe there is something to it, but I would just want to leave it at I've got two names. You should try it, it's fun (laughs).

PLAZM: You have some experience with drugs, controlled substances. Do you see that there is a legitimate place for drugs in our culture or counter-culture?

IGGY: It's a real bitch for me because all I can say is I don't do them now and I don't recommend them. On the other hand, I don't have a rule against them. I can't bring myself to say, 'No, I won't do this, I won't do that.' I think that is a terrible way to think. I can tell you that since I've taken all the various major drug groups and many of the minor ones, they all have really enormously wacky side effects that start happening to you before you know it. By the time you really know they are happening they are a real problem to get rid of. These side effects can range from internal problems with your digestion, your competence, your skin, your eyes, your hair, your respiratory system—to things like memory loss, paranoia and lack of confidence. On the otherhand, I took them and I made some really good records (laughs) and had some great loves. In the end if I had to talk to somebody I really knew and cared for about it, I would just say try and be moderate.

PLAZM: Is the song *Social Life* about difficulty in dealing with perceptions of things you've done in the past but don't do now?

IGGY: No. Anybody that works in a big city, particularly in the entertainment industry or advertising or any high powered industry where there are social demands on them always understands that song. It's just about having to go out when you don't want to or getting caught up with a crowd that you don't really have anything to say to. Going along with things and not really feeling like your heart is in it. A lot of people are in that situation.

PLAZM: Your two latest albums, *Brick by Brick* and *American Caesar*, were critical on both a personal and political level. I am interested in both of these directions; what has prompted you to become more personal within your music; and are the political albums something new or timely expression?

IGGY: I was asking myself before I made either of these records. Well look now, you are 46, you've been around, you're not a band, you've already said fuck you, you're bored 14 different ways, what is going to be the intrinsic value you can offer in your music and particularly what is going to justify putting your name on the front of a record? Because, so often I am disappointed when I go in the record store or if I go to an art gallery, or I see the things that people put their name on in the name of art. The person isn't in it, they don't tell you anything about themselves, they don't talk to you. I get very pissed off. I'm lonesome enough as it is. So basically what I was trying to do is really put myself and how I was feeling, on the line. Sort of halfway between subjective and objective. Where the inner world and the outside world, as I see it, collide and try to say, 'Okay, this is what I'm doing and seeing, this is how it affects me,' and try to get personal. My hope being that idea would somehow come through the humanoid boredom process of the recording studio, the record company, the promo man, the *Tower Pulse* magazine, the shopping experience, and actually make a human feeling to the person that's listening to it. I'm not aiming for what their reaction will be, but I always have a faith that if I put out somebody will be there that will have a similar orientation to mine. I do that on faith. I don't calculate what the effect is going to be on anybody else but me. It just feels good to get stuff out and that's why I did it. Otherwise the song feels false and lacks vigor and therefore doesn't qualify as worth doing. In other words, in a song like *Home*, you've got a greaser singing a hard rock song in a sort of Eddie Cockran genre. But instead of singing about my new '39 Ford and this chick I want to pick up, I'm singing about trying to build myself a solid shelter so that I don't end up homeless. Which is very scary and realistic subject matter. When I wrote it I was really nervous about it's reception. After I write a song I wonder, 'God, what are people going to think of these songs. Are people going to think 'that's a disgusting, boring topic for a rock song. We don't want to hear about that depressing shit.' But when I play that song live, all the people 16, 17 years old, they go nuts. The young ones. I never guessed, but a lot of them feel that pressure. Either they feel like they don't have a real home where they are or they are worried about how they are going to take care of themselves. Maybe they just know it from MTV. That and the song *Brick by Brick* were the two most straightforward, pointed songs on that album and they were also songs like *Main Street Eyes* and *Won't Crap Out* that were trying to hold onto values.

IGGY POP
designer/art director: Joshua Berger; design studio: Plazm Media; client: Plazm; illustrator: Joe Sorren; typeface designers: Marcus Burlile (Anvil), Pete McCracken (Altered); typefaces: Anvil, Altered, Bernhard Modern

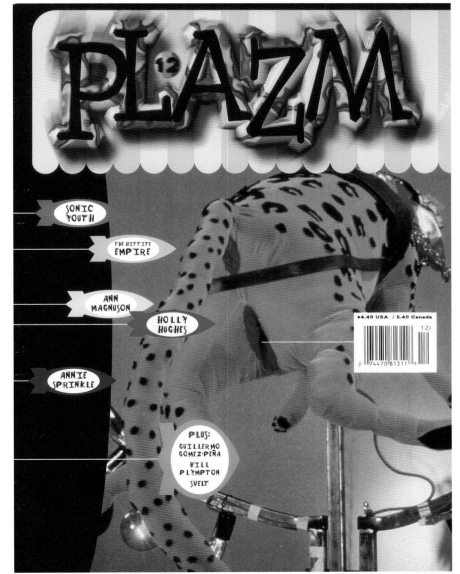

SONIC YOUTH

THE HITTITE EMPIRE

ANN MAGNUSON

HOLLY HUGHES

ANNIE SPRINKLE

PLUS: GUILLERMO GOMEZ-PEÑA BILL PLYMPTON SVELT

$4.49 USA / 5.49 Canada

PLAZM #12/COVER
designers: Modern Dog; design studio: Plazm Media; client: Plazm Media; art director: Joshua Berger; installation artist: Michelle Rollman; typeface designers: Charles Wilikin (Superchunk), Pete McCracken (Inky-Black); typefaces: Superchunk, Inky-Black;

STEPHEN BYRAM has been an art director in the music business for fifteen years and has designed packages for Tim Berne, Paul Motian, the Beastie Boys, Living Colour, Indigo Girls, David Sanborn and Midnight Oil. He was an art director at Sony Music for seven years, also working with MTV on several special projects, which include the program books for their annual Video Music Awards. Currently he is the design director for Winter/Winter, a label based in Munich, and is the principal of stephenbyramdesign&illustration. Byram teaches typography and design at the School of Visual Arts, New York City. His work has been cited by the AIGA, the One Show, the Art Directors Club, the Society of Illustrators, American Illustration, the Broadcast Designers Association, the American Center for Design, Communication Arts and has been featured in assorted books about music package design.

S T E P H E N
BYRAM

TIM BERNE'S CAOS TOTALE, "NICE VIEW"
designer/art director: Stephen Byram; design studio: stephenbyramdesign&illustration; client: JMT Records; photographer: Robert Lewis; liner notes lettering: Stephen Byram; typefaces: hand-created lettering (front cover), Berol RapiDesign Futura lettering guide, untitled

Byram wrote the front cover in ballpoint pen on a cocktail napkin and had Lewis photograph it. The Berol RapiDesign Futura style was used to trace all of the inside copy, which was then sized with a Xerox machine and composed. Lewis, Berne and Byram wanted to create a "nondesign" design—no typesetting and humble materials—for this cover. The inside was a reaction to Template Gothic.

SLAMMIN' WATUSIS

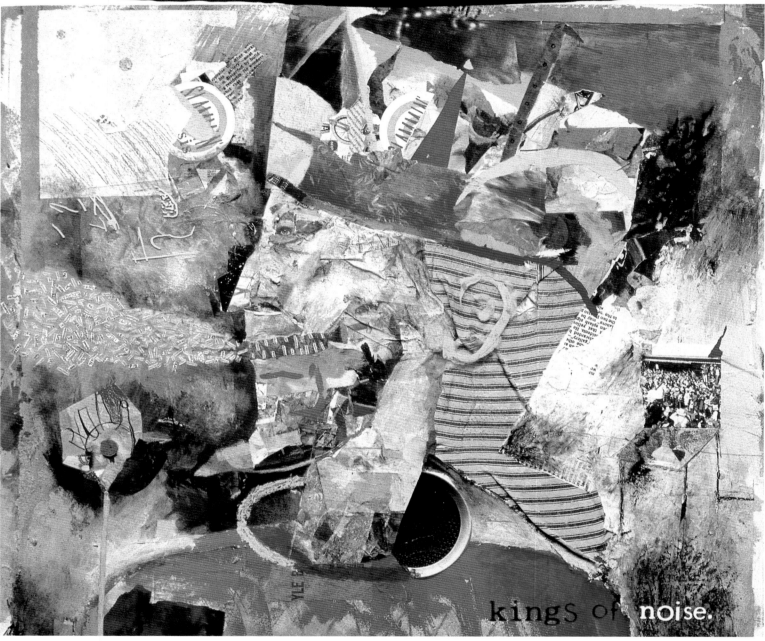

SLAMMIN' WATUSIS, "KINGS OF NOISE"
designer/art director: Stephen Byram; design studio: stephenbyramdesign&illustration; client: Epic Records; illustrator:
Stephen Byram; typefaces: hand-created lettering, Futura Book, untitled

"Slammin'" was drawn by Byram with a felt-tip pen, then statted several times to make it more round. "Watusis" was
cut from black waxed paper waxed down to white board. The third font, untitled, was taken from an old novel and
altered. The typefaces were inspired by the cutouts of Henri Matisse, the "punk" typography of Jamie Reed and bad
printing.

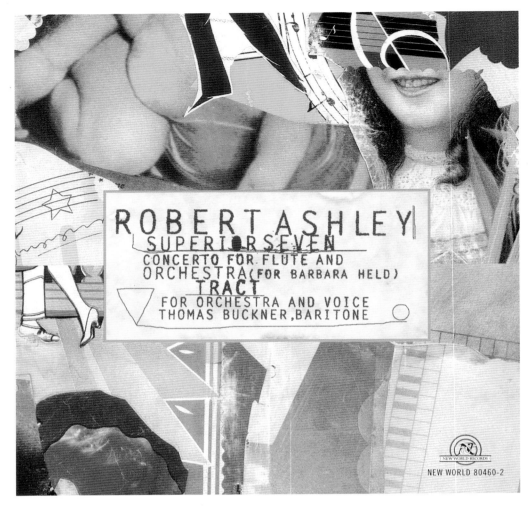

ROBERT ASHLEY, "SUPERIOR SEVEN"
designer/art director: Stephen Byram; design studio:
stephenbyramdesign&illustration; client: New World
Records; typeface: Futura Medium

Byram wanted to make a digital type that reflected the
humanness of Ashley's electronic music. He set the type,
printed it out, slightly dissolved it with a blending marker,
scanned it back into Adobe Photoshop and continued to
manipulate it until he got the result he wanted.

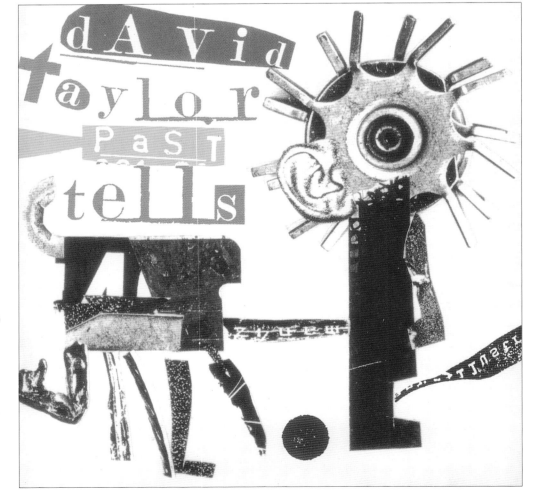

DAVID TAYLOR, "PAST TELLS"
designer/art director: Stephen
Byram; design studio: stephenbyram
design&illustration; client: New
World Records; illustrator: Warren
Linn; typefaces: Plain Roman Letters
serif wood type, untitled sans wood
type

Both faces were photocopied many
times to erode them. The rules were
made with hand-cut shapes in
amberlith made from Xerox debris.
Byram's inspirations were Linn's
illustration, Jamie Reed's "punk"
typography and badly printed
posters.

THE HERB ROBERTSON BRASS ENSEMBLE, SHADES OF BUD POWELL
designer/art director: Stephen Byram; design studio: stephenbyramdesign&illustration; client: JMT Records; illustrator: Stephen Byram; typefaces: Chaltenham Book ("Shades of Bud Powell"), Trade Gothic Condensed ("The Herb Robertson Brass Ensemble")

Byram digitally altered Trade Gothic and Cheltenham Book to create a more condensed version of both fonts.

MARGO CHASE's education in biology and medical illustration and her love of medieval iconography may explain the organic and often unusual nature of her design. Her eclectic style has been seen on CD covers for Madonna, Prince, Bonnie Raitt and Crowded House, as well as on movie posters for Francis Ford Coppola's <u>Dracula</u>. Her recently launched digital font foundry and current projects such as motion graphics work for Turner Pictures and identity design for Kemper Snowboards continue to keep her on the cutting edge of technology and style.

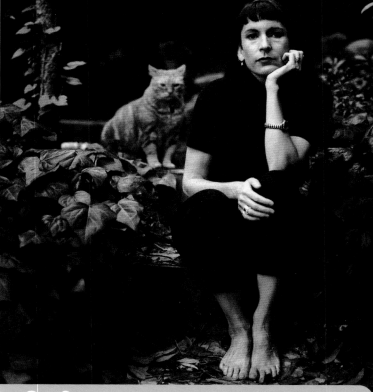

MARGO
CHASE

WOMAN/EDITORIAL SPREAD
designer/art director: Margo Chase; design studio: Margo Chase Design; client: Semiotext(e); typeface: Bernhard Modern ("Woman"), custom lettering ("Woman" logo)

Bradley, a custom digital creation, was inspired by Czechoslovakian typeface Grafotechna by Vojtech Preissig (1927). "Woman" is also a custom digital creation but not a font.

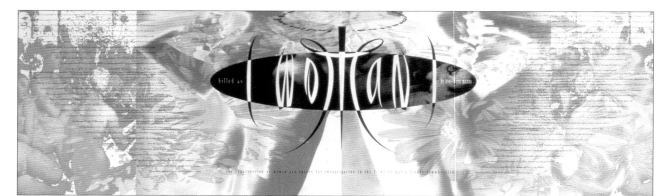

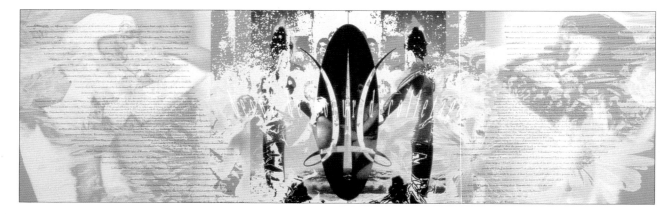

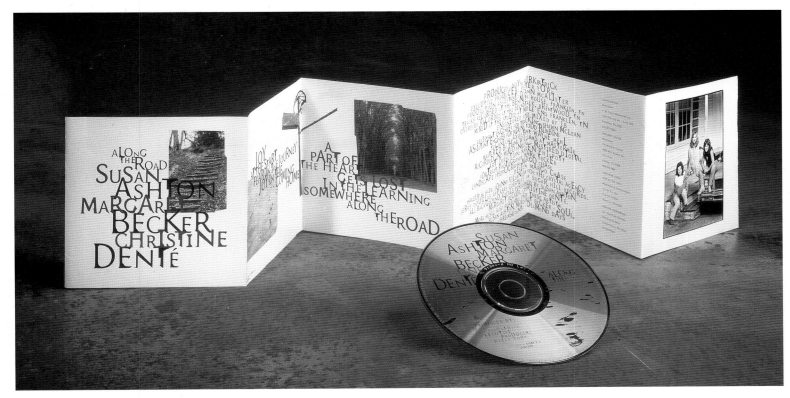

SUSAN ASHTON, MARGARET BECKER,
CHRISTINE DENT; ALONG THE ROAD/
CD PACKAGING
designer: Margo Chase; design studio:
Margo Chase Design; client: The Sparrow
Corporation; art director: Karen Philpott;
photographers: Mark Tucher (portrait),
Margo Chase (landscape); typeface: Pterra

Pterra was created by Chase through the
extensive modification of a digital "font
blend" between OCR and Trojan fonts. The
typeface was inspired by bad reproduc-
tions of classical Roman alphabets
(chipped stone carvings, aged manu-
scripts, etc.).

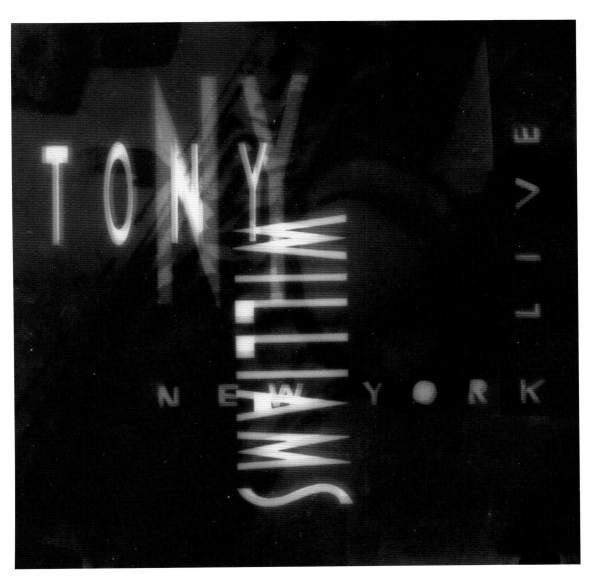

TONY WILLIAMS
designers: Nancy Ogami, Margo Chase; design studio: Margo Chase Design; client: Capitol Records, Inc.; art director: Margo Chase; photo-
grapher: Margo Chase; typefaces: custom calligraphy and hand-lettering ("Tony Williams" script), Box Gothic ("Tony Williams" type)

Chase's hand-lettering was inspired by Chris Bigg's calligraphy for 4AD Records. Box Gothic is a custom digital typeface also created by Chase.

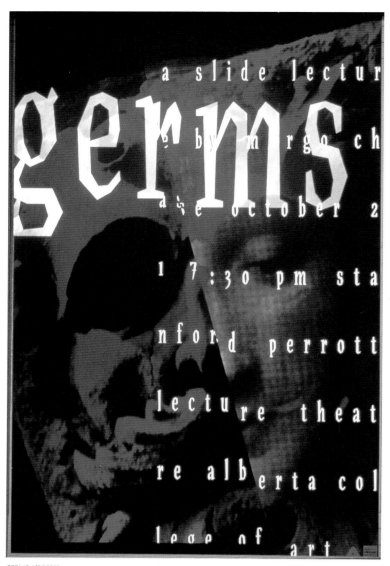

GERMS I/POSTER
designer/art director: Margo Chase; design studio: Margo
Chase Design; client: Margo Chase; typeface: Bradley

Bradley, a custom digital creation, was inspired by
Czechoslovakian typeface Grafotechna by Vojtech Preissig
(1927).

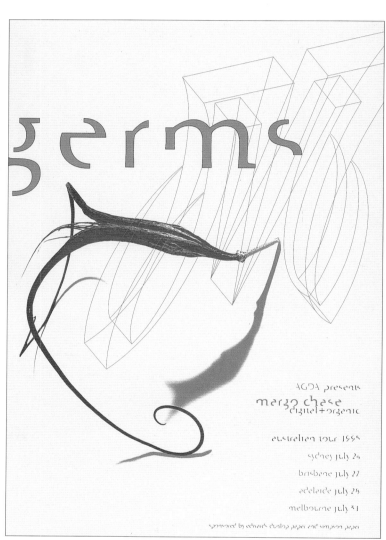

GERMS III/POSTER
designer/art director: Margo Chase; design studio: Margo
Chase Design; client: Margo Chase Design/Australian
Lecture Tour sponsored by Edwards, Dunlop and Simpson
Paper Co.; photographer: Barry Goyette; typefaces: Edit
(headline), Pterra (body copy)

Inspired by Swiss minimalist-type designs, Edit was
created through digital manipulation of Calligraphy 810
and then removing as much of each letter as possible
and modifying the remaining forms. Chase created Pterra
by extensively modifying the digital "font blend"
between OCR and Trojan and was inspired by bad
reproductions of classic Roman alphabets.

GEFFEN GENERIC SLEEVE
designer/art director: Margo Chase; design studio: Margo
Chase Design; client: Geffen Records; typefaces: Futura
XBold, Headline "Geffen" Modified

The digital alteration of the existing Futura typeface by
Chase was inspired by Kurt Schwitter's collages.

MARVIN GAYE, "THE MASTER"
designer: Margo Chase; design stu-
dio: Margo Chase Design; client:
Motown Records; art directors:
Margo Chase, Candace Bond; type-
faces: Fatboy ("Marvin Gaye"),
Triplex and Matrix Script ("The
Master," copy)

The Fatboy typeface, a custom digi-
tal creation by Chase, was inspired
by the 1970s style of bold and ugly
fonts.

SCOTT CLUM's main focus has been design and film direction, but he also pursues painting and photography. His studio, Ride Design, produces two magazines: <u>Blur</u>, an art and culture magazine, and <u>Stick</u>, which is devoted to snowboarding and was developed by Clum and longtime partner/action photographer Trevor Graves. His other works include film and video creations, gallery shows and various typeface designs. He has done projects for AT&T, Coca-Cola, Nike, Fuse, Nintendo and Nordstrom. His studio lectures about their work, discussing their views on design and its processes. The studio's main goal is to introduce a fluidity in the relation of design and image. Clum believes computers are, at times, used too often in commercial work and he advocates working outside the computer to introduce a stronger balance between art and design.

Photographer: Trevor Graves

SCOTT
CLUM

THE NEW ROCK AND ROLL/STICK AD
designer: Scott Clum; design studio: Ride Design; client: Ray Gun Publishing; photographer/illustrator: Scott Clum; typefaces: Santo Damingo (address), hand-manipulated type

Clum manipulated this typeface manually in a darkroom.

BIKINI COVER
designer: Scott Clum; design studio: Ride Design; client: Ray Gun Publishing; photographer: Stephen Stickler; typefaces: Meta Normal, Burn Font

Originally created by Clum for Fuse #13, Burn Font is a digitized version of a hand-drawn font.

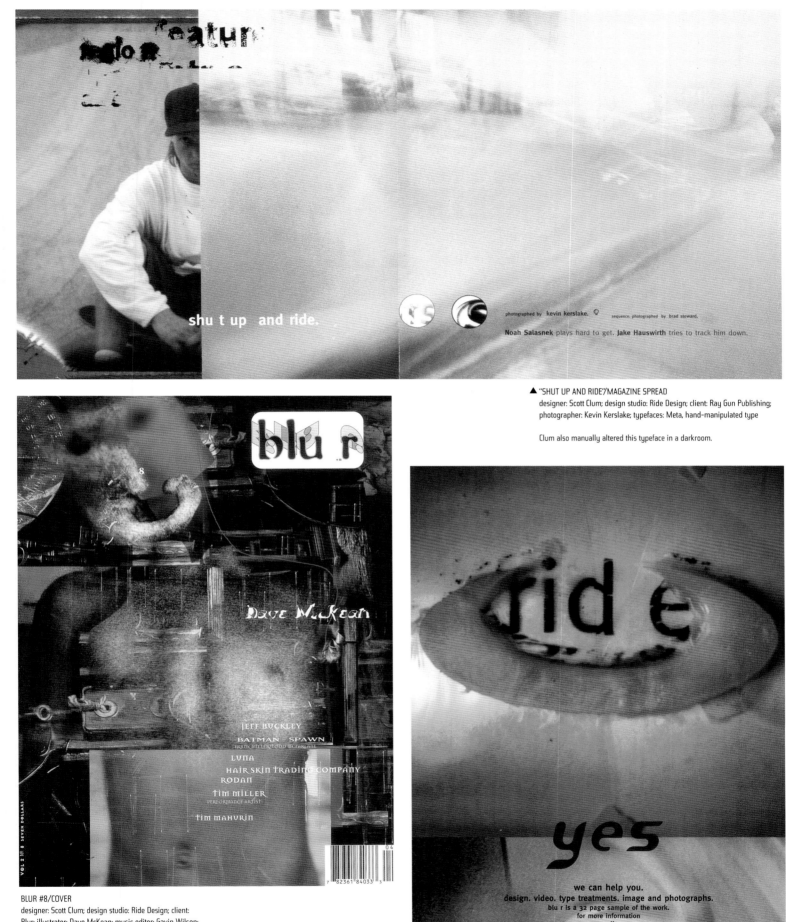

shu t up and ride.

photographed by **kevin kerslake.** ♀ sequence. photographed by brad steward.

Noah Salasnek plays hard to get. **Jake Hauswirth** tries to track him down.

▲ "SHUT UP AND RIDE"/MAGAZINE SPREAD
designer: Scott Clum; design studio: Ride Design; client: Ray Gun Publishing;
photographer: Kevin Kerslake; typefaces: Meta, hand-manipulated type

Clum also manually altered this typeface in a darkroom.

BLUR #8/COVER
designer: Scott Clum; design studio: Ride Design; client:
Blur; illustrator: Dave McKean; music editor: Gavin Wilson;
typefaces: Flo Motion and Virtual (logo), Room 222 ("Dave
McKean"), Mason (other names)

we can help you.
design. video. type treatments. image and photographs.
blu r is a 32 page sample of the work.
for more information
call
scott clum. portland. 503 873 6402
gavin wilson. nyc. 718 965 0908.

YES/SELF PROMOTION
designer: Scott Clum; design studio: Ride Design; client: Ride Design; photogra-
phers: Scott Clum, Gavin Wilson; model: Scott Clum; typefaces: Cyberotica
("Yes"), Meta (address), hand-manipulated

The type used on the model is a hand alteration of the typeface Meta.

ROGER DEAN, while still a student at the Royal College of Art, started research into the radical forms of architecture that he became famous for in the 1970s and 1980s. After graduating with honors in 1968, he worked predominantly on designing record covers, stage sets and furniture. In 1975 Dean formed Dragon's Dream Publishing Company and published his first book, <u>Views</u>, which went straight to number one on the Sunday Times Best Seller List. He has been the concept planner and designer for many projects, including Darling Harbour in Sydney, Australia, a resort town in Portugal's Algarve and a sports and leisure center for Wakefield in Yorkshire, England. In 1991 he formed Curved Space with Henk B. Rogers to develop environmentally friendly, energy-efficient curvilinear architecture. Recently, the pair began developing multimedia software with architecture and landscapes.

ROGER DEAN

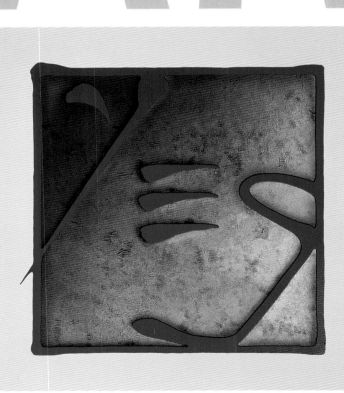

YES YEARS/BOXED SET
designer/art director/artist: Roger Dean; client: Yes; typefaces: Yes logo, Yes Chop Brush

Shown here are the cover of the boxed set (left) and the booklet (right). Both the "Yes" logo and the typeface (Yes Chop Brush) are hand-drawn.

ROGER DEAN, VIEWS/POSTER
designer/art director/artist: Roger Dean; client:
Roger Dean; typefaces: Roger Dean, Views

Both typefaces were created by the designer, who
was inspired by "sushi and rainy days."

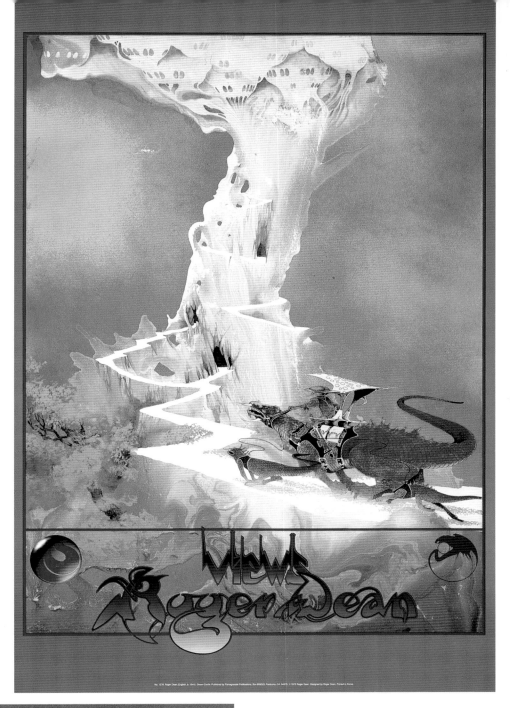

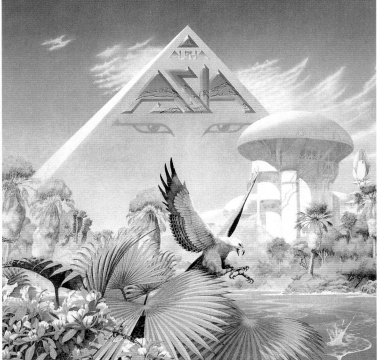

ASIA, ALPHA/ALBUM COVER
designer/art director/artist: Roger
Dean; client: Asia; typeface: Asia

This is a hand-drawn typeface.

LUC(AS) DE GROOT studied at the Royal Academy of Fine Arts in The Hague under Gerrit Noordzij. He then spent four years with the Dutch design group BRS Premsela Vonk, mainly on corporate identity work. In the meantime, he taught at the Art Academy in Den Bosch and free-lanced before moving to Berlin in 1993 to join MetaDesign as typographic director. There he occasionally finds time for sleep between work, reading, writing and drawing. He works on many diverse corporate design projects, including logos, magazine concepts, custom type-faces, fine-tuning and implementing type. He takes on any interesting challenge and is devoted to type day and night.

LUC(AS)
DE GROOT

Readability??? Last week, I went for a swim. On my way thunder broke loose. I fled in an antiques bookshop and spent all the money I had. The best one: «Das Buch im Wandel der Zeiten» from before the war, (with two pages type specimen), was all set in an old Fraktur

READABILITY LAST WEEK
designer/art director: Luc(as) de Groot; design studio: TheTypes; client: Luc(as) de Groot; typefaces: Bolletje Wol

De Groot used a manual and digital manipulation of another original design—TheSansMono—to create Bolletje Wol.

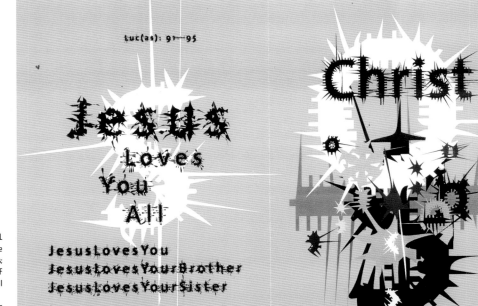

JESUS LOVES YOU ALL
designer/art director: Luc(as) de Groot; design studio: TheTypes; client: Luc(as) de Groot; typeface: FF Jesus Loves You All

Thesis Sans was used to create the typeface FF Jesus Loves You All.

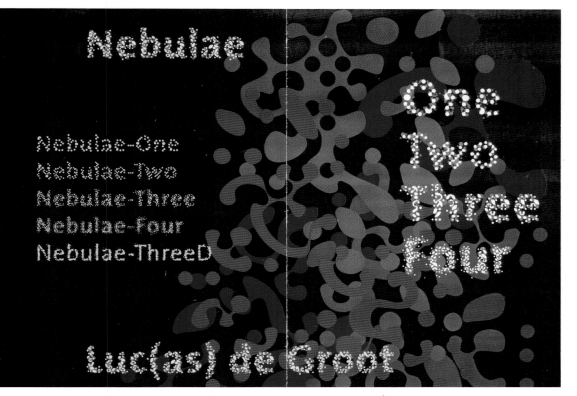

NEBULAE
designer/art director: Luc(as) de Groot; design studio: TheTypes; client: Luc(as) de Groot; typeface: FF Nebulae

De Groot manually and digitally manipulated Thesis Sans to create FF Nebulae.

FF THESIS TM/THESISPOSTCARD
designer: Richard Buhl; design studio: TheTypes; client: Luc(as) de Groot; art director: Luc(as) de Groot; typefaces: Thesis family: TheSans, TheMix, TheSerif

De Groot worked for six years creating these fonts from scratch with manually digitized sketches and five-kilogram test prints.

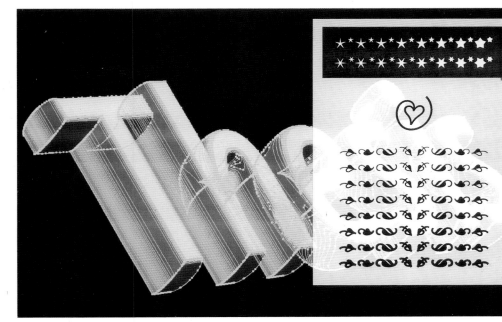

THESIS, THESIS3D.FH5
designer/art director: Luc(as) de Groot; design studio: TheTypes; clients: Luc(as) de Groot, Hamburger Satzspiegal; photographer/illustrator: Luc(as) de Groot; typefaces: TheSans, TheSans Expert (in all eight weights)

De Groot created the Thesis family by manually digitilizing his sketches and creating five-kilogram test prints over a period of six years.

SPENCER DRATE, creative director, designer, CD consultant and author, has created award-winning CD packaging for many popular recording artists, including Bon Jovi, Lou Reed, U2, the Ramones, the Velvet Underground, Joan Jett and the Talking Heads. One of the first to recognize and take advantage of the graphic possibilities of CD special packaging, he recently curated the first CD Special Packaging Show at the One Club in New York City with Jütka Salavetz. He is the author of Designing for Music and Rock Art for PBC International and coauthor with Roger Dean and Storm Thorgerson of Album Cover Album 6. Drate is an active member and committee participant of the National Academy of Recording Arts and Sciences and the Art Director's Club, NYC. He has been given many design awards, including ones from the AIGA and the Art Directors Club, and has been interviewed by many leading publications and on MTV and VH-1.

JÜTKA SALAVETZ has freelanced for Justdesign for the past twelve years and has codesigned most of the packaging with Spencer Drate. Many of her pieces, in addition to being shown in a variety of books, have won awards. The language of design is what brought Salavetz and Drate together, and their vision for infinite fantasies and new creations is what keeps them together.

S P E N C E R / J Ü T K A
DRATE/SALAVETZ

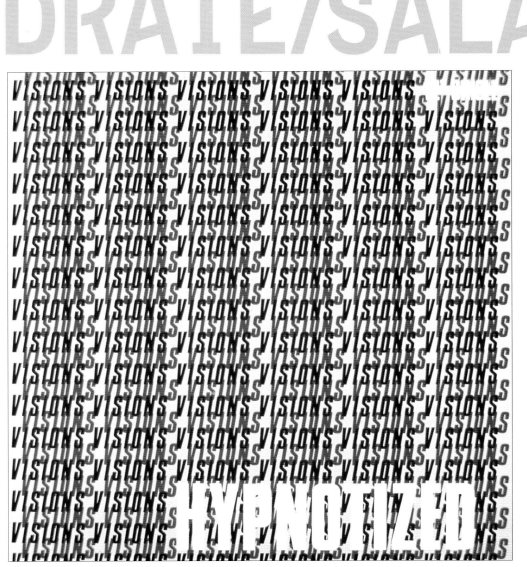

VISIONS, HYPNOTIZED/CD COVER
designers: Spencer Drate, Jütka Salavetz; design studio: Justdesign; client: Polygram Records; art director: Michael Bays; typefaces: Folio Bold Extra-Condensed Italic ("Visions"), Folio Bold Extra-Condensed ("Hypnotized")

Inspired by the band name, Visions, the designers created a repetitive pattern through the traditional process of typeset to layout.

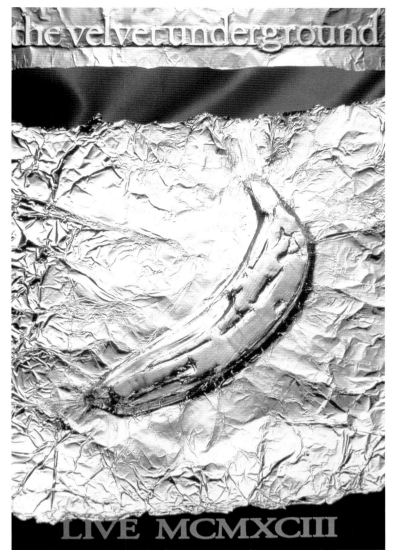

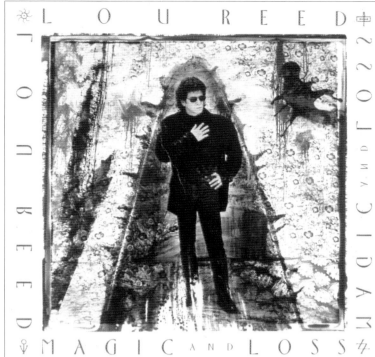

This traditionally typeset typeface integrates symbolic art with
type and photos. By partially typesetting the type backward,
a slightly bizarre touch is added.

The designers clashed the Garamond typeface with the more contemporary visual of a metallic
banana to bring the classic Velvet Underground image into a new, contemporary dimension.

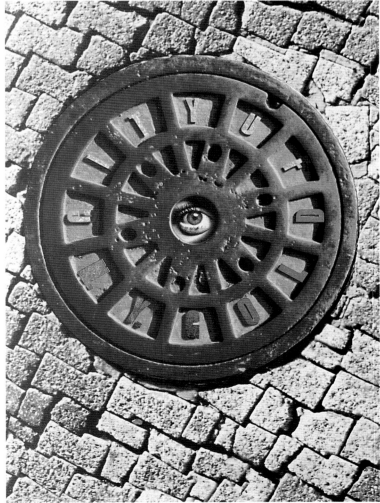

Inspired by the image of a manhole cover in the street,
Helvetica Compressed was designed by using Adobe
Photoshop to manually alter an existing typeface. This
was also the theme for the "New York" image and carried
through into the company's direct-mail brochure.

ELLIOTT PETER EARLS received his M.F.A. from Cranbrook Academy of Art and is the founder of The Apollo Program, an experimental media studio and type foundry located in Greenwich, Connecticut. Earls's work has been published widely, including in the publications of the American Institute of Graphic Arts, the Art Directors Club of New York, the American Center for Design, Emigre and I.D. Earls's recent lectures include Digitale Zuppa; his essay entitled "WD40™...a tool kit in a can, or the importance of David Holzman's Diary" was published in Emigre #35. His recent studio projects include "Throwing Apples at the Sun," an enhanced CD-ROM distributed exclusively through Emigre.

ELLIOTT PETER
EARLS

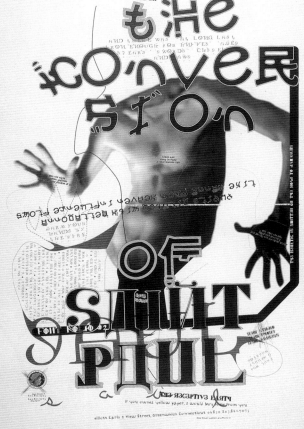

THE CONVERSION OF SAINT PAUL
designer/art director: Elliott Peter Earls; design studio: The Apollo Program; client: The Apollo Program; photographer: Elliott Peter Earls; typefaces: Mothra Paralax ("the conversion of Saint Paul"), Troopship Blanched ("the Creative Heaven," "the Receptive Earth")

These fonts were created in Fontographer from hand-drawn sketches of individual characters and inspired by Japanese characters and Cyrillic characters.

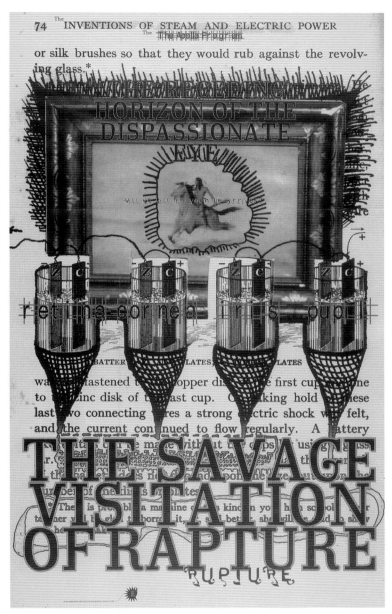

THE SAVAGE VISITATION OF RAPTURE
designer/art director: Elliott Peter Earls; design studio: The
Apollo Program; client: The Apollo Program; photographer:
Elliott Peter Earls; typefaces: Calvino Hand, Penal Code Bland
(smaller text copy)

Italo Calvino's book Six Memos for the Next Millennium served
as the primary inspiration for these computerized versions of
hand-drawn individual characters.

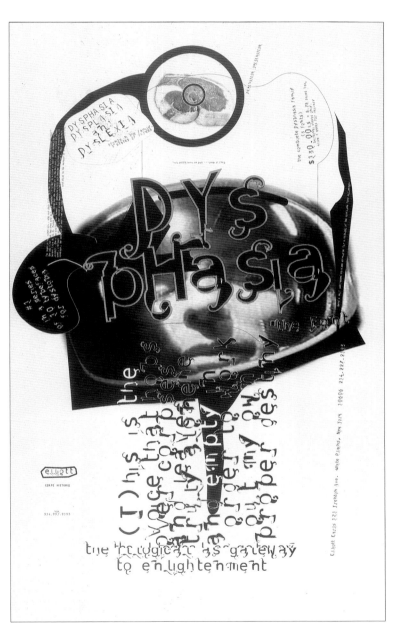

DYSPHASIA
designer/art director: Elliott Peter Earls; design studio: The
Apollo Program; client: The Apollo Program; photographer:
Elliott Peter Earls; typefaces: Dyslexia ("the illogical as
gateway to enlightenment"), Dysphasia

Earls created both fonts in Fontographer from hand-
drawn sketches of individual characters.

Eg.G is a small but widely respected design company based in Sheffield, England. Formed in 1991 by Dom Raban, Eg.G has a steadily growing reputation in the United Kingdom and beyond for their innovative and often challenging work for a growing list of clients. In the future you will be able to see their design work on the Internet, on film, video, CD-ROM, floppy disk, slide and, of course, paper.

DESIGNERS:
NEIL CARTER (L), DOM RABAN (R)

EG.G

UNITED STATES OF E/
PROMOTIONAL MATERIAL
designer: Dom Raban; design studio:
Eg.G; client: Inveresk Fine Papers;
typefaces: many various

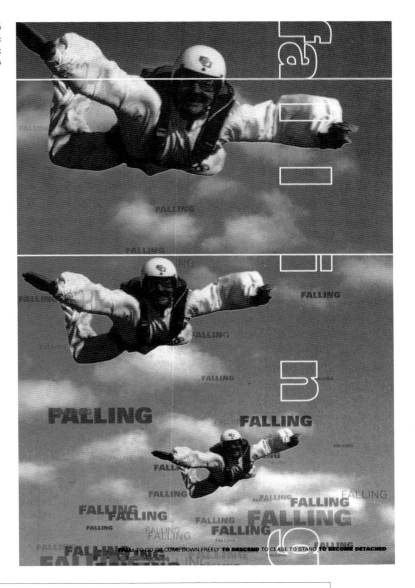

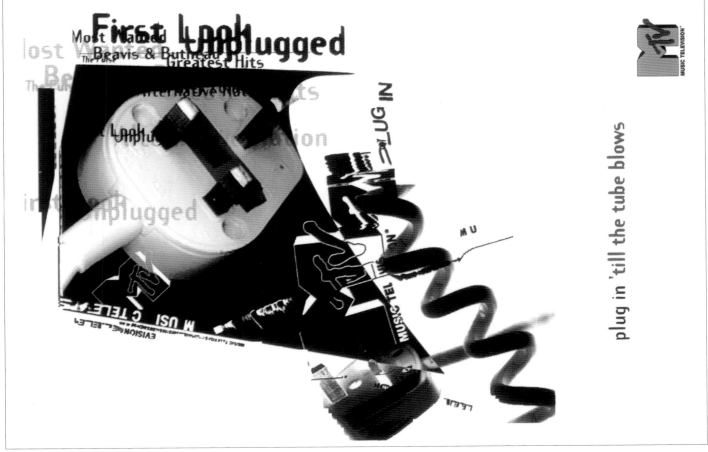

REWIND YOUR MIND
designer: Neil Carter; design studio:
Eg.G; client: Braintree Barn; type-
faces: Fitipaldi, Univers

Fitipaldi, inspired by racing car
graphics, is a custom digital
creation.

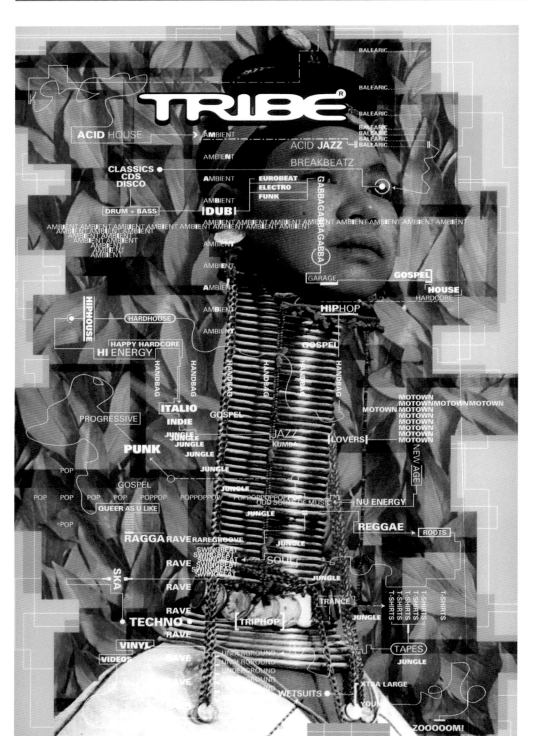

TR0002
designer: Dom Raban; design studio: Eg.G;
client: Tribe Records; typefaces: Akzidenz
Grotesk, Tribal

Raban created Tribal by manipulating
Handel Gothic.

BIODIVERSITY/ILLUSTRATION
designer: Neil Carter; design studio:
Eg.G; client: British Council; type-
faces: Giddyup Thangs, Toolbox,
Franklin Gothic, Akzidenz Grotesk

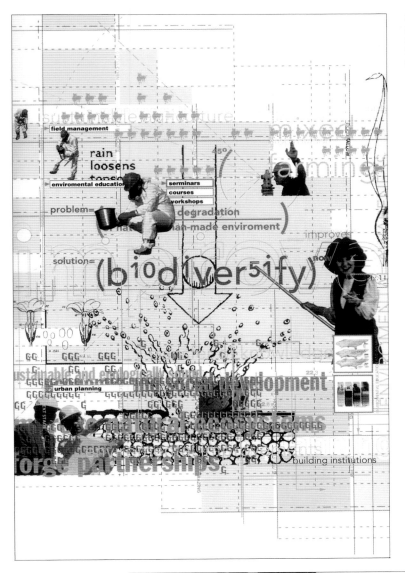

OH ISABELLA/FLYER AND POSTER
designer: Neil Carter; design studio: Eg.G; client: Alison
Andrews Company; photographer/illustrator: Neil Carter;
typefaces: Balmoral, Meta

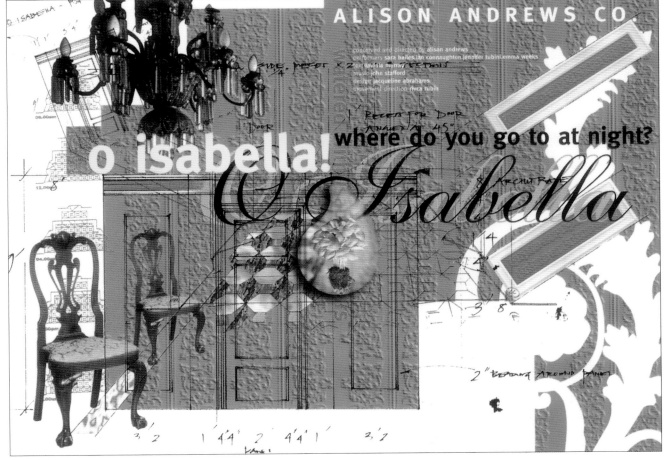

EDWARD FELLA is a professor of graphic design at CalArts in Valencia, California, and one of the most controversial, experimental and influential type designers working. His work, such as that for the Detroit Focus Gallery, is high-postmodern in its mixture of styles and design "cultures," or apparent levels of expertise. One of a movement of American designers who have attempted to apply Derrida-inspired deconstructionist theory to graphic design, Fella has been described as "anti-quality" and an "expert at the inept." He says himself, "I hate fine anythings."

EDWARD

FELLA

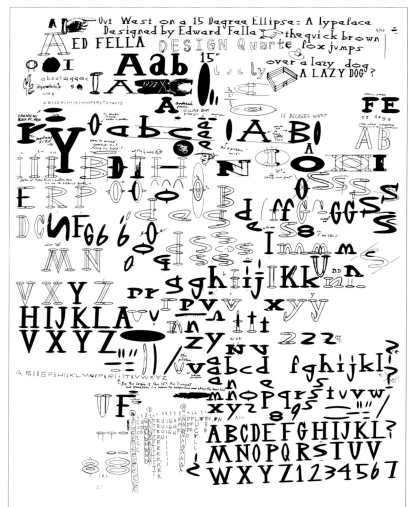

**OUT WEST ON A
15 DEGREE ELLIPSE**
designer: Edward Fella; client:
Design Quarterly Winter 1993; art
director: Laurie Haycock Makela;
typeface: Out West on a 15 Degree
Ellipse

This typeface was later digitized
by Zuzana Licko.

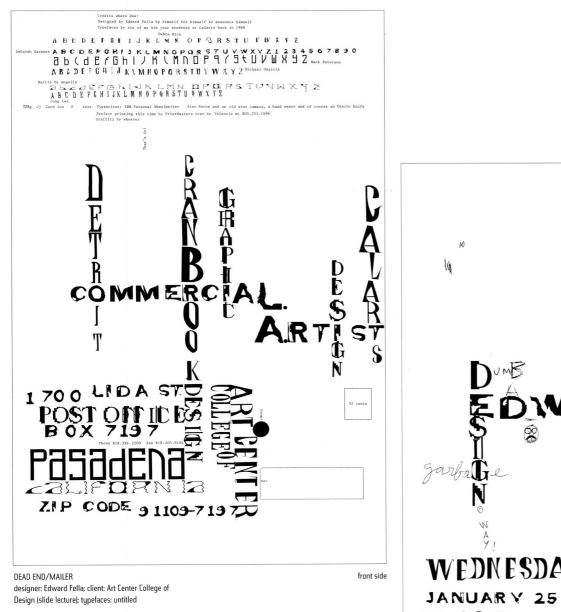

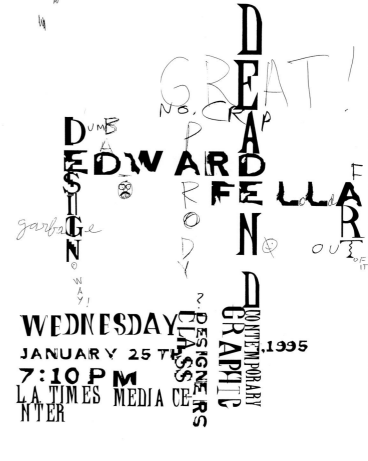

front side

DEAD END/MAILER

designer: Edward Fella; client: Art Center College of
Design (slide lecture); typefaces: untitled

All six faces were designed by fourth-year students at
CalArts in 1988, either through hand-lettering or hand-
lettering from an existing typeface or computer crash.

reverse side

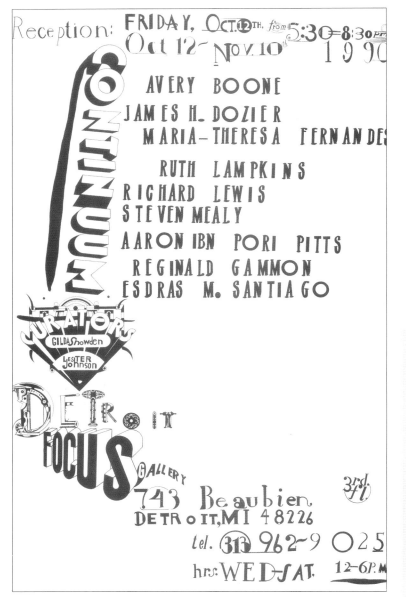

CONTINUUM
designer: Edward Fella; client: Detroit Focus Gallery; typefaces:
hand-created lettering

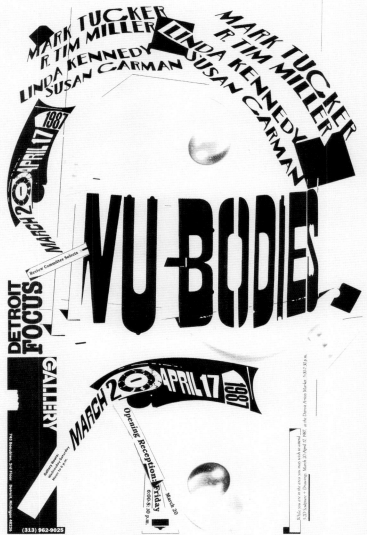

NUBODIES
designer: Edward Fella; client: Detroit
Focus Gallery; typeface: untitled

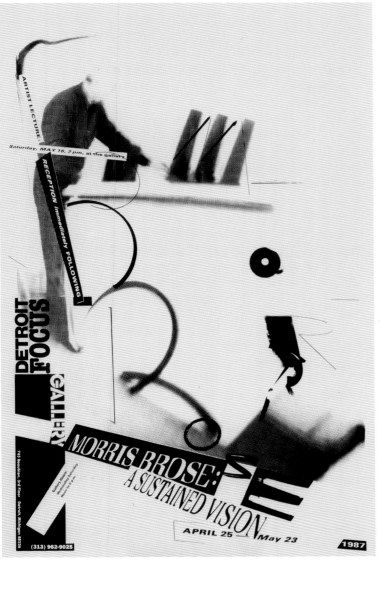

MORRIS BROSE: A SUSTAINED
VISION
designer: Edward Fella; client:
Detroit Focus Gallery; typefaces:
untitled

VICKI ARNDT, PETER LENZO: FROM ARTISTS
STUDIOS/CURRENT WORK
designer: Edward Fella; client: Detroit Focus Gallery;
typeface: hand-created lettering

Fella was inspired by "Garage Sale" hand-lettered signs
and other forms of vernacular hand-lettered work.

TOBIAS FRERE-JONES was born in 1970 in New York. He graduated from the Rhode Island School of Design in 1992 and began full-time work for the Font Bureau, Inc. in Boston, where he is currently a senior designer. He has lectured at RISD, Pratt Institute, the Royal College of Art and Yale School of Design, where he teaches a letterform course with Matthew Carter. When asked if the world really needs any more typefaces, he replied, "The day we stop needing new type will be the same day that we stop needing new stories and new songs."

TOBIAS
FRERE-JONES

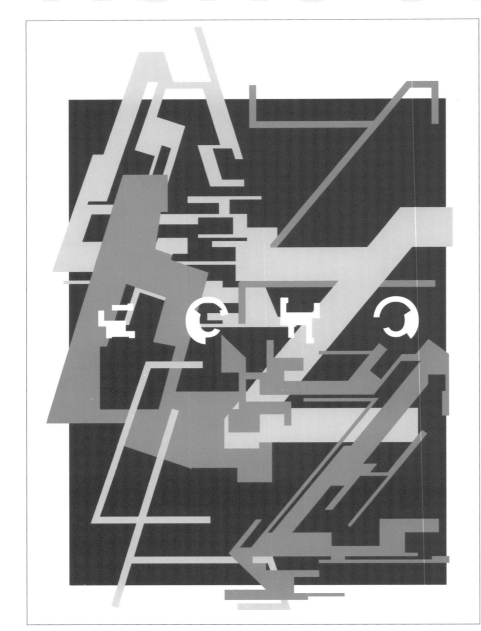

ECHO
designer: Tobias Frere-Jones; design studio: Font Bureau, Inc.; client: Tobias Frere-Jones; typeface: Echo

Echo begins with a basic sans serif, which follows a very straightforward model of character structure. The contour of these characters was then cut apart and looped back on itself, to deliver the same image but in an unfamiliar way. Because it depends on perception of area rather than line, it has the unusual effect of being more legible the smaller it is set.

EPITAPH

designer: Tobias Frere-Jones; design studio: Font Bureau, Inc.; client: Font Bureau; typeface: Epitaph

Two concepts that Frere-Jones thought could never be combined find harmony in the capitals. He had tried a lowercase for this face, but it was unsuccessful. Instead, he decided on a second set of capitals that would carry the same voice but in different forms.

Epitaph was modeled on a graceful Art Nouveau letterform that was drawn at the close of the nineteenth century at the Boston branch of American Type Founders. The energy and life of the Vienna Secession alphabet drew the attention of Frere-Jones, who digitized the original set of titling capitals and added alternate characters.

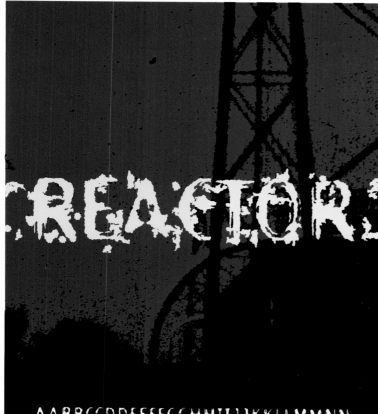

REACTOR

designer: Tobias Frere-Jones; design studio: Font Bureau, Inc.; client: Fuse; typeface: Reactor

Originally inspired by an abandoned building that was burning, Frere-Jones introduced an otherwise normal typeface to the real world of decay and entropy. The lowercase was inspired by Nikolai Tesla's theory of sympathetic vibrations: a repeated vibration, regardless of size, will multiply itself through a structure and (if kept constant) will eventually cause the structure to collapse. The lowercase is filled with copies of the uppercase, but with "noise fields" that extend into neighboring characters. If left unchecked, this noise will accumulate until the text is all but destroyed; the more you type, the worse it gets.

VITRIOL

designer: Tobias Frere-Jones; design studio: Font Bureau, Inc.; client: Tobias Frere-Jones; typeface: Vitriol

The characters of Nobel Light were made to feed back on themselves, repeating their events and structures. The noise this creates both obscures and reinforces the identity of each character. The characters scream so loudly they can't be heard.

JONATHAN HOEFLER is a typeface designer and armchair type historian whose work over the past eight years has had a subtly profound effect on the look of American publishing. His New York studio, the Hoefler Type Foundry, counts Apple Computer, Entertainment Weekly, Harper's Bazaar, IBM, Martha Stewart Living, Newsweek, Rolling Stone and US among its clients. Hoefler's interest in contemporary critical typography is satisfied by serving as creative director of Typo and by sharing office space with antipodal designer Barry Deck.

JONATHAN HOEFLER

GOOD LETTERING *requires as much skill as good painting or good sculpture.*

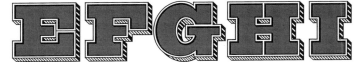

Although it serves a definite purpose and not necessarily eternity, good lettering

is equal to the fine arts. The designer of letters, whether he be a sign painter, a

graphic artist or in the service of a type foundry, participates just as creatively

in shaping the style of his time as the architect or poet. — JAN TSCHICHOLD

EGIZIANO FILIGREE · *A Decorative Typeface developed for Fred Woodward at Rolling Stone Magazine, 1990*

EGIZIANO FILIGREE
designer: Jonathan Hoefler; design studio: Hoefler Type Foundry; client: Rolling Stone; art director: Fred Woodward; typeface: Egiziano Filigree

Inspired by two- and three-color ornamented "Tuscan" types of the late nineteenth century, Hoefler designed the detailing to match the Rolling Stone logo.

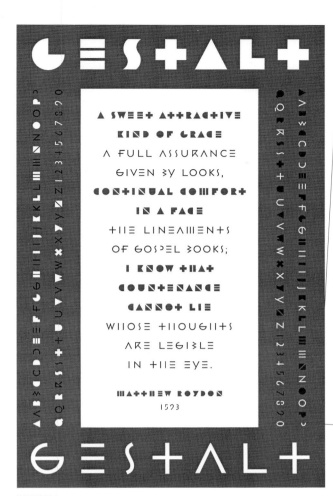

HTF GESTALT
designer: Jonathan Hoefler; design studio: Hoefler Type Foundry; client: Muse; typeface: HTF Gestalt (linear, volumetric, Ying and Yang)

HTF Gestalt is an experimental typeface inspired by a tenet of Gestalt psychology that suggests no idea is comprehensible out of context. Thus, in Gestalt, each character is ambiguous, taking form only from the suggestions of its context. The full family of designs, which includes three weights and an outline, comprises the first issue of Muse, an imprint of experimental typography.

Gestalt Yin & Yang · An Experimental Two-Color Design, 1993

HTF REQUIEM
designer: Jonathan Hoefler; design studio: Hoefler Type Foundry; client: Travel and Leisure; typeface: HTF Requiem

HTF Requiem is based on a font of engraved capitals, cut by Ludovico Vicentino degli Arrighi, which appeared in his Il Modo de la Temperare le Penne published in 1523. The lowercase (not shown) is original, as Arrighi offered none, although it is inspired by the work of Arrighi's contemporaries Giovanni Creci and Giambattista Palatino. An italic of the chancery style favored by Arrighi is in progress.

CAUSA
GIAMAI TARDE NON FUR GRATIE
SACRUM
DIVINE IN QUELLE SPERO CHE
LIBER
IN ME ANCOR FARANO ❧ ALTE
EST SUI
OPERATIONE E PELLEGRINE

i/o 360° is a multidisciplinary design studio, specializing in design and programming within technology-mediated environments. Their projects range from Internet Websites and internal Web applications to CD-ROM and IPK developments, video graphics and effects, custom application interface design/programming and media incorporated into exhibits and trade shows. The multi-disciplined staff give i/o 360° unique expertise and depth to provide clients with intelligent, creative and forward-thinking solutions to challenging design problems. During the studio's first two years, i/o 360° has developed a client list that includes Sony, IBM, Microsoft, NorTel, Bellcore and Sotheby's. Recently, the design studio has been included in the I.D. Forty and featured in articles in a variety of publications, including AdAge Creativity, State of Cyberspace and Designing for Multimedia.

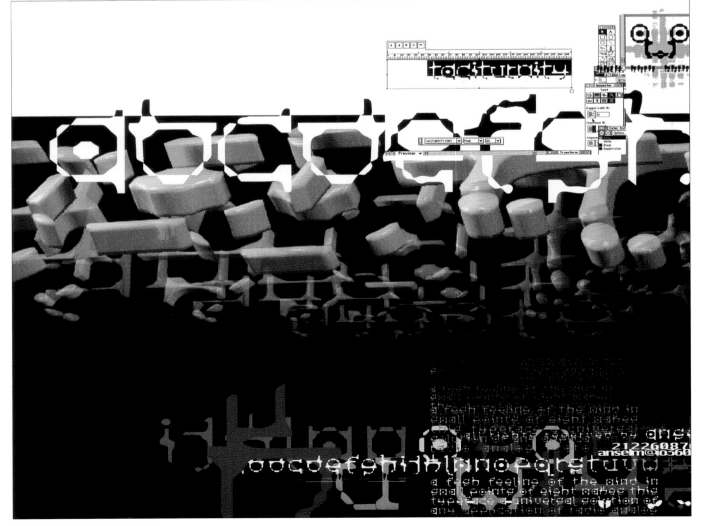

TACITURNITY
design studio: i/o 360°;
typefaces: Zygote
("Taciturnity," "Zygote"
background), Dublix
("Telefonn")

Taciturnity is a promotion for the typeface Zygote, inspired by blobs of milk floating in space. i/o 360° created Zygote by freehand drawing in Fontographer.

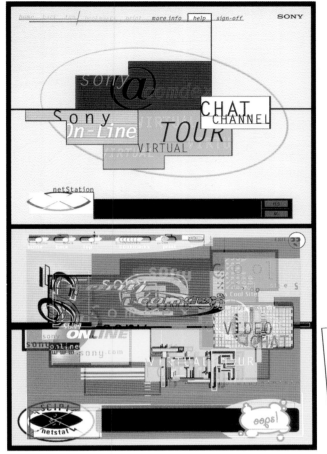

SONY ONLINE/CHANNEL-VIDEO
CHAT
design studio: i/o 360°; client: Sony;
typefaces: Old Letter Gothic, Letter
Gothic

Both typefaces were custom digital
creations.

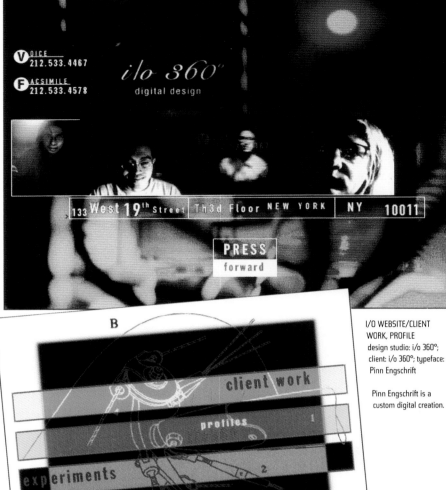

I/O WEBSITE/CLIENT
WORK, PROFILE
design studio: i/o 360°;
client: i/o 360°; typeface:
Pinn Engschrift

Pinn Engschrift is a
custom digital creation.

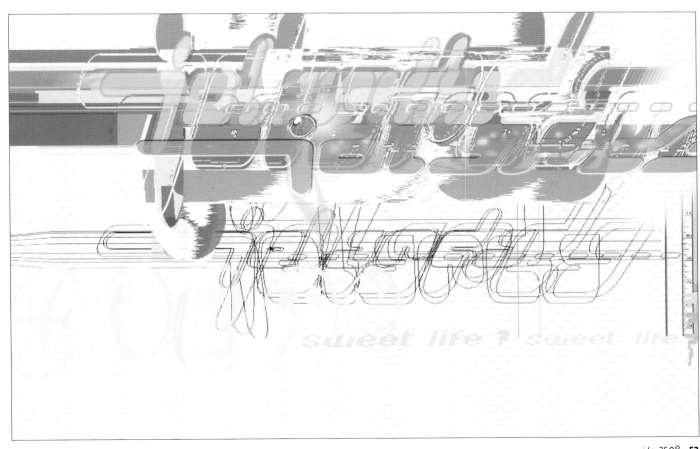

SWEET LIFE
design studio: i/o
360°; typefaces:
Gigafont 1.0
("Jolanda," "?"),
Bundesbahn (icons),
Union Round
("Sweet Life")

Sweet Life is
described by the
designers as "a let-
ter to a friend to
check if she is
happy." Gigafont 1.0
was created using
Adobe Illustrator
and Fontographer
and was inspired
by German rave
culture.

JOHN C. JAY is international creative director for Wieden & Kennedy, a world-renowned advertising and design agency based in Portland, Oregon, with global clients such as Nike, Microsoft, Coca-Cola and ESPN. Jay was previously senior vice president/creative director for ten years and later executive vice president of marketing and creative services for Bloomingdale's in New York. He was also director of his own creative consultancy, John Jay Design. He has received over 150 international awards honoring him for creativity in print and television advertising, graphic and editorial design, and documentary film as well as interior design. In 1994 I.D. named him one of America's forty most influential designers. He is active in the arts and contributes his time back to his profession regularly.

JOHN C.
JAY

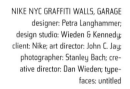

NIKE NYC GRAFFITI WALLS, GARAGE
designer: Petra Langhammer; design studio: Wieden & Kennedy; client: Nike; art director: John C. Jay; photographer: Stanley Bach; creative director: Dan Wieden; typefaces: untitled

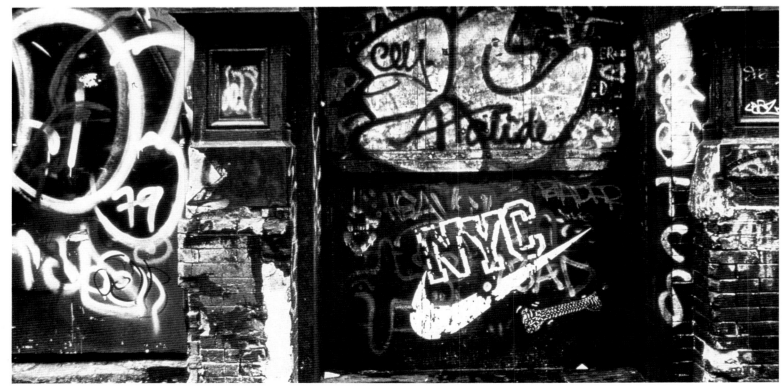

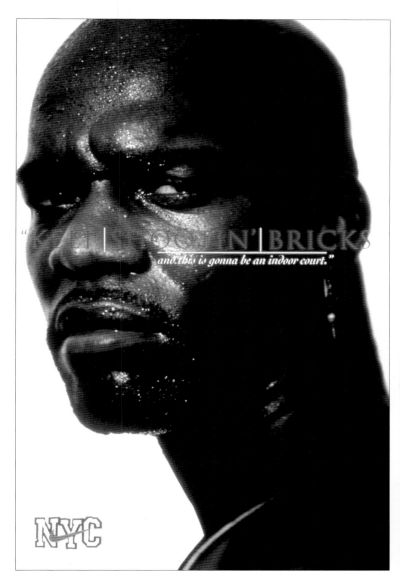

"SHOOTIN' BRICKS
and this is gonna be an indoor court."

NIKE NYC TRASH TALK, KEEP
SHOOTIN' BRICKS
designer: Imin Pao; design studio:
Wieden & Kennedy; client: Nike; art
director: John C. Jay; photographer:
John Huet; creative directors: Dan
Wieden, Jamie Barrett, Jim Riswold;
copywriter: Jimmy Smith; typefaces:
Cochin Italic, Trojan Regular

NIKE NYC COURTS,
SOUL IN THE HOLE
design studio: Wieden & Kennedy;
client: Nike; art director: Young Kim;
photographer: Exum; creative direc-
tors: John C. Jay, Dan Wieden; copy-
writer: Jimmy Smith; typefaces:
Coronet MT Bold, Trixie Plain

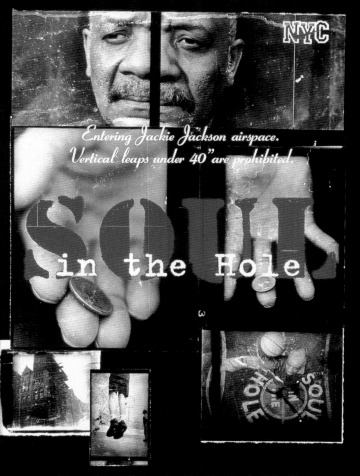

Entering Jackie Jackson airspace.
Vertical leaps under 40" are prohibited.

SOUL in the Hole

Pro or streetball legend, who will you vote into the
NYC Basketball Hall of Skillz? 212-575-YOKE.

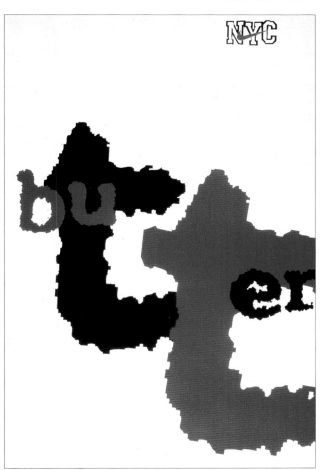

NIKE NYC LEXICON, BUTTER
designer: Imin Pao; design studio: Wieden & Kennedy;
client: Nike; art director: John C. Jay; illustrator: Javier
Michalski; creative director: Dan Wieden; copywriter:
Jimmy Smith; typeface: untitled

Butter's typeface was a custom creation on Adobe
Illustrator.

GALIE JEAN-LOUIS, a graduate of the Ontario School of Art, is the design director of the <u>Anchorage Daily News</u> and principal of Galie Inc. Under her direction, the <u>Anchorage Daily News</u> has gained worldwide recognition in the international design community, ranking third in the world this year for overall awards through the Society of Newspaper Design. Her work as a designer, illustrator and art director has been featured in <u>Print</u>, <u>Graphis</u>, <u>Communication Arts</u> and in the 1996 I.D. Forty for innovation in design. Recent honors for her publication and entertainment design include gold and silver medals from the Society of Publication Designers and the New York Art Directors Club.

GALIE
JEAN-LOUIS

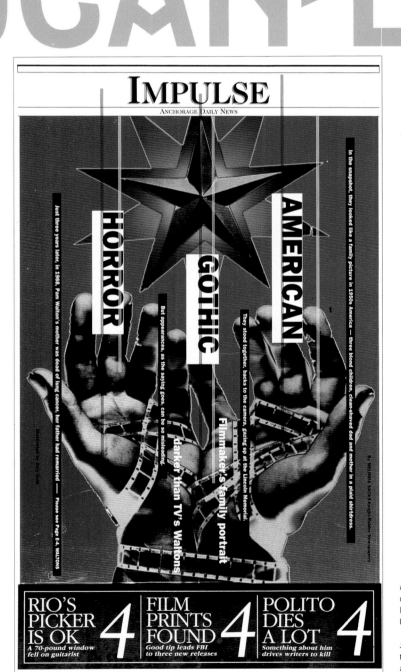

AMERICAN GOTHIC HORROR
designer/art director: Galie Jean-Louis; design studio: Galie Inc.; client: Anchorage Daily News; photographer: Amy Guip; typeface: Franklin Gothic

Jean-Louis designed this cover for the entertainment section of the Anchorage Daily News, "Impulse," in an effort to attract a younger demographic.

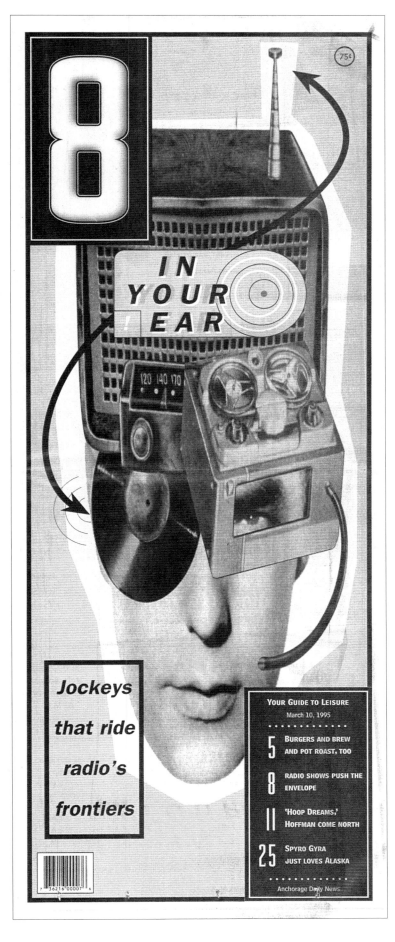

IN YOUR EAR

designer/art director: Galie Jean-Louis; design studio: Galie Inc.; client: 8; photographer: David Plunkert; typeface designers: Mike Bain (Galie Thin and Tall), Dennis Ortiz Lopez (interior fonts); typefaces: Franklin Gothic Italic (headline), Galie Thin and Tall (subheadline, text)

Jean-Louis worked with type designer Mike Bain on Galie Thin and Tall. Dennis Ortiz Lopez designed the interior fonts for the magazine. Both fonts designed by Lopez and Bain were custom digital creations. Galie Thin and Tall was inspired by the fonts Bank Gothic and Dead History, and by supermodel Kate Moss. The fifteen-inch (thirty-eight centimeter) initial caps by Lopez were inspired by the Bodoni family of fonts. This publication received a gold medal for redesign from the Society of Publication Designers in February 1996.

HIP HOP HYPE

designer/art director: Galie Jean-Louis; design studio: Galie Inc.; client: Anchorage Daily News; illustrator: Galie Jean-Louis; typefaces: Franklin Gothic (headline), Univers (text)

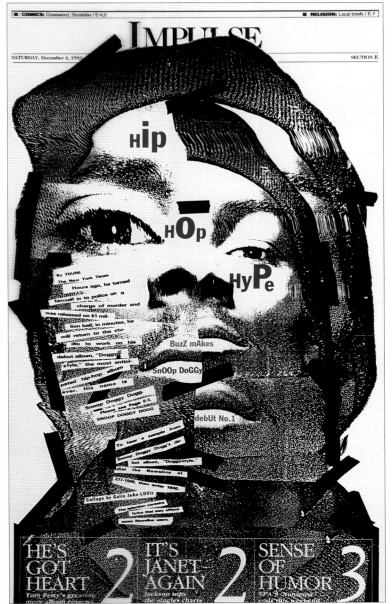

JEFFERY KEEDY received an M.F.A. from Cranbrook Academy of Art and a B.F.A. from Western Michigan University and is faculty member and past director of California Institute of the Arts' graphic design program. He has designed publications for the Museum of Contemporary Art in Los Angeles, the Santa Monica Museum of Art, Los Angeles Contemporary Exhibitions and San Francisco Artspace. His typeface designs are distributed internationally and have received awards from the AIGA, the Council for Advancement and Support of Education, the American Center for Design and the Broadcast Designers Association. His designs and essays have been published in periodicals such as I.D., Emigre, HOW, Design Quarterly, Eye, Design, Fuse and Print and in the books The New Discourse—Cranbrook Design, The 20th Century Poster—Design of the Avant Garde, Twentieth-Century Type and Typography Now: The Next Wave.

JEFFERY KEEDY

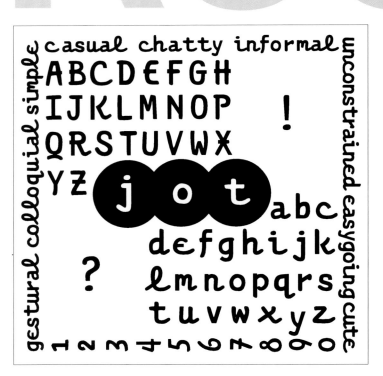

JOT ALPHABET
designer/art director: Jeffery Keedy; photographer/illustrator: Jeffery Keedy; typeface: Jot

Jot combines the attributes of two contradictory ideas into one typeface. The monospace character widths and exaggerated simplicity of typewriter faces like Courier and Letter Gothic are reconciled with the gestural expressiveness of typefaces derived from handwriting, like Dom Casual and Brush Script. The final version of Jot, the result of many computerized and hand-drawn sketches, was created in Fontographer.

KEEDY SANS
designer/art director: Jeffery Keedy; photographer/illustrator: Jeffery Keedy; typeface: Keedy Sans

Keedy Sans, the first typeface released by Emigre Graphics that was not designed by Zuzana Licko, was loosely based on Highway Gothic. Keedy wanted to create a typeface with the same vernacular crudeness as Highway Gothic but with an added idea of irregularity. Trying to contradict the assumption that typefaces are systematic, he designed Keedy Sans to willfully contradict expectations.

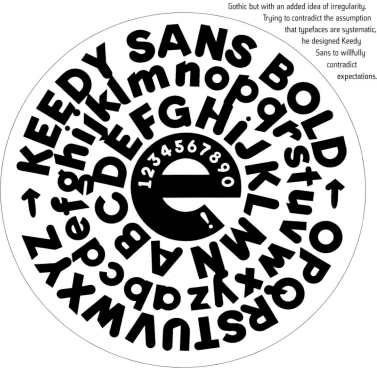

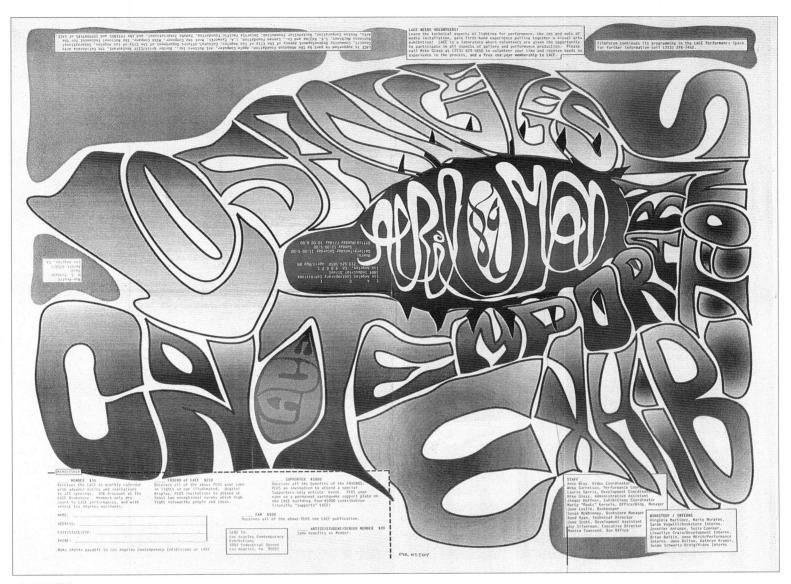

LACE, PSYCHEDELIC
POSTER/CALENDAR
designer/art director: Jeffery Keedy;
client: Los Angeles Contemporary
Exhibitions; photographer/illustrator:
Jeffery Keedy; typefaces: hand-cre-
ated lettering, Courier

Keedy designed this poster to pay
homage to psychedelic poster
designers Wes Wilson and Victor
Moscoso.

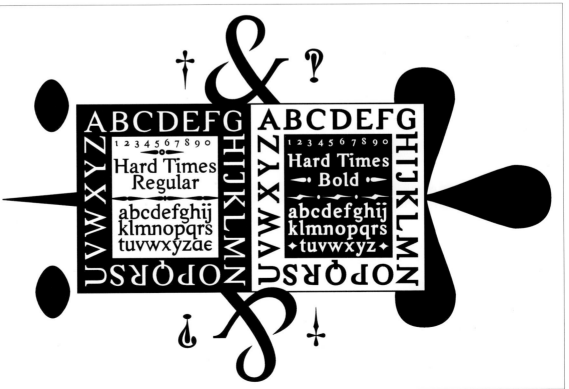

HARD TIMES REGULAR
AND BOLD
designer/art director:
Jeffery Keedy; photogra-
pher/illustrator: Jeffery
Keedy; typefaces: Hard
Times Regular, Hard
Times Bold

Keedy used Times Roman as the initial pattern for Hard Times, wanting to create a new typeface that was as economical and practical as Times Roman. Hard Times is a retrofit that
gives Times Roman a hard time by showing the wear and tear of time. However, Hard Times is a complete reinterpretation—not just a few serifs knocked off here and there.

The contrast of the thicks and thins has been reduced to counterbalance the asymmetry of the serifs. Soft oval forms have been added to contrast the hard edges. Keedy also intro-
duced some elements from Plantin, the precursor to Times Roman.

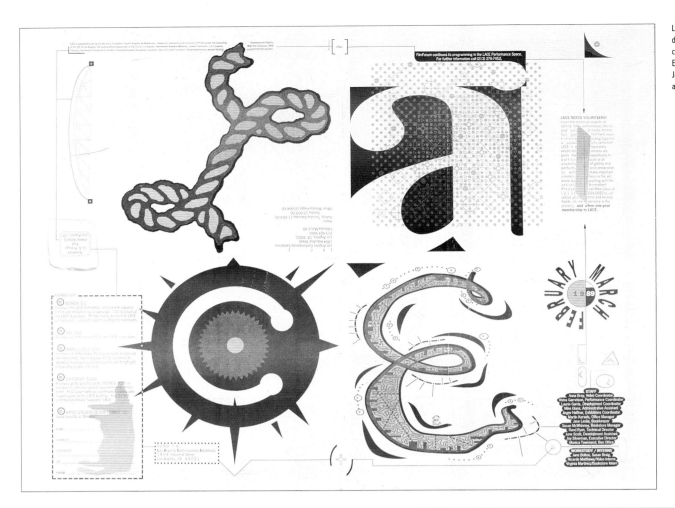

LACE, ROPE "L"
designer/art director: Jeffery Keedy;
client: Los Angeles Contemporary
Exhibitions; photographer/illustrator:
Jeffery Keedy; typefaces: hand-cre-
ated lettering, Franklin, News Gothic

LACE, 4 BIG SQUARES
designer/art director: Jeffery Keedy;
client: Los Angeles Contemporary
Exhibitions; photographer/illustra-
tor: Jeffery Keedy; typeface design-
ers: Jeffery Keedy (Keedy Sans,
Handy Script), Barry Deck
(Canicopulus Script); typefaces:
Keedy Sans, Handy Script,
Canicopulus Script, Letter Gothic
(text)

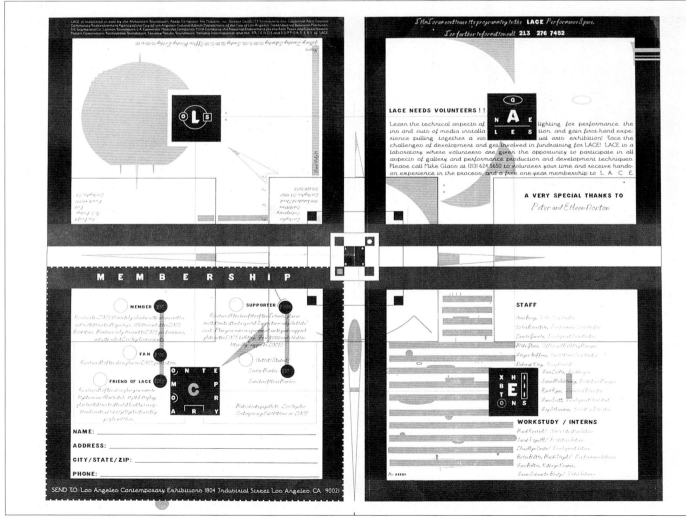

LACE/CALENDAR
designer/art director: Jeffery Keedy;
client: Los Angeles Contemporary
Exhibitions; photographer/illustrator:
Jeffery Keedy; typefaces: Letter
Gothic, Courier, Cooper Black, Dom
Casual, Park Avenue, Bitmapped Type,
Helvetica

Keedy used many different decora-
tive vernacular types from clip art
books mixed with digital text type.
Helvetica was outlined with a drop
shadow.

Once upon a time, it was widely believed that typography was a type of language unto itself, that runs parallel to the written word. The specific significance of the signs of this typographic language were regulated by the craftsmen who practiced the typographic arts. Therefore, they alone could accurately evaluate the use/value of the art. However as language use multiplied and expanded through time, typography expanded far beyond the reaches of the craftsman. Now typography is straining at the farthest edge of language. Keep on reading into the shadow of language.

EMIGRE #11, VISION
designer/art director: Jeffery Keedy;
client: Emigre; photographer/
illustrator: Jeffery Keedy; typefaces:
Times Roman, Letter Gothic

CHIP KIDD is a graphic designer functioning primarily in the world of book design and literature. He has been a book jacket designer for Alfred A. Knopf since 1986, and his work has been featured in Metropolis, Vanity Fair, The Graphic Edge, Eye, Print, Entertainment Weekly, The New Republic, Time, Graphis, New York and I.D. magazines, among others. I.D. chose him as part of its first I.D. Forty group of the nation's top designers. His designs have been described as "monstrously ugly" (John Updike), "apparently obvious" (William Boyd), "faithful, flat-earth rendering" (Don DeLillo), "surprisingly elegant" (A.S. Mehta), "a distinguished, parochial, comic, balding, Episcopal priest" (Allan Gurganus), "two colors plus a sash" (Martin Amis) and "not a piece of hype. My book was lucky" (Robert Hughes).

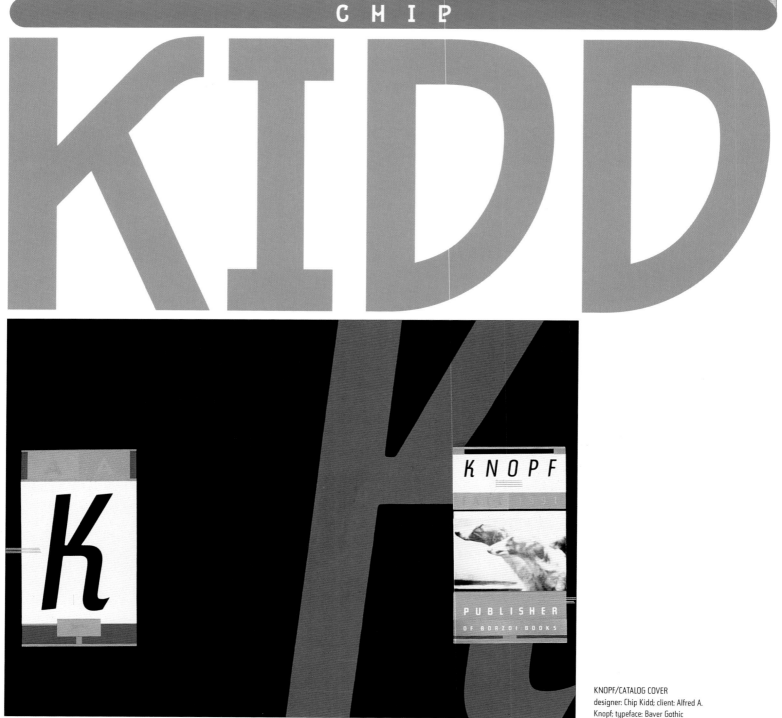

C H I P

KIDD

KNOPF/CATALOG COVER
designer: Chip Kidd; client: Alfred A. Knopf; typeface: Baver Gothic

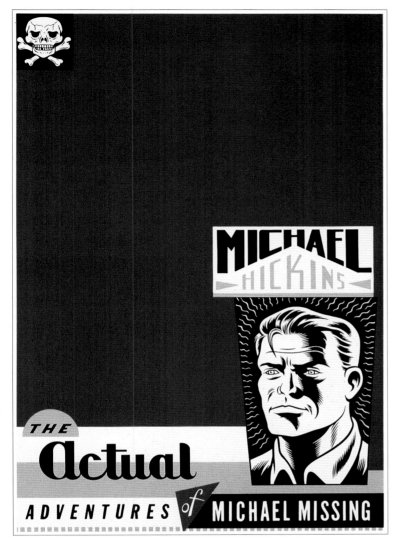

THE ACTUAL ADVENTURES OF
MICHAEL MISSING
designer: Chip Kidd; client: Alfred A.
Knopf; illustrator: Charles Burns;
typeface: hand-drawn

Kidd, inspired by pulp fiction covers,
created the ink-on-paper title type.

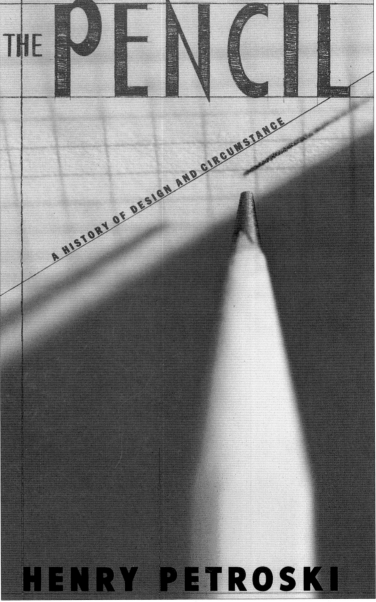

THE PENCIL
designer: Chip Kidd; client: Alfred A.
Knopf; photographer: Geoff Spear;
typeface: hand-drawn

Kidd used pencil on tracing paper to
create the title lettering.

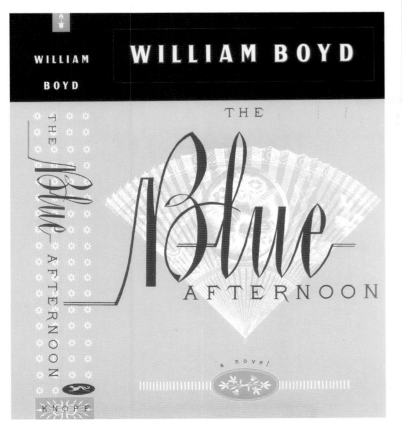

THE BLUE AFTERNOON
designers: Chip Kidd, Carol Devine Carson; client: Alfred
A. Knopf; typeface: hand-drawn

Carson and Kidd's ink-on-paper title was inspired by
turn-of-the-century candied rose petal tins.

GREY IS THE COLOR OF HOPE
designer: Chip Kidd; client: Alfred A.
Knopf; typeface: hand-drawn

Inspired by his subject matter—women in
a Russian prison—Kidd used only pen on
paper to create this lettering.

MICHAEL CRICHTON, DISCLOSURE
designer: Chip Kidd; client: Alfred A.
Knopf; typeface: Bell Gothic Bold

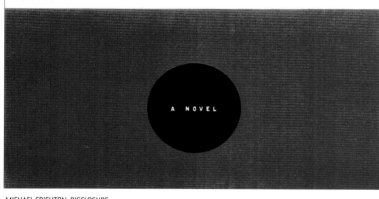

EXTINCTION
designer: Chip Kidd; client: Alfred
A. Knopf; typeface: Alternate
Gothic

The blurred typeface was meant
to reflect man's underlying sense
of imminent and inevitable
disintegration brought about by
his deep antipathy toward the
overall collapse of morality in the
twentieth century.

WATCHING THE BODY BURN
designer: Chip Kidd; client: Alfred
A. Knopf; illustrator: Chip Kidd;
typefaces: untitled

These typefaces were created
through the manual alteration of
existing typefaces on a black-
and-white Xerox machine.

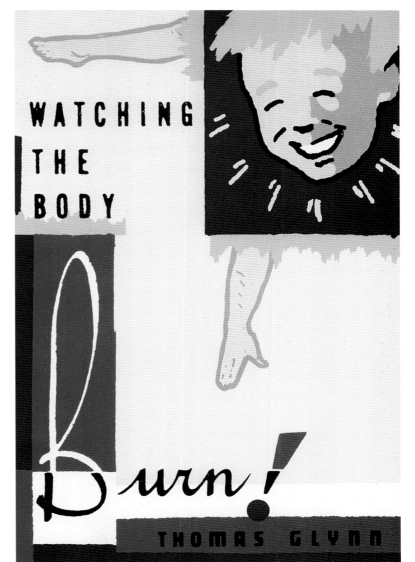

WATCHING
THE
BODY

Burn!

THOMAS GLYNN

GEEK LOVE
designer: Chip
Kidd; client:
Alfred A. Knopf;
typeface: Geek
Love

Sheer deformity
was Kidd's
inspiration for
this ink-on-
paper typeface.

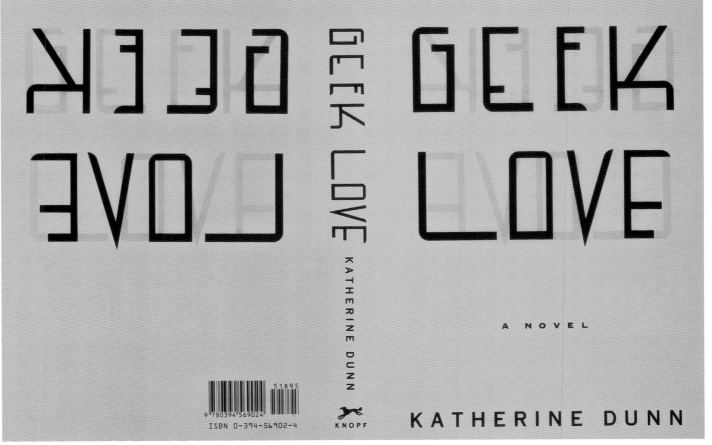

GEEK LOVE

KATHERINE DUNN

A NOVEL

KNOPF

KATHERINE DUNN

ISBN 0-394-56902-4

MAX KISMAN graduated from the Academy for Art and Industry in Enschede and Amsterdam's Gerrit Rietveld Academy in 1977. Kisman went on to become one of the pioneers of digital technology in graphic design through his designs for Language Technology/Electric Word Magazine and Paradiso Concert Hall in Amsterdam. He has designed typefaces for Font Shop International and for Fuse, co-founded TYP/Typografisch Papier, an alternative magazine on typography and art, and has designed exhibitions, books, magazines, calendars, animations, posters, and even postage stamps. Lately he has become involved in Web design and interactive media, and has designed for the Web servers of VPRO-digital and Hotwired. In 1995 he received the audience award at the Design Prize of the City of Rotterdam for his television graphics and animation work. He currently works beside VPRO television for the International Film Festival Rotterdam.

MAX
KISMAN

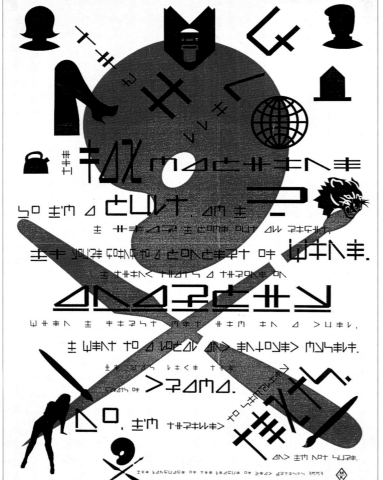

I'M THE FAX MACHINE
art director/designer: Max Kisman; client: Fuse; illustrator/photographer: Max Kisman; typeface: Linear Construct

Linear Construct is an original typeface that embodies the idea of a futuristic alphabet as typographic archeologic discovery.

COVER OF LANGUAGE TECHNOLOGY #7
art director/designer: Max Kisman; client: Language Technology Magazine; typefaces: LT Font/Helvetica, LT Block (now available as FF Rosetta)

LT Font is an original creation.

STAY TUNED
art director/designer: Max Kisman; client: F.S.I. Berlin;
illustrator/photographer: Max Kisman; typefaces: FF
Jaque, FF Fudoni, FF Cutout, FF Network, other MK fonts

All original typefaces, created digitally. The work is a
limited edition screen print for the FSI offices.

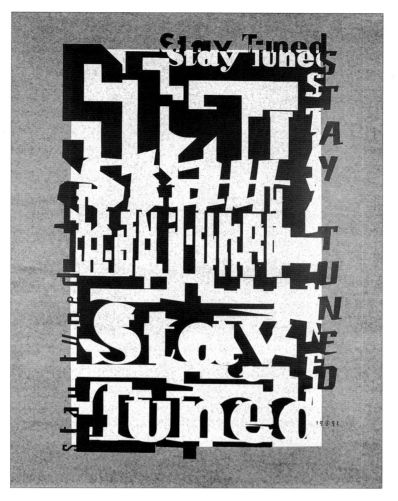

TYPOGRAPHIC MAGAZINE/COVER
1ST ISSUE TYP
art director/designer: Max Kisman;
client: Max Kisman; illustrator/pho-
tographer: Max Kisman; typefaces:
manually cut letters, now available
as FF Cutout

Working with the most basic
materials, these paper cuttings were
used to create a strong graphic
image.

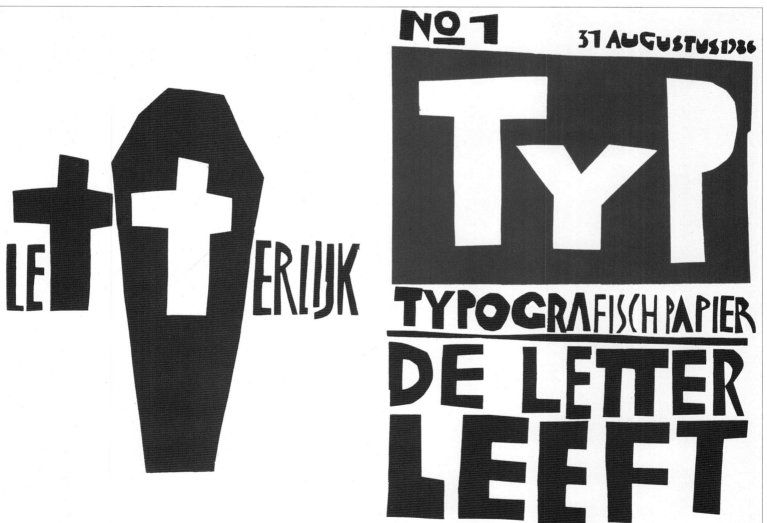

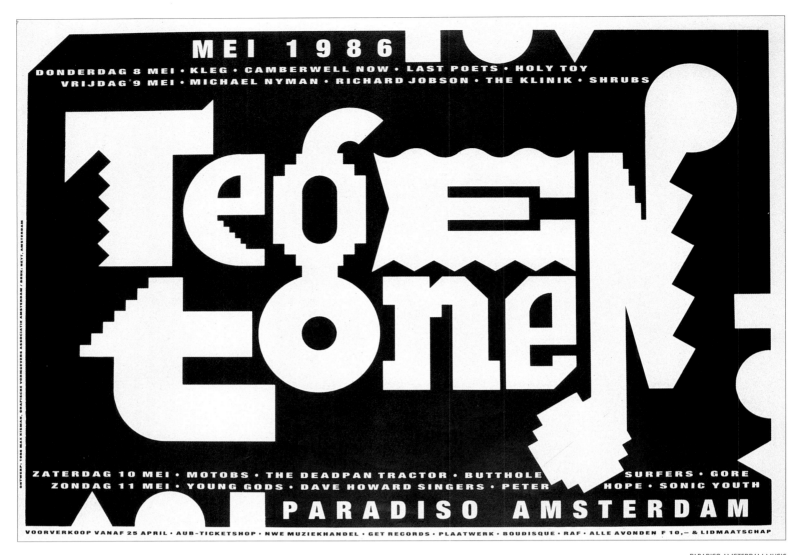

PARADISO AMSTERDAM MUSIC
FESTIVAL/POSTER
designer/art director: Max Kisman;
client: Paradiso Amsterdam; photog-
rapher/illustrator: Max Kisman;
typeface: Tegen Tonen

Tegen Tonen was created manually
for this poster.

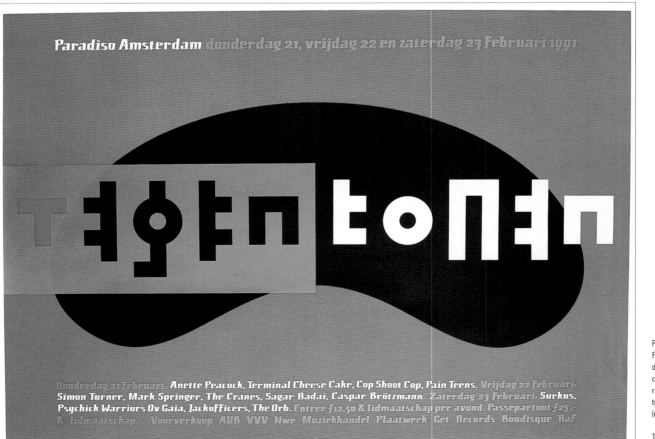

PARADISO AMSTERDAM MUSIC
FESTIVAL/POSTER
designer/art director: Max Kisman;
client: Paradiso Amsterdam; photog-
rapher/illustrator: Max Kisman;
typeface: Tegen Tonen, Jacque Fat
(date, groups, other small text)

Tegen Tonen is a computer-created
typeface.

WHaT's PIsSing ME oFf iS thAt ThEY usE so liTtlE oF mY

WIRED/QUOTE SPREAD
designer: Max Kisman; client: Wired;
art directors: John Plunkett, Barbara
Kuhr; photographer/illustrator: Max
Kisman; typeface: SSP Quick Step

This original typeface was inspired
by rough-cut lettering and was
digitally created.

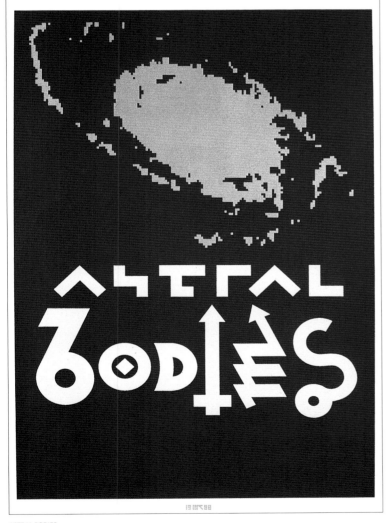

ASTRAL BODIES
designer/art director: Max Kisman; client:
Astral Bodies (pop group); photographer/
illustrator: Max Kisman; typeface: logo
was digitally drawn

This logo was inspired by the idea of
using astrological symbols as characters.

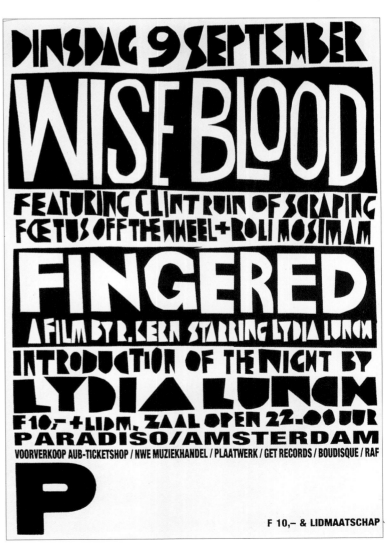

PARADISO AMSTERDAM MUSIC FESTIVAL, WISE BLOOD/POSTER
designer/art director: Max Kisman; client: Paradiso Amsterdam; photographer/
illustrator: Max Kisman; typeface: manually cut letters

Here is another image created with paper cuttings.

WILLIAM KOCHI attended the Art Center College of Design after graduating from UCLA. Arriving in New York City in 1982 with $500 in his pocket and living in a room in the YMCA, he worked freelance for "everybody," until accepting a senior art director position at Saatchi and Saatchi. Finding corporate life unsatisfying, he started KODE Associates in 1989. Since then, he has serviced a range of clients from electronic giants and financial institutions to independent record companies. His work, across the spectrum of media—corporate identity, advertising and exhibit design—has won considerable recognition and numerous awards, including a place in the permanent collection of the Library of Congress.

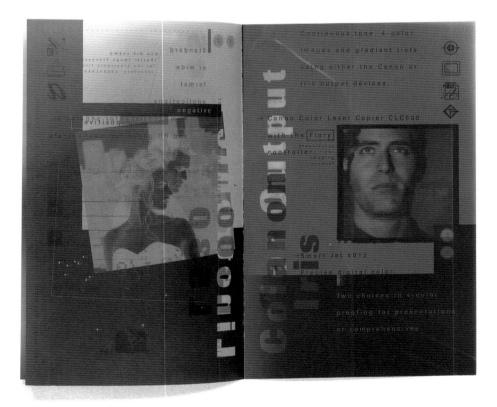

LINOGRAPHICS PRE-PRESS CAPABILITIES
designer/art director: William Kochi; client: LinoGraphics;
photographer/illustrator: William Kochi; printer: Otis
Graphics; typeface: Berthold Imago

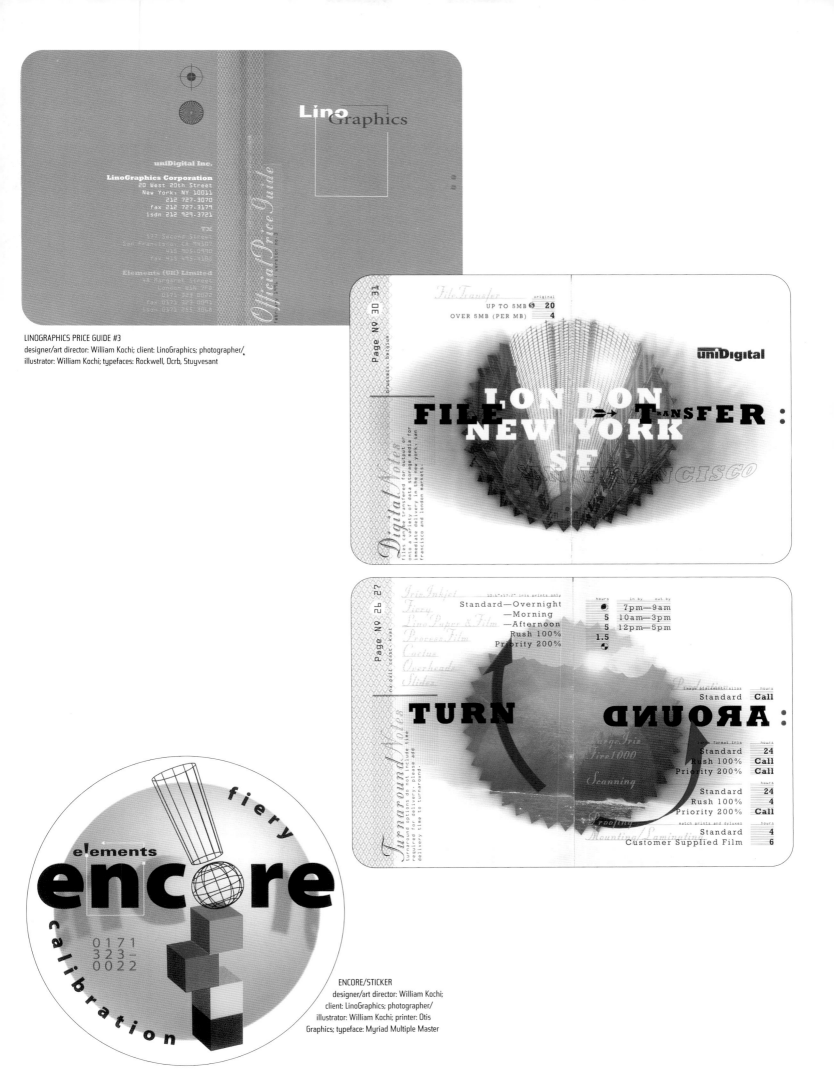

LINOGRAPHICS PRICE GUIDE #3
designer/art director: William Kochi; client: LinoGraphics; photographer/
illustrator: William Kochi; typefaces: Rockwell, Ocrb, Stuyvesant

ENCORE/STICKER
designer/art director: William Kochi;
client: LinoGraphics; photographer/
illustrator: William Kochi; printer: Otis
Graphics; typeface: Myriad Multiple Master

DAVID LAU is an art director and graphic designer working in Los Angeles. He designed for PolyGram Records for over six years, two of which he served as creative director of Verve, a division of PolyGram. While at PolyGram he was nominated for two Grammy awards and won the 1994 Best Recording Package Grammy for The Complete Billie Holiday on Verve 1945–1959 special edition box set. His work has also appeared in HOW, Print's Regional Design Annual, I.D., Graphis, AIGA Annual, Communication Arts and Creativity. Currently he is starting his own design studio in Los Angeles.

DAVID LAU

1940'S MERCURY SESSIONS
designer: Guilio Tuturrio; design studio: Verve Records, Inc.; client: Verve Records, Inc.; art directors: Michael Lang, David Lau, Guilio Tuturrio; typeface: hand-created lettering

This hand-lettering was created with the help of a copy machine.

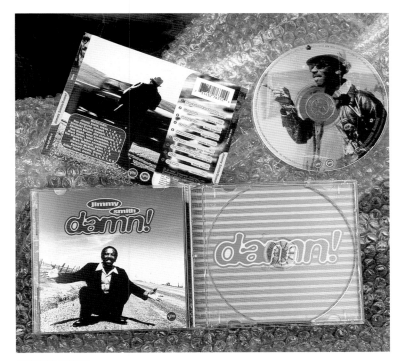

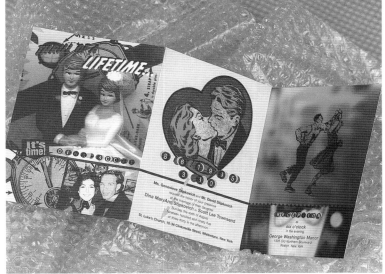

THRILL OF A LIFETIME/WEDDING INVITATION
designer/art director: David Lau; design studio: Verve Records, Inc.; clients: Scott
and Dina Townsend; typeface: hand-created lettering

Lau used a copy machine to alter his hand-drawn lettering.

JIMMY SMITH, DAMN!
designer/art director: David Lau;
design studio: Verve Records, Inc.;
client: Verve Records, Inc.; photogra-
pher: James Minchin; typeface:
untitled

Lau created this typeface in Adobe
Illustrator 6.0.

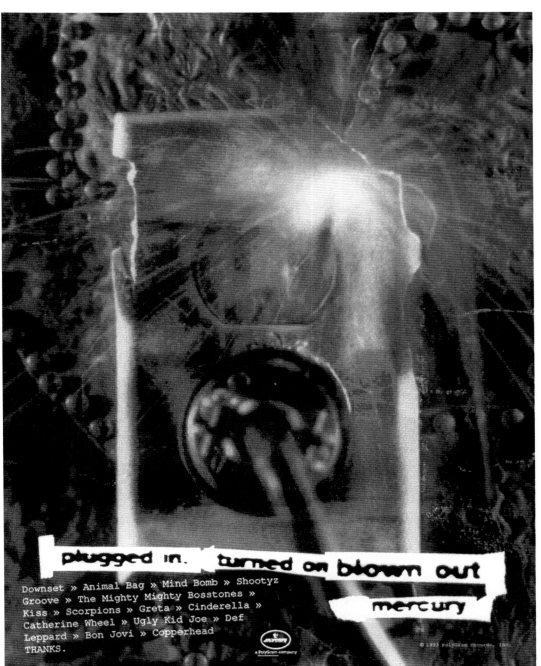

PLUGGED IN, TURNED ON, BLOWN
OUT/MERCURY ADVERTISEMENT
designer/art director: David Lau;
design studio: Verve Records, Inc.;
typeface: untitled

Lau's typeface was created on a
copy machine.

BRUCE LICHER graduated with a B.A. from UCLA in 1980 after spending the last two years at the university exploring all of the various creative endeavors offered to undergraduates. Licher's Independent Project Records got its start out of this time of experimentation with music, film, art and design. In 1982 he came across a class in letterpress printing. Wanting to create a mass-produced printed piece that had the look and feel of an art object, Licher wholeheartedly jumped into learning the technique. In 1984, seeing the need to have his own equipment, he borrowed money and rented a downtown warehouse space, searched out his own letterpress equipment and Independent Project Press was born. In the years since, he's printed packages for the record releases on IPR, developed a line of all-cardboard CD packages and continues to create his own music.

photographer: Jay Dunn

BRUCE

LICHER

SAVAGE REPUBLIC

JACKSON DEL REY — Vocals, Guitar, Percussion
MARK ERSKINE — Drums, Percussion
BRUCE LICHER — Guitar, Bass, Percussion
JEFF LONG — Vocals, Bass, Guitar
ROBERT LOVELESS
Keyboards on Film Noir, Bass on O Andonis

SAVAGE REPUBLIC, TRAGIC FIGURES/CD PACKAGE
designer/art director: Bruce Licher; design studio: Independent Project Press; client: Independent Project Records; photography: UPI; illustrator: Philip Drucker (collage); typefaces: (back) Bodoni Bold, Spire, Typo Roman; (insert) Spire Ultra Bodoni, Bodoni Bold

Licher carved the Arabic out of a linoleum block.

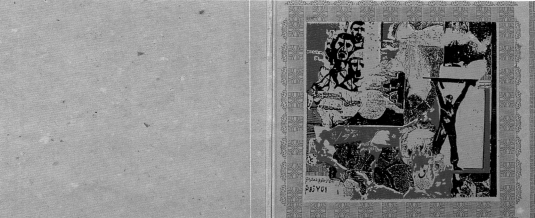

HALF STRING, TRIPPED UP BREATHING/CD
designer/art director: Bruce Licher; design studio: Independent Project Press; client:
Independent Project Records; photographer: Ari Neufeld; typefaces: Radial Gothic
Condensed ("Half String"), Cheltenham ("Tripped Up Breathing"), Franklin Gothic (song
titles), Venus Bold Extended ("Discfolio"), Bank Gothic ("Designed and Printed At" info),
Grotesque Bold and 20th Century Extra Bold Italic (credits), Egyptian (IPR)

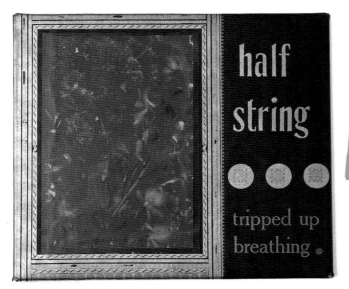

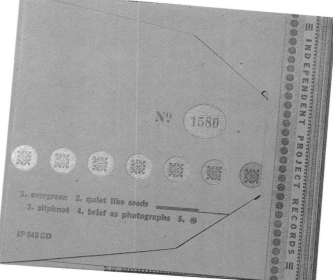

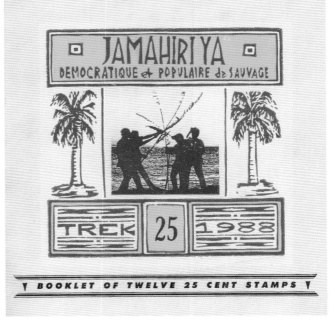

SAVAGE REPUBLIC, JAMAHIRIYA/STAMP BOOKLET
designer/art director: Bruce Licher; design studio: Independent Project Press; client: Savage Republic;
photographer: Abe Perlstein; illustrator: Bruce Licher; typefaces: hand-carved Linoleum block (stamp
image), 20th Century Extra Bold Italic ("Booklet of 12 25-cent stamps")

INSOMNIA/VOLUME 1/CD COVER
designer/art director: Bruce Licher;
design studio: Independent Project
Press; client: We Never Sleep; type-
faces: Wood Type (Insomnia logo),
Grotesque Bold (6 point), 20th
Century Extra Bold, 20th Century
Extra Bold Extended

ANTHONY MA OF TANAGRAM, INC. attributes his design sensibilities to having been raised in the multi-ethnic city of Honolulu, which gives him a unique perspective that has influenced his philosophy of both

design and life. Following graduation from the University of Illinois in Champaign-Urbana, he joined Strandell Design Associates in 1985. In 1987 he established his own firm, Yellow, and has since been responsible for projects including corporate identity, publications, illustration, exhibits, structural packaging and interactive media. Ma joined with partner Lance Rutter to establish Tanagram, Inc. in 1992. He supports his love for academia through his involvement with the AIGA Chicago's education committee and teaching positions at the School of the Art Institute of Chicago and the University of Illinois Champaign-Urbana. His firm has been committed to providing appropriate and innovative design solutions for the community at large.

designers: (left) Anthony Ma, (right) Lance Rutter

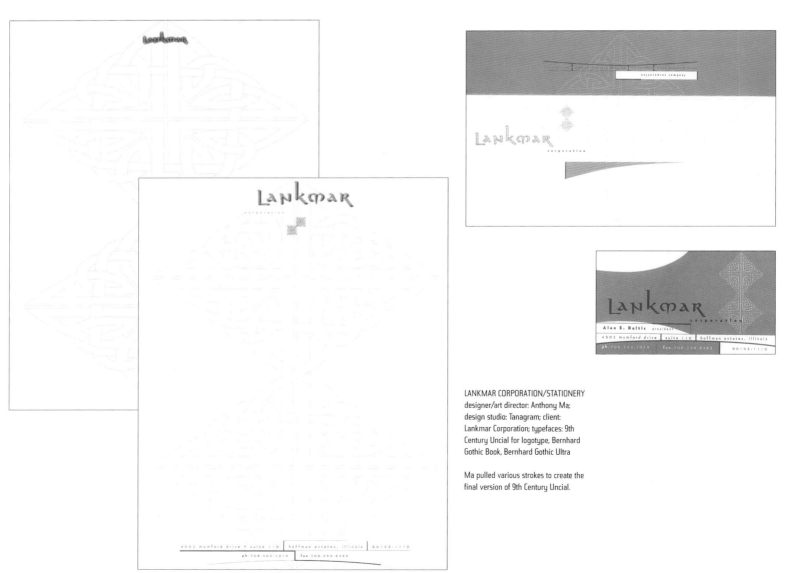

LANKMAR CORPORATION/STATIONERY
designer/art director: Anthony Ma;
design studio: Tanagram; client:
Lankmar Corporation; typefaces: 9th
Century Uncial for logotype, Bernhard
Gothic Book, Bernhard Gothic Ultra

Ma pulled various strokes to create the
final version of 9th Century Uncial.

WHAT IS THE VERGE/PAGE FROM
SUBNATION
designer/art director: Anthony Ma;
design studio: Tanagram; client:
Subnation; photographer/illustrator:
Anthony Ma; typefaces: Gotish Ganz
Gross ("Verge"), Palatino

Ma redrew and extended the type-
face for "Verge" with a texture map.

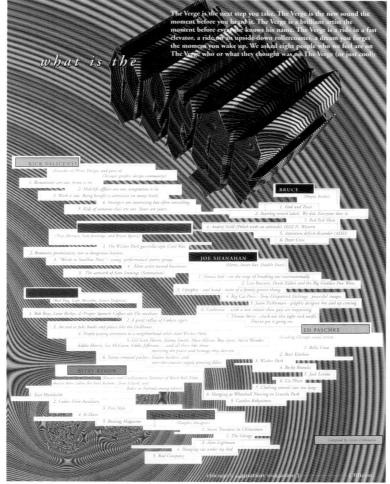

ACD, INTERACT AMERICAN CENTER FOR
DESIGN JOURNAL/SPREAD
designers: Grant Davis, Anthony Ma;
design studio: Tanagram; art directors: Eric
Wagner, Lance Rutter, Anthony Ma, Grant
Davis; typeface: Franklin Gothic

The Interdisciplinary Dance (Shall We?)

LAURALEE ALBEN AND JIM FARIS

"WILL YOU, WON'T YOU, WILL YOU, WON'T YOU, WILL YOU JOIN THE DANCE?"

Lewis Carroll, Alice's Adventures in Wonderland, 1865

Author's note
As authors, we feel compelled to state our objections to the layout of this article. First, we believe that setting the text in the shape of footprints compromises legibility and discourages people from reading the article. Second, while our article compares dancing to interdisciplinary collaboration, dance is a metaphor and not the true subject of the article. The images of footprints misplace the emphasis. Words are used merely as a fill pattern to create repetitive and trivial shapes instead of being used in a way which enhances their meaning.

Although we had an agreement with the American Center for Design Journal, ACD was unwilling to make any changes in response to those concerns. We were not offered the opportunity to work collaboratively with the designers. This is ironic given the subject of our article, which discusses various models of collaboration and the degree to which they foster or hinder effective design. We believe that a more collaborative approach to the design of this article would have produced a result which would have been more agreeable to all of those involved, especially the readers. What do you think?

Editor's note
The American Center for Design considers design to be a form of authorship, and does not generally ask its designers to rework their proposed solutions based on subjective criteria, just as it does not ask authors to rewrite their contributions to reflect a different point of view should someone disagree.

Where there is an open mind,
there will always be a frontier.
Charles Kettering

On with the dance! Let joy be unconfined;
No sleep till morn, when Youth and Pleasure meet
To chase the glowing Hours with flying feet.
Lord Byron, Childe Harold's Pilgrimage,
1812-18, canto 3, stanza 12

DANCING
ON THE FRONTIERS

On the American frontier, settlers gathered together for corn husking frolics, quilting bees and barn raisings. Once the work was done, they often turned to dancing. The human need for self-expression and collaboration is not bound by time or place. Today this need manifests itself in the new frontier of multimedia.

The creation of multimedia is an interdisciplinary dance. Depending on the scope of the project, development teams may include content experts, cognitive psychologists, graphic and interface designers, instructional designers, programmers, writers, animators, video and sound producers and "media wranglers." These experts dance in just as intricate and varied a way as any square dancers. The result in both cases is a product of how well the individuals have danced together.

The dances of the early pioneers reflected their concern with survival and daily activities like hunting for food. In the square dance called Chase a Rabbit, the caller beckons, "First couple out of the couple on the right; Chase a rabbit, chase a squirrel; Chase a pretty girl round the world..."

Dances made an important connection between pioneer families, friends and neighbors who often lived many miles apart from each other. "To spread the word of the upcoming event, a man might stand on the steps of the general store and shout, 'Junket! Junket!," according to Richard Kraus. "When a crowd had gathered, he would give the details of the dance. The selected meeting place might be in the store itself, in a barn, or even in a farm house kitchen. When it was scheduled to be held in a kitchen, all the furniture would have to be cleared out — even the stove. Sometimes only the woodbox would be left for the fiddler to stand on, with plenty of room for his well-rosined bow to scrape away."

In a similar spirit of informality, invention and creative improvisation, an industry grew from the garages of Silicon Valley. Like the American frontier, the technological frontier requires rapid adaptation to changing circumstances. Often it is necessary to abandon rigid concepts and

9

P. SCOTT MAKELA is a true media hybrid. His graphic design and typography have been featured regularly in design and culture magazines such as <u>Eye</u>, <u>Studio Voice</u>, <u>HOW</u> and <u>Emigre</u>. He has written on design for the digital environment in <u>I.D.</u> and <u>Design Quarterly</u>, developed a prototype for an urban youth CD player for Sony Electronics, served as graphic design director on commercials for Vans Shoes, Lotus Software and for Michael Jackson's video Scream. Makela's wide-ranging work is constantly evolving with a sensory itchiness beyond words, making him sought after by clients desiring avant-garde graphic solutions for the crossroads between music, fashion, technology, cultural messages and an Internet/TV-savvy public. Recently he began direction on "Burden+Protection," a radical and rich theater-size, multimedia environment that looks at the U.S. Bill of Rights.

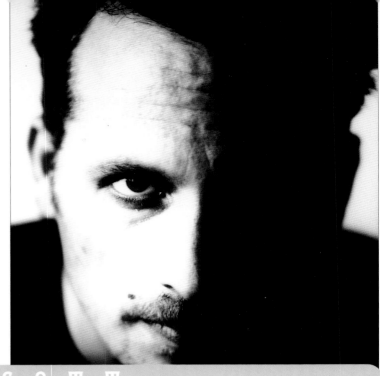

P. SCOTT
MAKELA

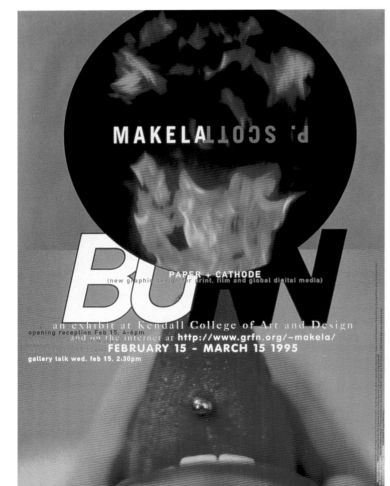

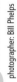

BORN EXHIBITION, BURN/POSTER
designer: P. Scott Makela; design studio: Words + Pictures for Business + Culture; client: Kendall College of Art and Design; photographer/illustrator: Bill Phelps; typeface: VAG, Trade Gothic, Utopia, Mittleschrift

Makela created these fonts through digital manipulation and was inspired by the work of Adrian Frutiger.

MUSIC ART FASHION INTERFACE ALLIANCE/COVER
designer: P. Scott Makela; design studio: Words + Pictures for Business + Culture; client: Ray Gun Publishing; photographer/illustrator: P. Scott Makela; typefaces: Barmeno, Dead History

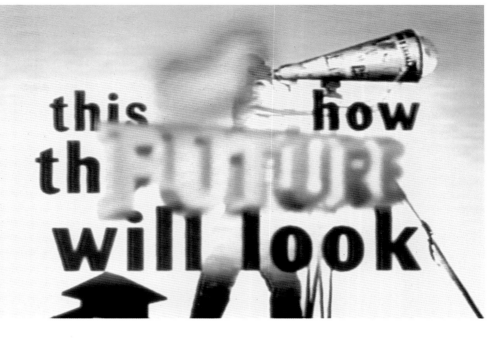

LOTUS, THIS IS NOTES/TV AD
designer: P. Scott Makela; design studio: Words + Pictures for Business + Culture; client: Lotus Software Corporation; photographic director: Jeffrey Plansker; typefaces: Barmeno, Dead History

Makela used digital manipulation, Fontographer and Pixar Typestry to redesign stock fonts and create Dead History, a typeface inspired by the illness and subsequent death of his mother.

PROPAGANDA FILMS/CORPORATION IDENTITY
designer: P. Scott Makela; design studio: Words + Pictures for Business + Culture; client: Propaganda Films; photographer/ illustrator: P. Scott Makela; typeface: Mittleschrift

These digitally manipulated type-faces were inspired by Polish political posters.

YOUARENAKED

AMERICAN CENTER
FOR DESIGN
DESIGN
CONFERENCE
FEATURED SPEAKER
SCOTT MAKELA
CHICAGO
APRIL 21-23, 1995
(1-800-257-8657)

YOU ARE NAKED BEFORE THE FUTURE/POSTER
designer: P. Scott Makela; design studio: Words +
Pictures for Business + Culture; client: American
Center for Design; photographer/illustrator: P.
Scott Makela; typeface: Structure Heavy

Inspired by carnival midway type, Makela
created Structure Heavy through digital manipu-
lation of stock fonts.

TODD LEVIN, DELUXE/CD COVER
designers: P. Scott Makela, Jordan
Nogood; design studio: Words +
Pictures for Business + Culture; client:
Deutsche Grammophon; photograph-
er/illustrator: Jordan Doner; type-
faces: Futura, Barmeno, Dead History

HOW, THE WILD NEXT/COVER
designer: P. Scott Makela; design studio:
Words + Pictures for Business + Culture;
client: F&W Publications, Inc.;
typefaces: Geometric, Barmeno

Haitian voodoo texts inspired these digital
manipulations of stock fonts.

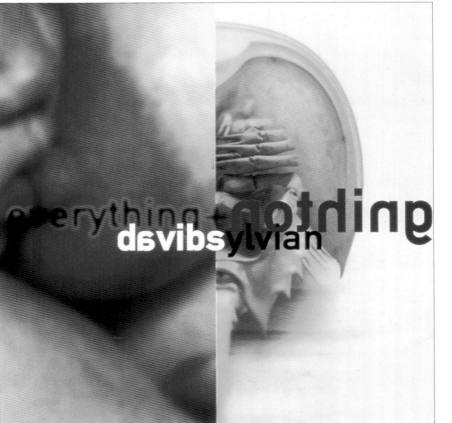

DAVID SYLVIAN, EVERYTHING AND
NOTHING/CD COVER
designer: P. Scott Makela; design studio:
Words + Pictures for Business + Culture;
client: Virgin Records; photographer/illus-
trator: Bill Phelps; typeface: Mittleschrift

BRUCE MAU studied art and design at the Ontario College of Art. After working in Toronto, and London, England, he returned to Canada in 1984 and with two partners established Public Good Design and Communication. In 1985 he established Bruce Mau Design Inc., an independent design practice. Clients of Bruce Mau Design include Zone Books, the Getty Center for the History of Art and the Humanities in Los Angeles, the Whitney Museum in New York, Netherlands Architectural Institute in Rotterdam and Design Exchange in Toronto. Mau has taught and lectured in the areas of graphic design and architecture both in Canada and the United States. In his work Mau approaches design as a critical practice that embraces social and political concerns.

BRUCE MAU

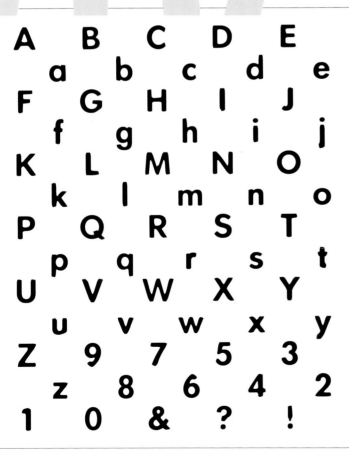

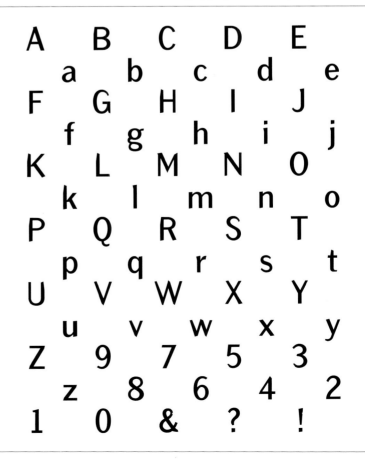

A FONT CALLED FRANK
designer: Bruce Mau; design associates: Gregory Van Alstyne, Hon Leong; design studio: Bruce Mau Design; client: The Walt Disney Concert Hall, Frank Gehry and Associates; typeface: Frank (created for this piece)

This work proceeds from the premise that the graphic identity should not mimic the architecture for which is was created; rather, it should share the same values: honesty, originality, humanity and wit. By applying animation techniques to typographic form, the designers were able to generate a new font that had a strange sympathy with the unstable qualities of the architecture.

JUSSIEU
designer: Bruce Mau; design studio: Bruce Mau Design; client: The Monacelli Press (for the book S,M,L,XL, by Rem Koolhaas and Bruce Mau); typeface: Jussieu

This font was generated using the studio's exclusive Multiple Hybridization Technique (MHT) system. This software is capable of integrating the "influence" of form from existing fonts almost as a genetic code, creating "children" distinct and separate from their typographic parents.

THE SOCIETY OF THE SPECTACLE
designer: Bruce Mau; design
associate: Gregory Van Alstyne;
design studio: Bruce Mau Design;
client: Zone; typefaces: Perpetua,
Trade Gothic Heavy

The Society of the Spectacle is a
book about the commodification of
life and the power of the image to
facilitate that. In order to create a
cover that does something other
than reproduce the problem, the
designers inverted the typical condi-
tion and filled the text with image—
rather than filling an image with
text. The result is a "typeface" where
every letter contains different colors,
a different image.

Few works of political and cultural theory
have been as enduringly provocative as Guy
Debord's *The Society of the Spectacle*. From
its publication amid the social upheavals of
the 1960s up to the present, the volatile
theses of this book have decisively transformed
debates on the shape of modernity, capitalism
and everyday life in the late twentieth century.
Now finally available in a superb English
translation approved by the author, Debord's
text remains as crucial as ever for under-
standing the contemporary effects of power,
which are increasingly inseparable from the
new virtual worlds of our rapidly changing
image/information culture.

"In all that has happened in the last twenty
years, the most important change lies in
the very continuity of the spectacle. Quite
simply, the spectacle's domination has
succeeded in raising a whole generation
moulded to its laws. The extraordinary new
conditions in which this entire generation
has lived constitute a comprehensive sum-
mary of all that, henceforth, the spectacle
will forbid; and also all that it will permit."
–Guy Debord (1988)

The Society of the Spectacle | Guy Debord

Distributed by The MIT Press
OE8SH ISBN 0-942299-80-9

ZONE BOOKS

The Society of the Spectacle

Guy Debord

Translated by Donald Nicholson-Smith

ZONE BOOKS

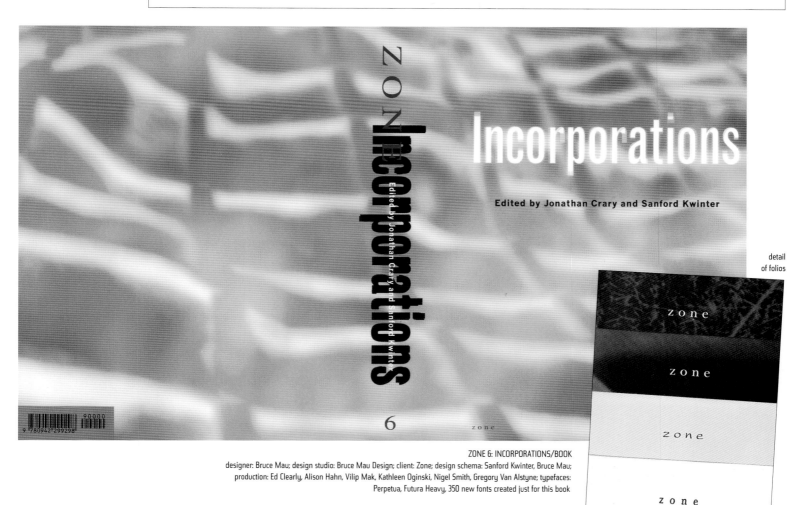

detail
of folios

ZONE 6: INCORPORATIONS/BOOK

designer: Bruce Mau; design studio: Bruce Mau Design; client: Zone; design schema: Sanford Kwinter, Bruce Mau;
production: Ed Clearly, Alison Hahn, Vilip Mak, Kathleen Oginski, Nigel Smith, Gregory Van Alstyne; typefaces:
Perpetua, Futura Heavy, 350 new fonts created just for this book

The designers created all of the typefaces used in the book by creating a continuous animation sequence of 350
new fonts. On every page of ZONE 6, the word zone is set in one of these 350 unique typefaces. From page to page
a subtle and unavoidable shift in the form of the word becomes evident.
For the title "Incorporations" on the cover, the designers "averaged" four distinct fonts by knocking one out of
each of the four plates creating a hybrid font with some evidence of the four parents around edges of each letter.
(The effect is subtle; for example, note the different edges to the letter "r.")

PETE MCCRACKEN grew up in Vermont and left when he was eighteen to pursue a career. Through his travels he found type, which lead to printmaking and letterpress printing. He has been looking at, dissecting and drawing type ever since. He owns and runs a small design (graphic design and custom type) and print shop, cCrak Press, in Portland, Oregon, which specializes in fine printing, silkscreen and letterpress. He has been trying to get back to Vermont ever since he left.

PETE

MᶜCRACKEN

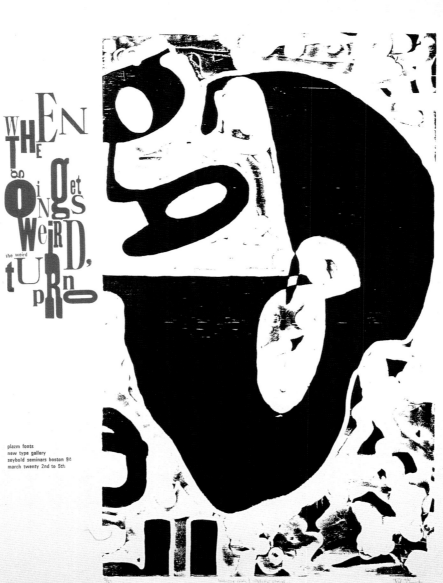

plazm fonts
new type gallery
seybold seminars boston 9¢
march twenty 2nd to 5th

WHEN THE GOING GETS WEIRD
designer/art director: Pete McCracken; client: Plazm Media Inc.; typeface designers: Pete McCracken (Erosive), Marcus Burlile (Colony); typefaces: carved wood block, Erosive ("G"), Colony ("g")

The large type was cut from wood and printed as a wood relief on an intaglio press. The smaller type is a variety of woodtype and was printed letterpress.

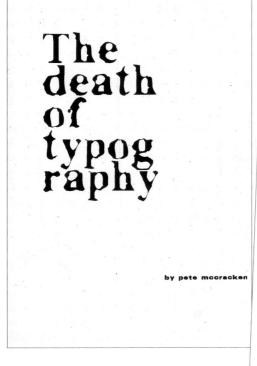

The death of typog raphy

by pete mccracken

THE DEATH OF TYPOGRAPHY
designer/art director: Pete McCracken; typeface: serif type

This piece was designed on computer and describes the literal and metaphorical death of life and type.

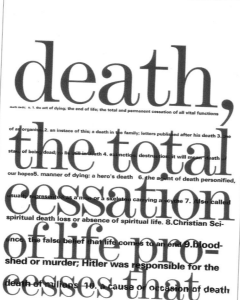

death, the total cessation of life pro- cesses that

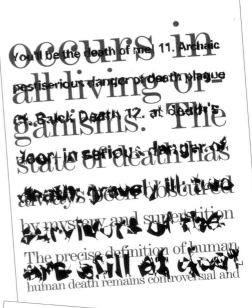

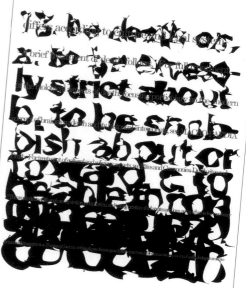

MY PEN IS MY TOOL
designer/art director: Pete McCracken; typefaces: from Underwood 315, wood cuts

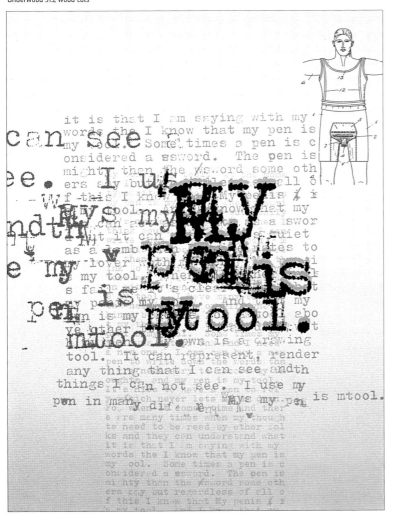

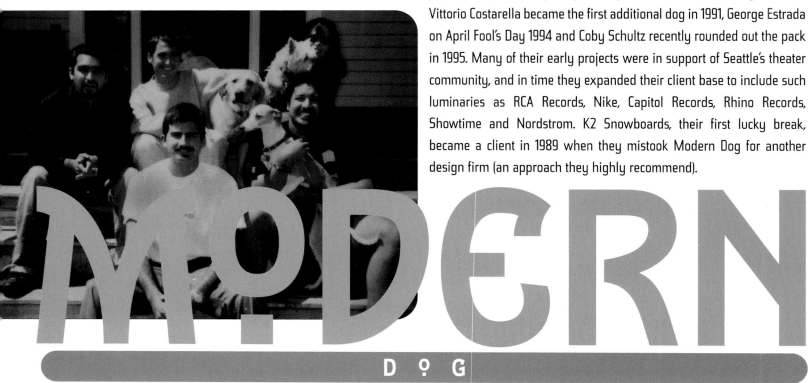

MODERN DOG is a small Seattle design studio cofounded by Robynne Raye and Michael Strassburger in 1987. Vittorio Costarella became the first additional dog in 1991, George Estrada on April Fool's Day 1994 and Coby Schultz recently rounded out the pack in 1995. Many of their early projects were in support of Seattle's theater community, and in time they expanded their client base to include such luminaries as RCA Records, Nike, Capitol Records, Rhino Records, Showtime and Nordstrom. K2 Snowboards, their first lucky break, became a client in 1989 when they mistook Modern Dog for another design firm (an approach they highly recommend).

MODERN
DOG

JIMI HENDRIX MUSEUM ROCK ARENA/POSTER
designer/art director: Michael Strassburger; design studio: Modern Dog; client: Experience Music Project; illustrator: Michael Strassburger; typefaces: untitled

Inspired by psychedelic art, Strassburger created the entire poster. Once satisfied with the fonts and layout, he went over his pencil sketches with a fine-tip felt pen. Color separations were later done with overlays.

ENVISION 21/POSTER

designer/art director: Robynne Raye; design studio: Modern Dog; client: Art Directors and Artists Club, Sacramento; illustrator: Robynne Raye; typefaces: hand-stenciled lettering ("Intuition," "Envision 21"), Orator and Clarendon—both stressed (mouth and other type)

Raye used Krylon for the hand-stenciled lettering. The remaining typefaces were created through the manual alteration of existing digital type on a photocopier.

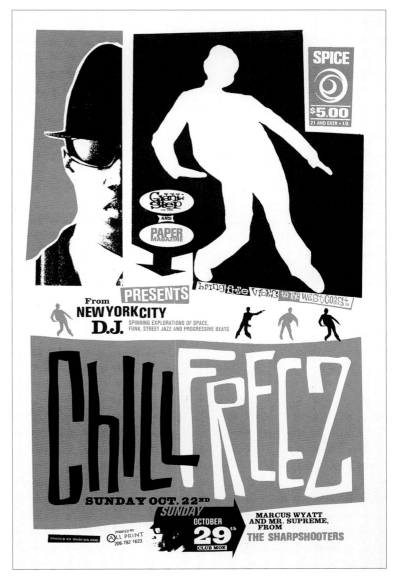

CHILL FREEZ/FLYER

designer/art director: George Estrada; design studio: Modern Dog; client: Tasty Shows; illustrator: George Estrada; typefaces: Akzidenz, Clarendon, hand-cut face ("Chill Freez")

Inspired by the TV game show Wheel of Fortune, Estrada cut "Chill Freez" and "Bringing Free Vibes to the West Coast" out of Rubylith.

DEBORAH NORCROSS, born in Springfield, Massachusetts, lived in Boston for ten years and graduated from the Massachusetts College of Art in 1980 after five years of study in graphic design. Norcross—a resident of Los Angeles since 1984—worked at Media Home Entertainment for two years designing video packaging. She then moved to Warner Brothers Records where she has worked under Jeri Heiden for nine years. During her career as a graphic designer, she has received many awards and her work is featured in the Library of Congress.

DEBORAH
NORCROSS

BOINGO/CD
designers: Deborah Norcross, Anthony Antiaga; clients: Oingo Boingo, Giant Records; art director: Deborah Norcross; photographer/illustrator: Anthony Antiaga; typefaces: Ocra, Ideoque, Franklin Gothic

Mike Diehl's Ideoque typeface, which was used for interior copy, was inspired by a typeface from the 1200s; the type on the cover, designed by Anthony Antiaga, was inspired by the circus.

"HEY MAN NICE SHOT," FILTER/CD
designer/art director: Deborah
Norcross; client: Reprise; typefaces:
Futura, Folio, Helvetica—manipulated

The logo was manipulated in Adobe
Photoshop.

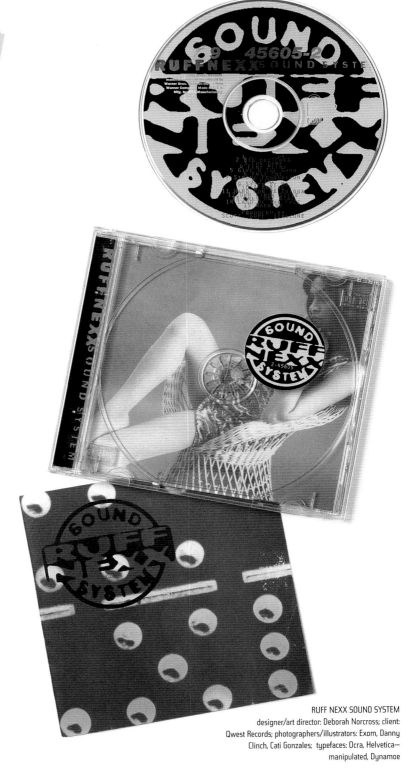

RUFF NEXX SOUND SYSTEM
designer/art director: Deborah Norcross; client:
Qwest Records; photographers/illustrators: Exom, Danny
Clinch, Cati Gonzales; typefaces: Ocra, Helvetica—
manipulated, Dynamoe

Norcross manipulated the old logo in Adobe Photoshop to
come up with this new version.

"BUT IF YOU GO," MC 900 FT. JESUS/DIGIPAK
designer/art director: Deborah Norcross; typeface: Ocra

DAVID PLUNKERT, a graphic designer and illustrator, is a 1987 graduate of Shepherd College. He taught graphic design and illustration at the Maryland Institute College of Art and at Shepherd College and also served on the board of directors for AIGA/Baltimore. Plunkert is a co-founder of SPUR Design in Baltimore, Maryland, which has been featured in HOW, Print, Graphic Design USA, Graphis and Graphis Posters. Their clients include: Capitol Records, Grove Atlantic, and MTV Networks. As an illustrator with an international reputation, Plunkert has worked for clients including: Gatorade, Gilbert Paper and Newsweek, Rolling Stone and Time magazines. He has garnered awards from American Illustration, Communication Arts and the Society of Publication Designers. Examples of his design work are in the permanent collection of the Library of Congress and museums in the US and abroad.

DAVID PLUNKERT

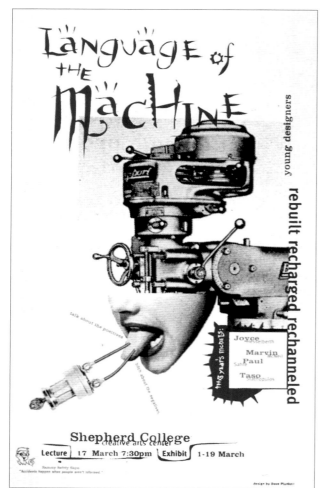

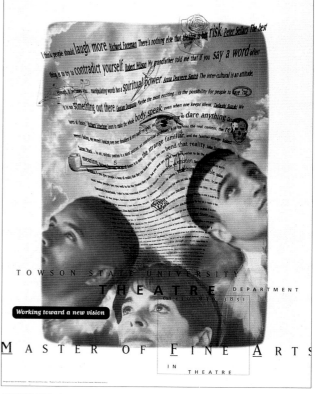

SHEPHERD COLLEGE, LANGUAGE OF THE MACHINE
designer: David Plunkert; design studio: SPUR; client: Shepherd College; illustrator/photographer: David Plunkert; typefaces: Lingo for "language of the machine," Craw Modern for "young designers," Meta Bold for "rebuilt, recharged, rechanneled"

Lingo—a typeface inspired by the doodling in a student's notebook—was created by Plunkert in Photoshop.

WORKING TOWARD A NEW VISION
art director/designer: David Plunkert; design studio: SPUR; client: Towson University Theatre; illustrator/photographer: José Villarubia; typefaces: Matrix Book and Script, Frutiger for all lower copy, Matrix Book Distorted (all upper floating copy)

The distorted version of Matrix Book was twirled and bent into perspective in Adobe Photoshop.

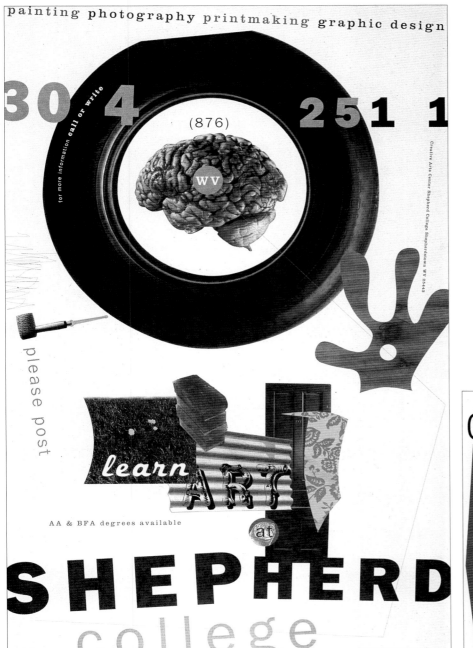

LEARN ART AT SHEPHERD COLLEGE
art director/designer: David Plunkert; design studio: SPUR; client: Shepherd College; photographer: Geoff Graham; typefaces: Fleetwing for "Learn," Rustic for "Art," Franklin Gothic for "at," and "College," Franklin Gothic Heavy for "Shepherd"

Fleetwing was blurred in Photoshop.

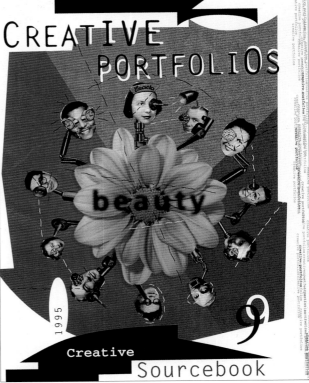

CREATIVE SOURCEBOOK/COVER
art director/designer: David Plunkert; design studio: SPUR; client: Sumner Publishing; photographer: Pam Soorenko; illustrator: David Plunkert; typefaces: Letter Gothic, Frutiger, Courier

For this piece, Plunkert manipulated existing typefaces: a filter in Adobe Illustrator was used on Letter Gothic, and Frutiger was blurred in Adobe Photoshop.

PROTOTYPE 21 was created in September 1992 by Paul Nicholson and Jon Boak. Nicholson, an honors graduate from Kingston-Upon-Thames University, won a design competition while an undergraduate with his logo design for experimental techno club Knowledge. Over the last four years, Prototype 21 has designed logos and packaging for many record labels, including Emissions Audio Output, Hansome Records and Jungle Records. In addition they have designed corporate identities for the Coalition Group and Intersections Software Limited. Prototype 21 is also a specialist garment printing company, allowing Nicholson to apply design to the fashion market via a series of printed T-shirts. Nicholson is now involved in creating computer games, CD-ROMs, design and packaging, fonts and corporate identities.

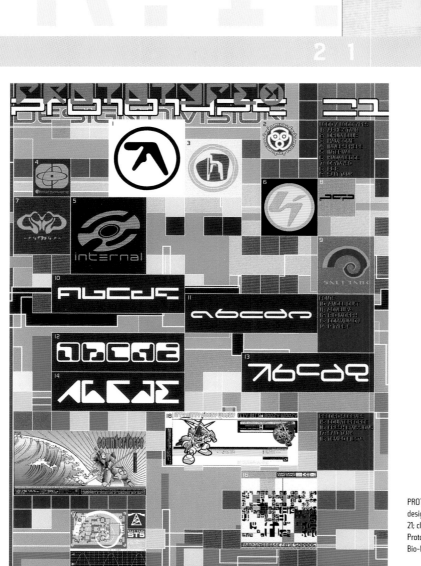

PROTOTYPE 21/PRESS RELEASE
designer/art director: Paul Nicholson; design studio: Prototype 21; client: Prototype 21; illustrator: Paul Nicholson; typefaces: Prototype 21, various others including Angel Dust, Aoneura, Bio-Morph, Communion and P Type-F

This artwork was to illustrate the design output at Prototype 21 and was page two of a press release (page one was the corporate biography). Paul Nicholson says of this piece: "I enjoy [its] structural complexity.

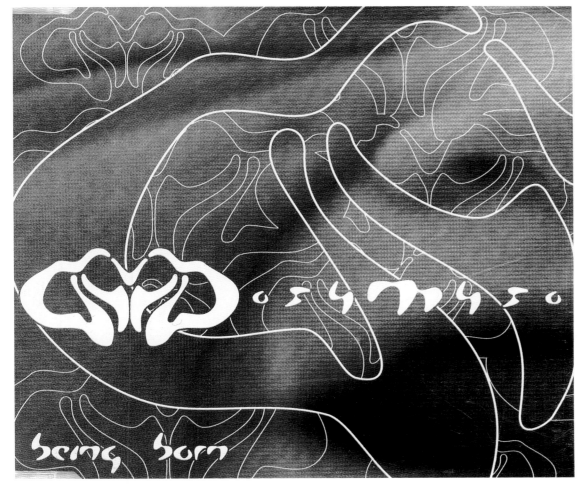

OSYMYSO
designer/art director: Paul Nicholson;
design studio: Prototype 21; client:
Hansome Records; illustrator: Paul
Nicholson; typeface: Osymyso

This typeface, created for the musician
Osymyso, is a derivative of the logo and
was inspired by the inkblot test used by
psychiatrists.

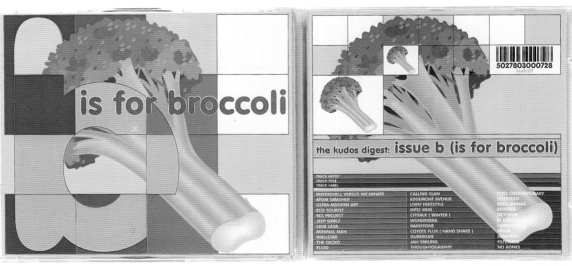

the kudos digest: issue a (is for apple)

NURON	ELECTRIC ARC	LIKEMIND
PLUTO	JUPILER	I.T.P.
B.J. BALONY	END OF AN ERA	SCHATRAX
PERBEC	CHEVY RAINBOW	IFACH
ROXY	MIDST OF TIMULT	PURE PLASTIC
SPIRA	GRIPTAPE	SPIRA
P.V.P.	CHECK IT OUT	PORK
STASIS	SOLITUDE	OTHERWORLD
IN SYNC vs MYSTERON	DIFFERENT EMOTIONS	10TH PLANET
LE PANEL DE PANTS	HONDA SUZUKIS LAST M'CYCLE RIDE	S.A.D.
BEAUTYON	RUSTLESS.	IRDIAL DISCS

the kudos digest: issue b (is for broccoli)

TRACK ARTIST	TRACK TITLE	TRACK LABEL
WATERSHELL VERSUS INCARNATE	CALLING ELAN	POST CONTEMPORARY
ATOM SMASHER	EDGEMONT AVENUE	SYNTHESIS
ULTRA MODERN ART	LIVIN' FREESTYLE	BEAU MONDE
ECO TOURIST	INTO VIEW	REWIRED
KCL PROJECT	CITITALK [WINTER]	OCTORUS
JEEP GRRLZ	WONDERBRA	EL CHOCCO
LAVA LAVA	RAINSTONE	HONDA
MINIMAL MAN	COYOTE FLUX [HAND SHAKE]	
WALLSTAR	GURNIGAN	
THE GECKO	JAH SMILING	FILTERED
FLUID	THOUGHTOGRAPHY	NO BONES

A IS FOR APPLE, B IS FOR BROCCOLI
designer/art director: Paul Nicholson; design studio:
Prototype 21; client: Kudos (music distributor); illustrator:
Paul Nicholson; typeface: untitled

Both sleeves are for compilations of labels and artists
distributed by Kudos. With both pieces of artwork,
Nicholson had a strong desire to inject humor and color
into an area usually tightly controlled.

PAUL SAHRE is a nationally recognized graphic designer, working out of his own studio in Baltimore, Maryland where he has done work for Microsoft, AOL, Rock the Vote, Farrar Strauss and Giroux, Grove Atlantic, Simon and Schuster, Knopf, The Maryland Institute College of Art and many others. He is best known outside of Baltimore, however, for his silkscreen posters for non-profits which he prints himself in a basement with bad light and no headroom. His work has appeared in numerous magazines, including Communication Arts, The 100 Club, AIGA Graphic Design USA, The Type Directors Club Annual and Print magazine. Sahre received his MFA and BFA in graphic design from Kent State University and has taught graphic design at the University of Baltimore and Shepherd College.

PAUL
SAHRE

LOVE AND ANGER
designer: Paul Sahre; client: Fells Point Corner Theatre; typefaces: typewriter

Sahre manipulated the usual typewriter font using a photocopier to create this typeface.

BABY WITH THE BATHWATER
designers: Paul Sahre, David Plunkert; client: Fells Point Corner Theatre; typefaces: various

Each typeface was stretched and manipulated on a stat camera.

Edward Albee's
†INY
ALICE
Directed by Steve Goldklang
November 19 thru December 19

Info &
Reservations: 276-7837

Fells Point Corner theatre

TINY ALICE
designer: Paul Sahre; client: Fells Point Corner Theatre;
typefaces: Futura Bold ("T"s), Caslon 540

A LIE OF THE MIND
designers: Paul Sahre, David Plunkert; client: Fells Point Corner Theatre; typefaces:
Futura Bold, custom-designed

Sahre and Plunkert used a stat camera while designing both fonts. Futura Bold
was thrown out of focus in various degrees, while the custom font was produced
exclusively with the camera.

ALLEY APPLES
designer: Paul Sahre; client: Fells Point Corner Theatre;
calligrapher: Paul Sahre; typeface: hand-drawn

ABSTRACT PURPLE
designer: Paul Sahre; client: Fells Point Corner Theatre; type-
faces: Futura Bold (headline), A-Garamond

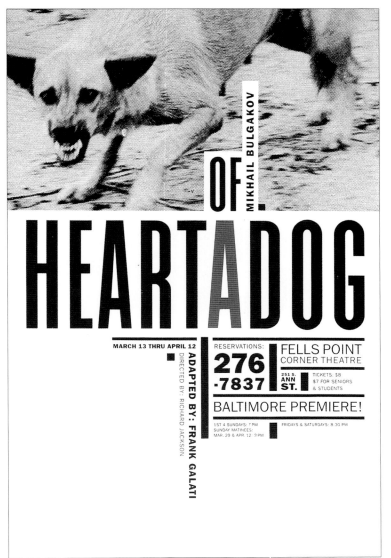

HEART OF A DOG
designers: Paul Sahre, Gregg Heard; client: Fells Point Corner
Theatre; photographer/illustrator: Lew Bush; typefaces: custom
font (headline), Franklin Gothic Bold, Franklin Gothic Regular

Heard and Sahre digitally manipulated the font Ludlow to
create their custom typeface.

PAULA SCHER is a master of the big image. Taking a direct, bold approach to graphic design problems, she helps her clients communicate both subtle and monumental changes. Scher served for ten years as art director for CBS Records and in 1984 joined forces with magazine designer Terry Koppel to found Koppel & Scher. With a keen sense of humor, glamour and public taste, she has developed identity systems, promotional materials, packaging and publication designs for clients such as Children's Television Workshop, The New York Times Magazine, Estee Lauder and the American Museum of Natural History. Scher's work has received hundreds of design awards and four Grammy nominations. She taught at the New York School of Visual Arts for eight years and has written numerous articles on criticism and practice of design.

PAULA SCHER

PENTAGRAM DESIGN

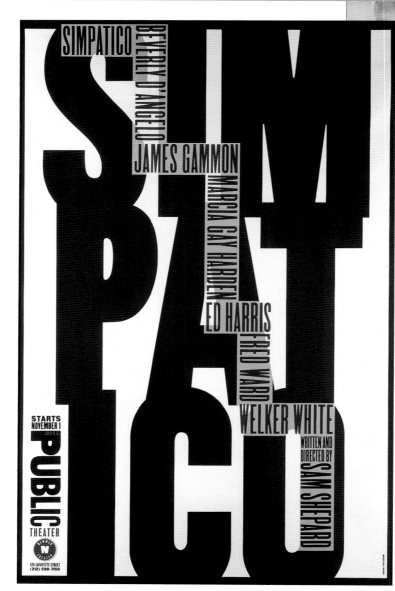

SIMPATICO/THE PUBLIC THEATER POSTER
designers: Ron Louie, Lisa Mazur; design studio: Pentagram Design; client: The Public Theater; art director: Paula Scher; typefaces: Morgan Foundry wood faces

The typefaces in this piece are used throughout Paula Scher's identity for the Public Theater. The varied but cohesive graphic language reflects street typography; it is extremely active, unconventional and almost graffiti-like. Applications to print and promotional materials and advertising use the same bold language of woodcut typefaces.

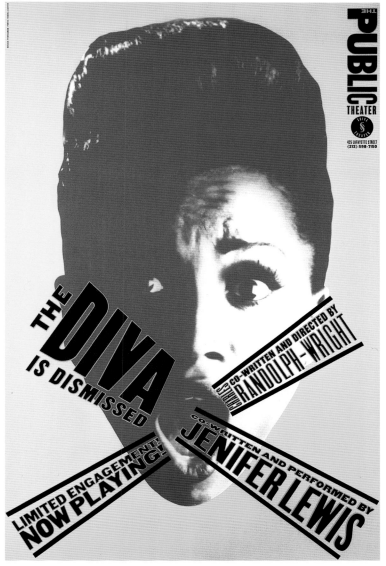

THE DIVA IS DISMISSED
designers: Ron Louie, Lisa Mazur; design studio: Pentagram Design; client: The
Public Theater; art director: Paula Scher; photographer: Teresa Lizotte; typefaces:
Morgan Foundry wood faces

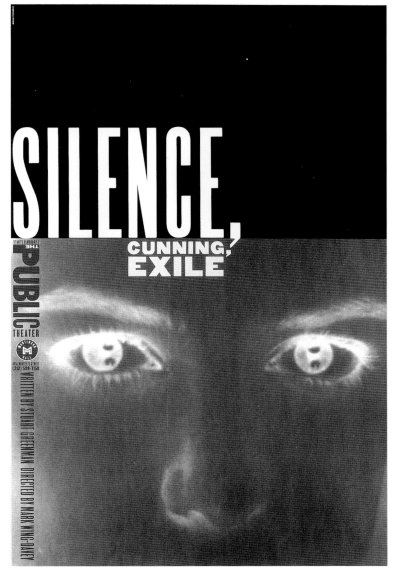

SILENCE, CUNNING, EXILE
designers: Ron Louie, Lisa Mazur; design studio: Pentagram
Design; client: The Public Theater; art director: Paula Scher;
typefaces: Morgan Foundry wood faces

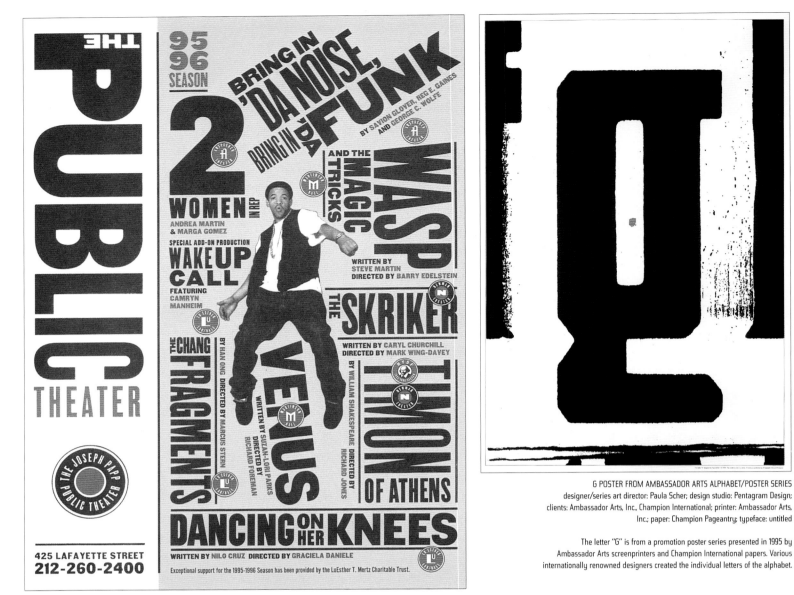

THE PUBLIC THEATER/SEASON POSTER
designer: Lisa Mazur; design studio: Pentagram Design; client: The Public
Theater; art director: Paula Scher; photographer: Carol Rosegg; printer:
Ambassador Arts, Inc.; typefaces: Morgan Foundry wood faces

Promotions for the new season at the Public Theater center on the image of
dancer Savion Glover, appearing in Bring in 'Da Noise, Bring in 'Da Funk. Play
titles and theater logos surround the tap artist in a typographical bebop,
reflecting urban noise.

G POSTER FROM AMBASSADOR ARTS ALPHABET/POSTER SERIES
designer/series art director: Paula Scher; design studio: Pentagram Design;
clients: Ambassador Arts, Inc., Champion International; printer: Ambassador Arts,
Inc.; paper: Champion Pageantry; typeface: untitled

The letter "G" is from a promotion poster series presented in 1995 by
Ambassador Arts screenprinters and Champion International papers. Various
internationally renowned designers created the individual letters of the alphabet.

DESIGN RENNAISSANCE,
AMBIGUITY/POSTER
designer/art director: Paula Scher; design
studio: Pentagram Design; client:
ICOGRADA; typeface: Ambiguity

This poster was used to promote
ICOGRADA's International Design
Rennaissance Congress in Glasgow,
Scotland, September 1993. The designer
used her favorite typefaces, Bodoni and
Futura, together to create Ambiguity, the
face of choice when it's impossible to
decide between the two.

HIM
designers: Ron Louie, Lisa Mazur; design studio: Pentagram Design; client: The Public Theater; art director: Paula Scher; type-
faces: Morgan Foundry wood faces

Christopher Walken portrayed Elvis in the afterlife.

THOMAS SCOTT, a graduate of the Art Institute of Pittsburgh, worked at various Florida studios before founding Eye Noise in 1992. Eye Noise produces a steady stream of high-profile work for corporate clients, such as the Walt Disney Company. But to indulge his passion for atypical design and typography solutions that communicate outside the mainstream, Scott turns to the music and entertainment fields, working primarily for independent companies and promoters. Scott's work has been published in Communication Arts, Print and HOW.

THOMAS
SCOTT

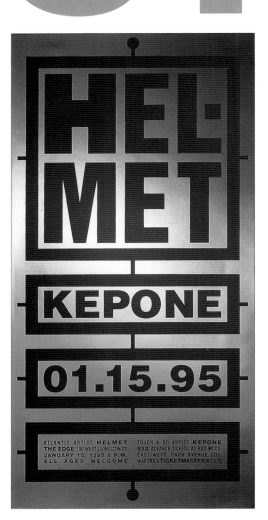

HELMET, KEPONE/CONCERT
POSTER
designer: Thomas Scott; design stu-
dio: Eye Noise; client: Figurehead;
typefaces: Helvetica Black,
Helvetica Inserat

The individual letters for "Helmet"
were adjusted in Adobe Illustrator.
Scott created these bold and clean
typefaces to complement the foil
stock and relate to Helmet's music.

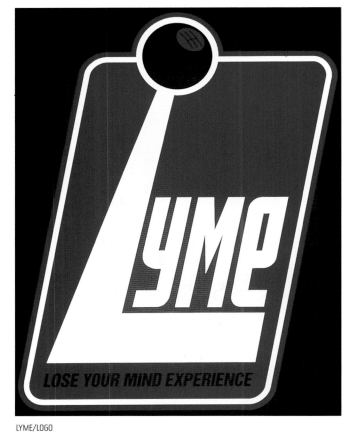

LYME/LOGO
designer: Robert Haines; design studio: Eye Noise; client: LYME (rock band); art director: Thomas
Scott; typefaces: hand-created lettering ("LYME"), Helvetica Inserat

Haines's hand-lettering, done in marker and used as a template for final art in Adobe Illustrator, was
inspired by auto racing sponsor logos.

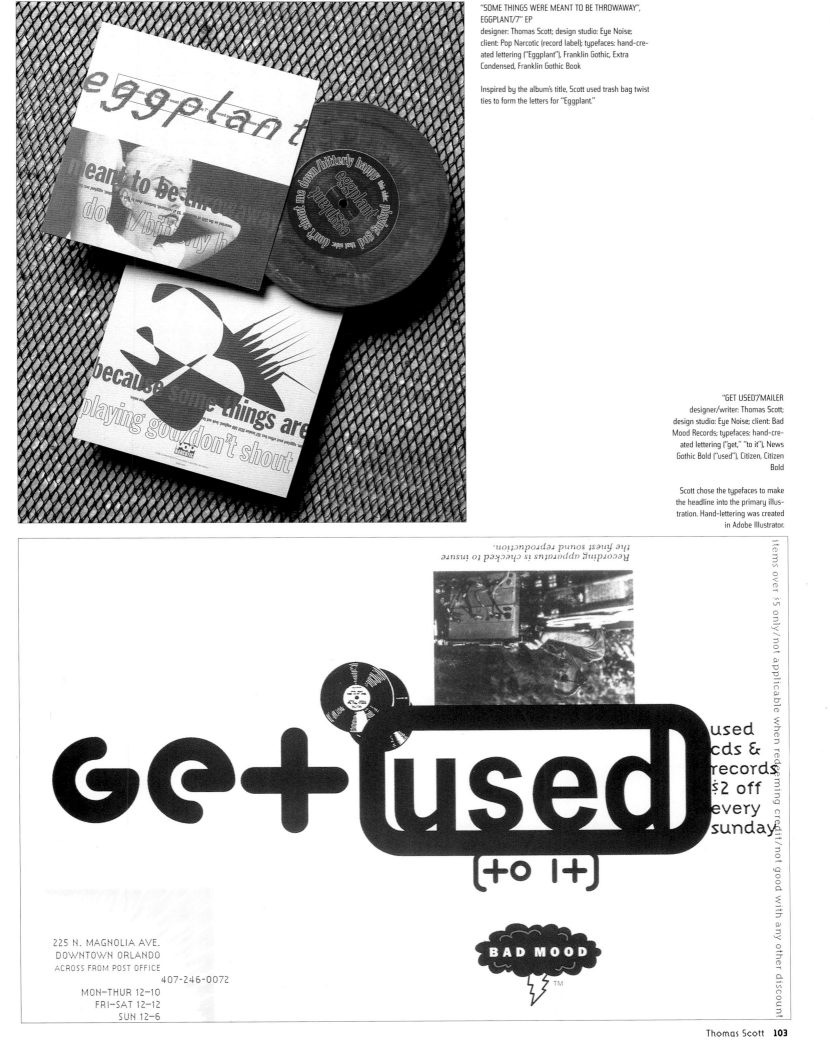

"SOME THINGS WERE MEANT TO BE THROWAWAY",
EGGPLANT/7" EP
designer: Thomas Scott; design studio: Eye Noise;
client: Pop Narcotic (record label); typefaces: hand-cre-
ated lettering ("Eggplant"), Franklin Gothic, Extra
Condensed, Franklin Gothic Book

Inspired by the album's title, Scott used trash bag twist
ties to form the letters for "Eggplant."

"GET USED"/MAILER
designer/writer: Thomas Scott;
design studio: Eye Noise; client: Bad
Mood Records; typefaces: hand-cre-
ated lettering ("get," "to it"), News
Gothic Bold ("used"), Citizen, Citizen
Bold

Scott chose the typefaces to make
the headline into the primary illus-
tration. Hand-lettering was created
in Adobe Illustrator.

used
cds &
records
$2 off
every
sunday

items over $5 only/not applicable when redeeming credit/not good with any other discount

225 N. MAGNOLIA AVE.
DOWNTOWN ORLANDO
ACROSS FROM POST OFFICE
407-246-0072
MON-THUR 12-10
FRI-SAT 12-12
SUN 12-6

BAD MOOD

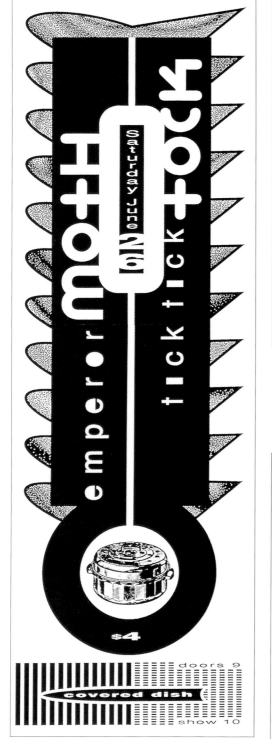

FISHBONE/CONCERT POSTER
designer: Thomas Scott; design studio: Eye Noise; client: The Edge Concerts;
typefaces: New Clarendon Bold ("Fishbone"), Platelet, Platelet Heavy

The individual letters for "Fishbone" were adjusted in Adobe Illustrator. Scott
especially likes this design for its square serifs.

TICK TICK TOCK, EMPEROR MOTH/SHOW FLYER
designer: Thomas Scott; design studio: Eye Noise; client:
Tick Tick Tock (pop band); typefaces: hand-lettering
("moth," "tock"), Helvetica ("emperor," "tick tick," other
text), Helvetica Black

Through use of hand-lettering and distortion of Helvetica
in Adobe Illustrator, Scott wanted to create a look as
peculiar as Emperor Moth's music.

BOB DYLAN/CONCERT POSTER
designer: Thomas Scott; design studio: Eye Noise; client: University of Central
Florida; typefaces: Adastra Royal ("D"), Caslon 540 Italic ("Thursday,
November"; "ylan"; numerals), Caslon 540 ("Bob," "TH," other text), Snell
Roundhand Script Bold ("12")

Scott chose these typefaces to create a look that was classic, elegant and yet
unusual. Adastra Royal was scanned from an old type book.

VELOCITY GIRL, FUZZY, DENATURE/CONCERT POSTER
designer: Thomas Scott; design studio: Eye Noise; client: Figurehead; typefaces: hand-created lettering ("Velocity Girl"), Template Gothic, Template Gothic Bold

Using "Velocity" as a template for the final art in Adobe Illustrator, Scott designed the primary typeface
to reflect Velocity Girl's fun and contemporary music. He used marker for the hand-lettering and scanned "Girl" using Adobe Streamline.

FLAMING LIPS, CODEINE, GRIFTERS/CONCERT POSTER
designer: Thomas Scott; design studio: Eye Noise; client: Figurehead; typefaces: Corporate Mono Bold, Corporate Rounded Bold

By reversing Corporate Mono and Corporate Rounded out of each other, Scott wanted to create an entire poster design that
was as disorienting as a Flaming Lips performance.

CARLOS SEGURA, a Cuban native, came to the United States in 1965. After drumming in a local band, he used his portfolio of band promotions to get his first job as a production artist. Segura worked in advertising agencies, including Marsteller, Foote Cone & Belding, Young & Rubicam and Ketchum, in both Chicago and Pittsburgh. Realizing he was not happy creatively, he started Segura Inc. in 1991 to pursue design, while trying to put as much fine art into commercial art as possible. In 1994, Segura and Scott Smith started [T-26], a new digital type foundry, to explore the typographical side of the business, and they have recently started an independent record label, Thickface Records. Segura considers himself very fortunate to have done some very interesting work, met some fine people, and had the opportunity to do something for a living that he really enjoys.

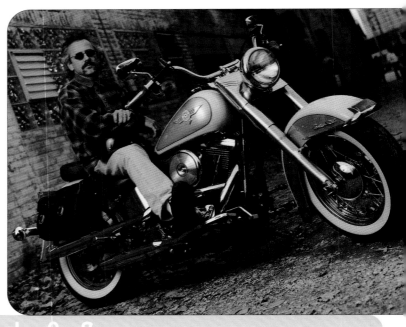

THE ALTERNATIVE PICK/STICKERS
designer: Carlos Segura; design studio: Segura Inc.; client: The Alternative Pick;
photographer/illustrator: Jordin Isip (Hatch); typeface: Boxspring

THE ALTERNATIVE PICK/POSTER
designer: Carlos Segura; design
studio: Segura Inc.; client: The
Alternative Pick; photographer/illus-
trator: Hatch; typeface: Boxspring

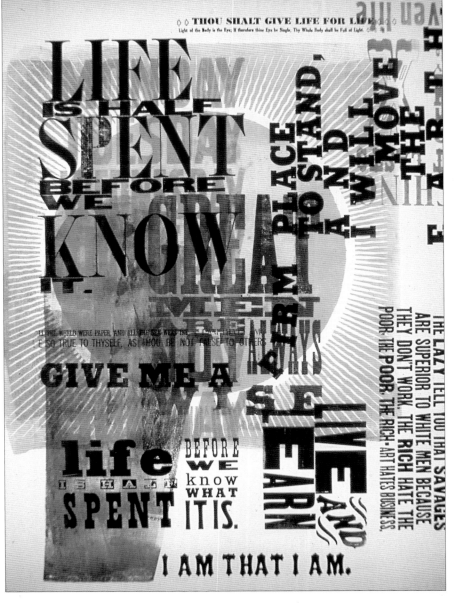

AFTERBURN/CD
designer/art director: Carlos Segura;
design studio: Segura Inc.; client:
TVT/Wax-Trax! Records; photographer/
illustrator: Eric Dinyer; typeface: Stinky
Movement—custom-designed

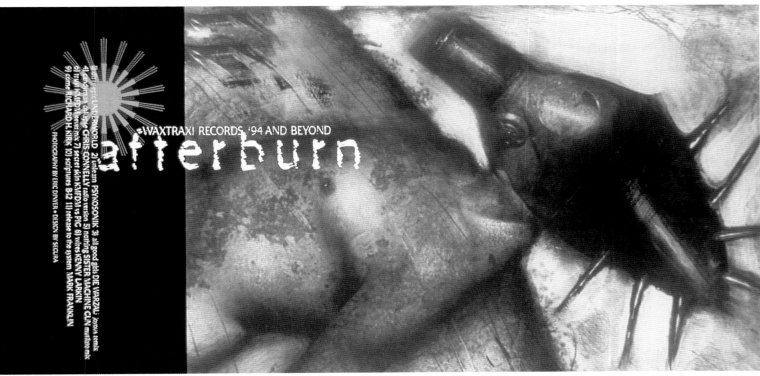

MTV/STATIONERY
designer/art director: Carlos Segura; design studio:
Segura Inc.; client: MTV Networks; photographer/
illustrator: Hatch; typeface: untitled

american crafts and ethnic objects

gimcracks

GIMCRACKS/POSTCARD
designer/art director: Carlos Segura;
design studio: Segura Inc.; client:
GIMCRACKS; typefaces: Dig, Dog

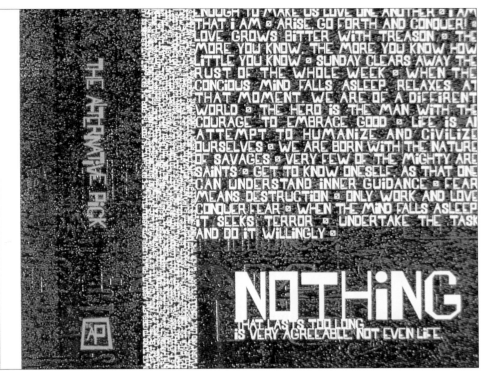

THE ALTERNATIVE
PICK/SOURCEBOOK COVER
designer/art director: Carlos Segura;
design studio: Segura Inc.; client: The
Alternative Pick; photographer:
Hatch; typeface: Boxspring

Segura custom designed this
typeface after the look of
box-spring mattresses.

[T-26]/AD
designer/art director: Carlos Segura; design
studio: Segura Inc.; client: [T-26];
photographer/illustrator: Tony Klassen;
typeface: Tema Cantante—custom-designed

SMAY VISION is the child of Stan Stanski and Phil Yarnall—renegade Amish boys and graduates of the Tyler School of Art in Philadelphia. Eventually, as fate would have it, the two grew jaded toward the whole corporate scene (workin' for The Man), decided to follow up on their college-days dream of starting their own studio and voila, Smay Vision was born. Originally based out of their East Village apartment, Smay Vision has grown considerably since its inception. They now design their own fonts based primarily on the four food groups and/or whatever's left over from lunch, send out self-promotional T-shirts and postcards and create packaging for such artists as the Meat Puppets, Billy Squier, Isaac Hayes and the Velvet Underground. Other clients include MTV, Guitar and a smattering of record labels.

SMAY

V I S I O N

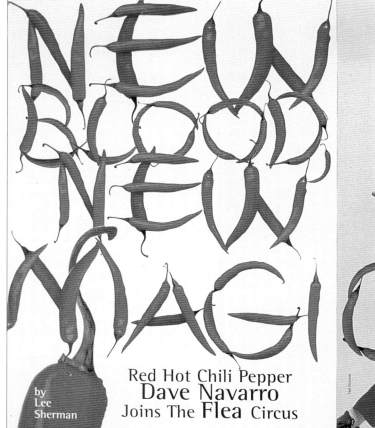

Red Hot Chili Pepper
Dave Navarro
Joins The **Flea** Circus

by
Lee
Sherman

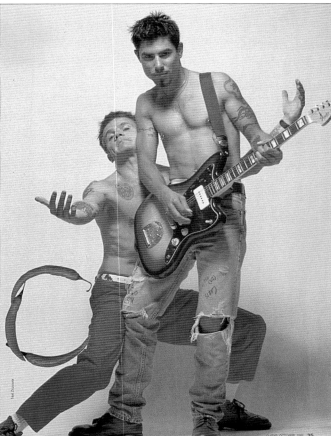

NEW BLOOD NEW
MAGIC/MAGAZINE
SPREAD
designers: Stan Stanski,
Phil Yarnall; design studio:
Smay Vision; client: Guitar;
art director: Smay Vision;
photographer/illustrator:
Neil Zlozower; typefaces:
Chili Peppers, Rotis

The chili peppers used
for the headline were indi-
vidually scanned and
assembled in Adobe
Photoshop.

WHATEVER MAKES YOU HAPPY, THE DWELLERS/CD
designers: Stan Stanski, Phil Yarnall; design studio: Smay
Vision; client: EMI Records; art director: Henry Marquez;
cover photographers: Denise Chastain, Ken Schels; type-
faces: Rhino Flex (Dwellers logo), Eat at Joes ("Whatever
Makes You Happy")

Rhino Flex was borrowed from an old rusty tire sign,
while the photos were taken from old signs.

MTV NEW FALL LINEUP/STILL FROM TV PROMO
designers: Stan Stanski, Phil Yarnall; design studio: Smay
Vision; client: MTV; art director: Smay Vision; typeface:
Ginricky

The primary typeface for this piece, Ginricky, was created
by the designers from a scan they made of a typeface on
a dinner place mat that was then printed without a TIFF
file, giving the characters their pixilated texture.

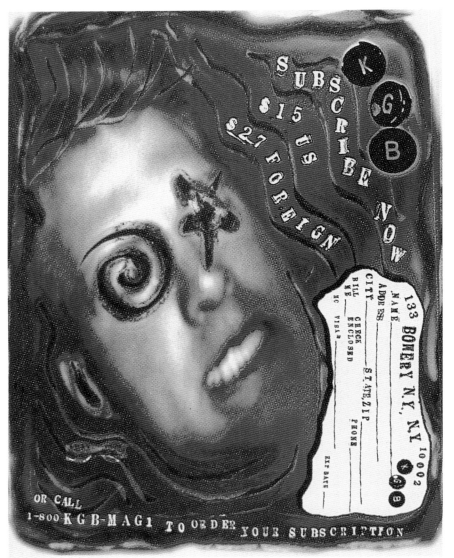

The designers created the primary typeface, Buttsteak
Bold, by scanning a bloody steak and, using Adobe
Photoshop and Illustrator, combining this scan with some
degenerated type from an old blues poster.

PGD COUNTRY SOUND SAVERS
designers: Stan Stanski, Phil Yarnall;
design studio: Smay Vision; client:
PGD; art director: Smay Vision; type-
face: custom-designed

The designers created the primary
typeface for this piece by enlarging
a one-half-inch reproduction of a
playing card box from an old Sears
catalog, then scanning it and
manipulating it in Adobe Photoshop.

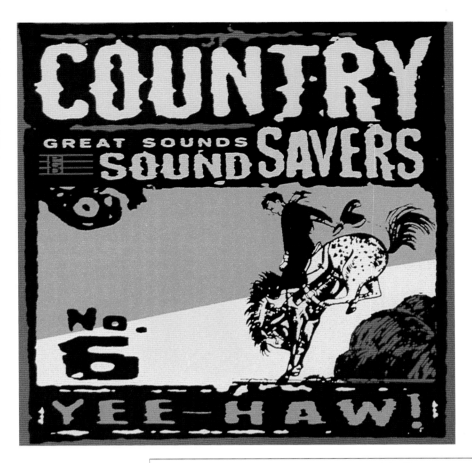

COUNTRY
GREAT SOUNDS
SOUND SAVERS
NO. 6
YEE-HAW!

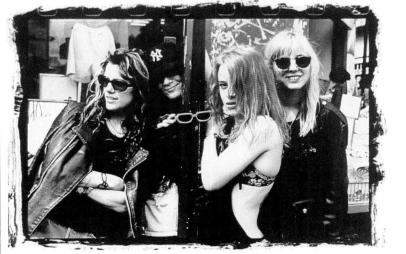

Backstage at Lollapalooza '94, there's a whole lotta waitin' goin' on. Members of The Bad Seeds, The Breeders, and the P-Funk All-Stars mill around an eerily impersonal trailer park quad waiting to take the stage. The press corps, trying hard not to look like glorified fans, wait for interviews, quotes, incidents—anything noteworthy to latch onto. (A zealous gaggle of photographers rushes over to snap a shot of someone being taken out of the pit on a stretcher.) L7 waits, too—but they're waiting to get the hell out.

The day started badly for the band. Local traffic and a few accidents tied up area highways for hours, catching the L7 tour bus in a jam that forced them to miss their set. In fact, if it weren't for performer/friend Nick Cave, who let the girls have the last 10 minutes of his stage time, the day would have been a complete washout.

"It fucking sucks," a miserable Suzi Gardner says to me later, on the way to the band's trailer.

"You know what it's like?" asks bassist Jennifer Finch about the band's curtailed appearance. "It's like jerkin' off and not bein' able to come."

Inside, the trailer reeks of smoke and cheap carpeting. On one side of the room an aluminum folding table offers a bowl of fruit, sandwich stuff, and some candy; on the other side, a couple of folding chairs. Suzi, dressed in a tight, French-cut navy t-shirt with the word "Baby" embroidered on it, sits cross-legged on the floor, smoking. Guitarist Donita Sparks, dressed in black down to her mud-caked shitkickers, walks in behind us and plops down on a chair. I pull up the second chair and try to appear comfortable. Though it's apparent the two are pissed off, a little guitar talk lifts their spirits.

"One of my favorite soloists is Angus Young," Suzi says, her mascara-striped eyes wide open. "He's so rockin'. Greg Ginn, too. His old Black Flag solos...They're like drivin' on ice; they never get too far out, but they're so out of control."

"I like Sweatin' to the Oldies kind of stuff," says Donita from behind wicked-looking sun specs. Her nose ring glimmers. "Dick Dale, John Fogerty, Neil Young, Keith Richards."

Eddie Van Halen draws unanimous raves, as do guys like twang king Duane Eddy and the ubiquitous Les Paul.

"And Albert King!" Suzi adds. "He'll just hang on this one note and there's so much more feeling to it than the deedle-lee-deedle-lee-dee stuff. Sure I'm impressed with technology, but where's the soul?"

"Sometimes I put a lot of notes in a solo if it's in a feverish part of a song," Donita notes. "But otherwise, we try to keep it basic."

Basic is what Hungry for Stink is, the band's new compound of molten metal and pulsating punk. Along with Gardner and Sparks, bassist Finch and drummer Dee Plakas kick up thunderheads the size of Texas with mangy power chords, confrontational stances, and adrenalizing sing-along choruses.

"We're also into feedback until people's eardrums start to bleed," Suzi jokes but doesn't smile.

"We all bought 'Grunge' pedals as a joke," says Donita, "kind of as a souvenir of the times. The first day we rehearsed with them, we did this amazing jam. We rarely jam during practice. But Jennifer and I were doing this basic thing and Suzi was just stomping on her Grunge pedal [she makes a sound like a squealing pig]. Then she'd play a note, like a low E, and wow! Two notes, two chords and Suzi stomping on her Grunge pedal, and poodle-headed guys were coming in going 'Whoa! What is this?'"

by Bob Gulla

Continued on page 172

L7/EDITORIAL PAGE
designers: Stan Stanski, Phil Yarnall; design studio: Smay Vision;
client: Guitar; art director: Smay Vision; photography/illustration:
Stills/Retna Ltd.; typeface: Duct Tape

For this feature on the rock group L7, the designers scanned in a
typeface they constructed out of duct tape.

MARK T. SMITH received his B.F.A. from the Pratt Institute in Brooklyn in 1990 and works as a freelance illustrator and designer. He sports a distinguished client list that includes Absolut Vodka, MTV, Nickelodeon, AT&T, Newsweek and the Walt Disney Corporation. He has won awards from Print and the Society of Illustrators, New York City, and has had exhibitions in galleries in New York, Washington, DC, and Wilmington, Delaware. He teaches illustration and design at Parsons School of Design in New York.

MARK
SMITH

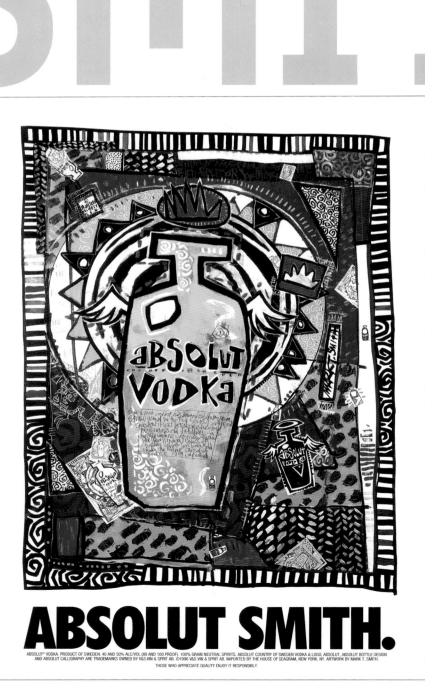

ABSOLUT SMITH.

ABSOLUT® VODKA. PRODUCT OF SWEDEN. 40 AND 50% ALC/VOL (80 AND 100 PROOF). 100% GRAIN NEUTRAL SPIRITS. ABSOLUT COUNTRY OF SWEDEN VODKA & LOGO, ABSOLUT, ABSOLUT BOTTLE DESIGN AND ABSOLUT CALLIGRAPHY ARE TRADEMARKS OWNED BY V&S-VIN & SPRIT AB. ©1996 V&S VIN & SPRIT AB. IMPORTED BY THE HOUSE OF SEAGRAM, NEW YORK, NY. ARTWORK BY MARK T. SMITH.
THOSE WHO APPRECIATE QUALITY ENJOY IT RESPONSIBLY.

(right)
HANGOVER SHOES
designer: Mark T. Smith; client: Janet Hughes and Associates/Kid Shelleen's; art director: Elizabeth Krewson; painter: Mark T. Smith; typeface: Smith Outline ("Kid Shelleen's Mardi Gras Feb. 18- March 3 1992")

All featured typefaces were designed and hand created by Smith.

ABSOLUT VODKA, ABSOLUT SMITH
designer/art director: Mark T. Smith; client: TBWA/House of Seagram's/Beisler and Partners; painter: Mark T. Smith; typefaces: Smith Bold Condensed ("Absolut Vodka"), Smith Bold Extended ("Country of Sweden"), Smith Scribble Type ("This superb . . .")

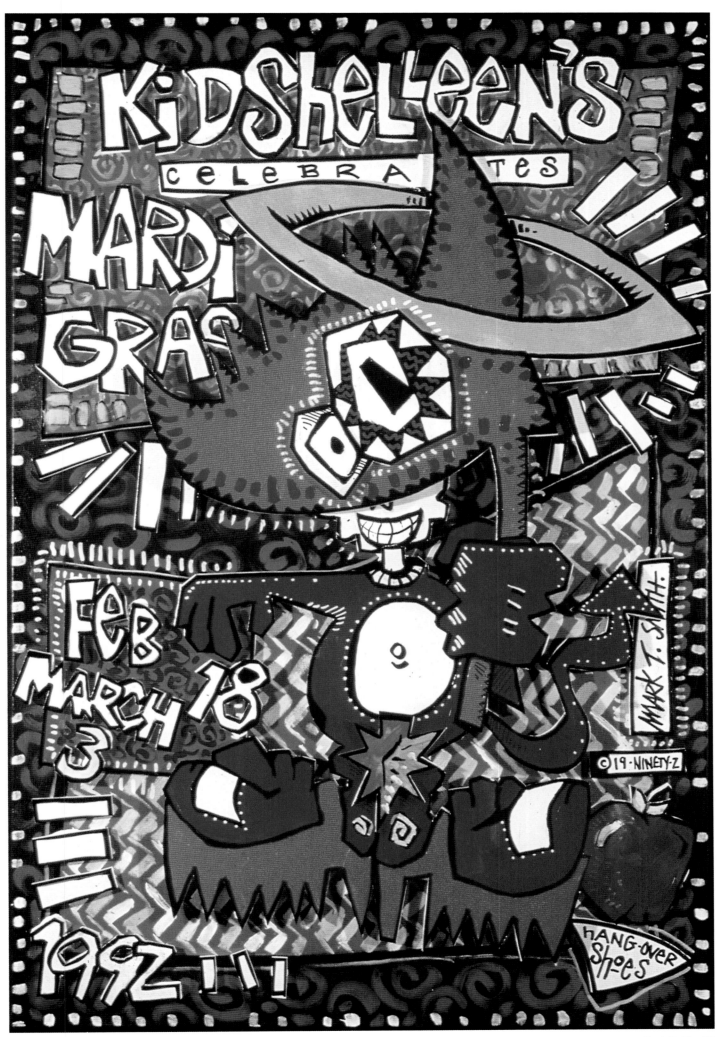

LUCILLE TENAZAS is principal of Tenazas Design, a communication graphics and design firm based in San Francisco. The scope of Tenazas's work is broad, ranging from corporate projects to publications for non-profit organizations, including Apple Computer, the NEA, the Stanford University Art Museum and the San Francisco Redevelopment Agency. She attempts to communicate with the public through her work by combining the design of information systems with visual poetry—as demonstrated by her design of the graphic identity and print publication materials for the Center for the Arts at Yerba Buena Gardens. In 1995 she was honored as one of I.D.'s forty top design innovators. Tenazas received her M.F.A. from Cranbrook Academy of Art. She teaches, holds workshops and lectures extensively around the country.

LUCILLE TENAZAS

17th Annual AIA SF | SFMOMA Lecture Series

Nicholas Grimshaw Sept. 18
Antoine Predock Oct. 2
Margaret Crawford Oct. 16

Rafael Moneo Oct. 23
Craig Hodgetts & Ming Fung Nov. 6

From Rome to cyberspace:
New typologies

FROM ROME TO CYBERSPACE: NEW TYPOLOGIES
designer: Kelly Tokerud; design studio: Tenazas Design; clients: AIA San Francisco, San Francisco Museum of Modern Art; art director: Lucille Tenazas; photographer/illustrator: Tenazas Design; typefaces: Frutiger (architects' names, "SFMOMA"), Centaur ("From Rome to Cyberspace")

MOTO
designer: Todd Foreman; design studio: Tenazas Design; client: Moto Development Group; art director: Lucille Tenazas; typefaces: Gill Sans ("Moto"), News Gothic (the floating words), Futura (the die-cut "Moto")

Tenazas Design created the Moto logotype through the digital manipulation of the custom-drawn typeface.

AIGA DESIGN LECTURE SERIES, SUBLIME SUBVERSIVES
designers: Lucille Tenazas, Tyler Wheeler; design studio: Tenazas Design; clients: AIGA, San Francisco Museum of Modern Art; art director: Lucille Tenazas; photographer/illustrator: Richard Barnes; typefaces: Din Schriften ("Subversives"), Franklin Gothic ("Sublime," title series)

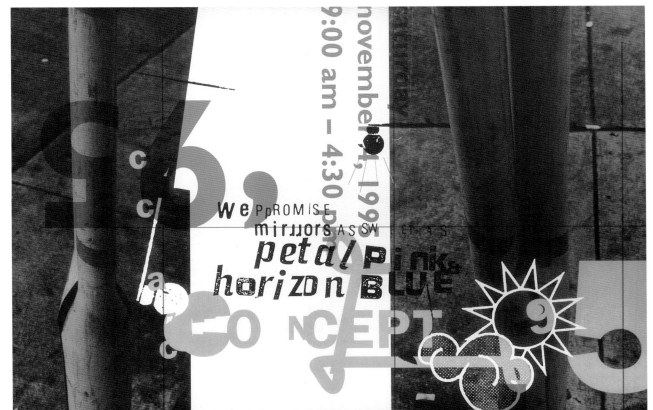

CCAC CONCEPT LECTURE SERIES, 1995
designer: Martin Venezky; design studio: Tenazas Design; client: California College of Arts and Crafts; art director: Lucille Tenazas; photographer/illustrator: Martin Venezky; typefaces: Gill Sans (names, "CCAC"), Varions Distressed

Venezky designed Varions Distressed, a manual alteration of an existing typeface.

RICK VALICENTI's last two years of self-employment have been by far the most rewarding. His collaborators are smart, fearless and talented as hell. Their Thirst world environment moved to his home forty miles outside of Chicago, and though none of his handful of clients is located in Chicago, the daily visits from UPS and FedEx keep the urban existence close enough. Day-to-day relevance pursuing ever-elusive self-expression through design has remained worth the adrenalin. At the moment, their small troupe performs daily to reposition Gary Fisher Mountain Bikes, Gilbert Paper and Revelation Snowboards and to support the fad-hungry world of Saatchi, Foote Cone, Ammirati, etc. Their best professional award, however, is the real presence and respect they have in a creatively healthy process. The money's not bad either.

RICK
VALICENTI

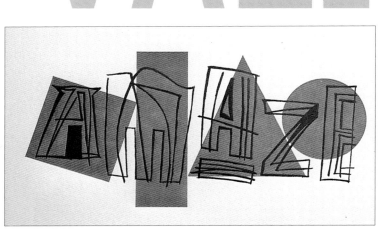

AMAZE
designer/art director: Rick Valicenti; design studio: Thirst; client: Gilbert Paper; photographer: Rick Valicenti; typefaces: hand-drawn from Valicenti's doodles, Futura Book ("Information")

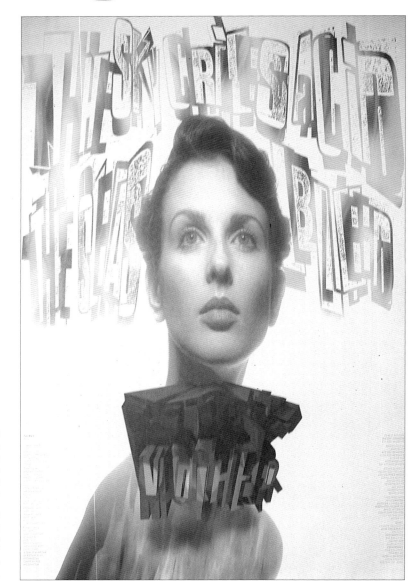

MOTHER
designer/art director: Rick Valicenti; design studio: Thirst; client: Ogilvy Mather—Argentina; photographer: William Valicenti; digital illustrator: Mark Rattin; typeface: Mother

Valicenti, inspired by the barrage of type in every U.S. newspaper's car section, used collage to create the original face. For the word "Mother," letters were scanned and put into a 3-D program.

FEEL STUPID IT'S OK
designer/art director: Rick Valicenti;
design studio: Thirst; client: American
Center for Design; digital illustrators:
Mark Rattin, Rick Valicenti; typeface:
OOGA BOOGA

OOGA BOOGA was created by Valicenti
from a digital scan of a sign painted on
an Elston Avenue building in Chicago.

SURFACE IS EVERYTHING
designer/art director: Rick Valicenti;
design studio: Thirst; client: Gilbert
Paper; photographer: William
Valicenti; digital illustrators: Rick
Valicenti, Linda Valicenti; typefaces:
Cyberotica (headlines), Metacaps
(body text)

Retro Futura was Barry Deck's point
of reference for Cyberotica.

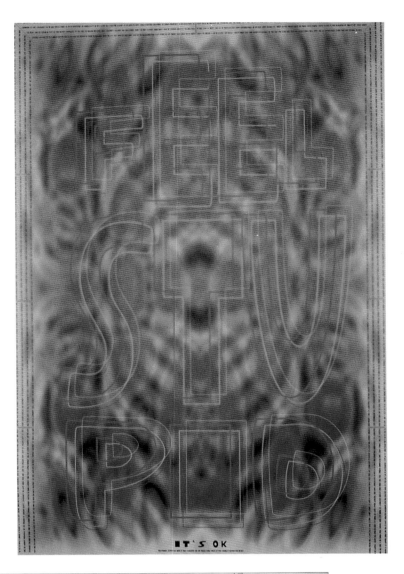

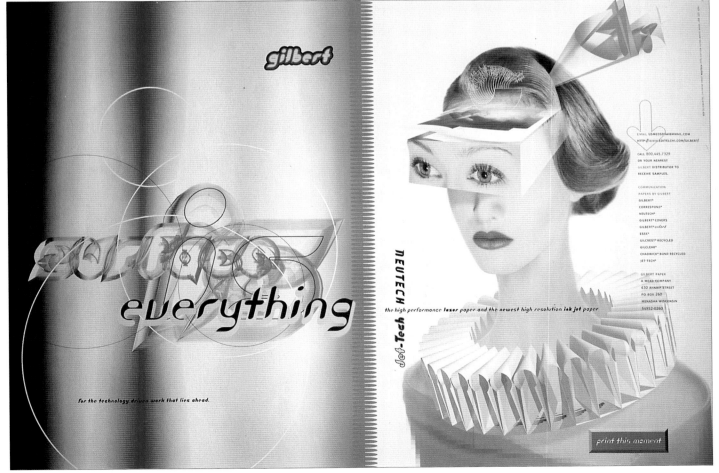

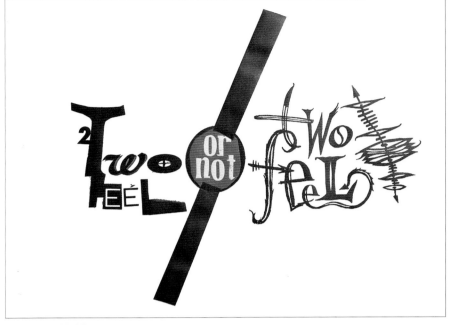

DREAM GIRL
designer/art director: Rick Valicenti; design studio: Thirst;
client: Gilbert Paper; photographers: Corrine Pfister,
Michael Papas; typefaces: hand-drawn

These typefaces originated in Valicenti's doodles and were
hand-drawn in collage form.

TWO FEEL OR NOT TWO FEEL
designer/art director: Rick Valicenti; design studio: Thirst; client: Rick Valicenti;
illustrator: Rick Valicenti; printer: Gilbert Paper; typefaces: hand-drawn

All typefaces were inspired by Valicenti's own doodles.

NOTHING BEATS STYLE LIKE REASON
designer/art director: Rick Valicenti; design studio: Thirst; client: Gilbert Paper; photographer: Francois Robert;
digital illustrators: Mark Rattin, Rick Valicenti; typefaces: Commerce, hand-drawn/collage

Greg Thompson and Rick Valicenti were inspired by grocery store typefaces to design the typeface Commerce.

GOTTA HAVE IT
designer/art director: Rick Valicenti;
design studio: Thirst; client: Rick
Valicenti; photographers: Tony
Klassen, Rick Valicenti; printer:
Gilbert Paper; typefaces: hand-
drawn

Valicenti created the hand-drawn
typefaces using collage.

GIVE AND TAKE
designer/art director: Rick Valicenti;
design studio: Thirst; client: Gilbert Paper;
photographer: Rick Valicenti; typefaces:
untitled (Give & Take), Bronzo

Valicenti's layout and eight color choices
pay homage to the first Elvis Presley
release and the Clash's London Calling.

RUDY VANDERLANS studied graphic design at the Royal Academy of Fine Art in The Hague, Holland. In 1984 VanderLans founded Emigre, a journal for experimental graphic design. The magazine garnered much critical acclaim when it began to incorporate Zuzana Licko's digital type-face designs. The exposure of these typefaces led to the manufacture of Emigre Fonts, which is now distributed worldwide as software. VanderLans's Emigre has worked for a variety of clients ranging from large multinationals, such as Apple Computer, Inc., to independent art organizations, such as San Francisco's Art Space. Emigre's work has been published in numerous design magazines, such as Blueprint, Baseline and Axis, and was the 1994 recipient of the Chrysler Award for Innovation in Design.

RUDY VANDERLANS

EMIGRE

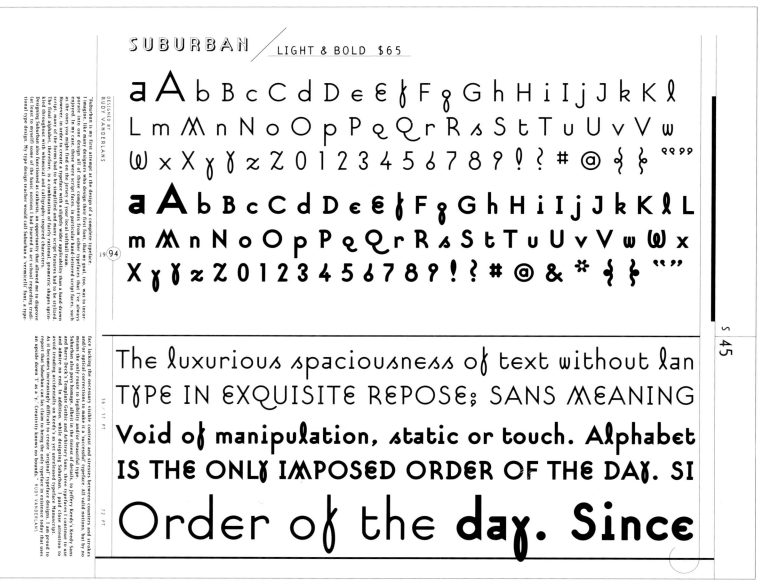

SUBURBAN / LIGHT & BOLD $65

DESIGNED BY
RUDY VANDERLANS

"Suburban is my first attempt at the design of a complete typeface. I imagine, like many designers who design their first font, that my goal, too, was to incorporate into one design all of those components from other typefaces that I've always enjoyed. In my case, these were script faces, in particular hand-lettered script faces, such as the ones you might find on old 1930s and 1940s chocolate boxes and cookie tins. However, in order to create a typeface with a slightly wider applicability than a hand-drawn script, many of the forms had to be simplified and many script features had to be stylized. The final alphabet, therefore, is a combination of fairly rational, geometric shapes sprinkled throughout with whimsical and calligraphy-inspired characters. Designing Suburban also functioned as catharsis, an opportunity that allowed me to disprove (at least to myself) some of the basic notions I had learned in art school regarding traditional type design. My type design teacher would have called Suburban a 'vermicelli' font, a type-

1994

face lacking the necessary visible contrast and stresses between counters and strokes and/or optical corrections to make it a 'successful' typeface. All valid notions, but by no means the only route to legibility and/or beautiful type. Suburban also pays homage, albeit in the tiniest of details, to Jeffery Keedy's Keedy Sans and Barry Deck's Template Gothic and Arbitrary Sans. These typefaces I continue to use and admire, no end. In addition, while designing Suburban, I paid close attention to avoid treading accidentally on Keedy's as yet unreleased typeface Manuscript. As it becomes increasingly difficult to create 'original' typeface designs, I am proud to report that Suburban can lay claim to being the only typeface in existence today that uses an upside down 'I' as a 'Y'. Creativity knows no bounds." RUDY VANDERLANS

S 45

36 / 37 PT

The luxurious spaciousness of text without lan
TYPE IN EXQUISITE REPOSE; SANS MEANING
Void of manipulation, static or touch. Alphabet
IS THE ONLY IMPOSED ORDER OF THE DAY. SI

72 PT

Order of the **day. Since**

SUBURBAN
designer: Rudy VanderLans; design studio: Emigre; client: Emigre; typeface: Suburban

VanderLans's goal in designing Suburban was to incorporate into one design favorite design components, such as hand-lettered script faces. In order to create a typeface with a slightly wider applicability than hand-drawn script, many of the forms had to be simplified and many script features had to be stylized. The final alphabet, therefore, is a combination of fairly rational, geometric shapes sprinkled throughout with whimsical and calligraphy-inspired characters.

Suburban also pays homage to Jeffery Keedy's Keedy Sans and Barry Deck's Template Gothic and Arbitrary Sans.

> "It is worth trying a brutally simple attitude to design: judge it by its content... But, having announced the simple criterion of 'content,' one then has to explore the ways in which content is mediated by, is inseparable from, the forms in which we find it."
> – Robin Kinross. *Fellow readers: notes on multiplied language* [1]

Know Questions Asked

A dialogue with fellow readers: notes on multiplied language
Anne Burdick / Louise Sandhaus / Rudy VanderLans

> "Architecture [design, writing]... is not the simple container, but a place that shapes matter, that has a performative action on whatever inhabits it..."
> Denis Hollier. *Against Architecture: the Writings of Georges Bataille* [2]

1. Robin Kinross. *Fellow readers: notes on multiplied language.* p 26-27. London: Hyphen Press. 1994
2. Denis Hollier. *Against Architecture: The Writings of Georges Bataille.* p.x. Cambridge, MA. MIT Press. 1989

[[Louise > anne: here's a little quip from my fave, laurie anderson, to get us in the mood [;-p]: in "stories from the nerve bible," laurie talks about traveling through europe during the gulf war and how, because of the hyper-security, they'll make her demonstrate her electronic equipment at the airport security checkpoints. she describes one occasion when the security people pointed to something - a filter - and asked what it was. laurie responded: "this is what I like to think of as the voice of authority" and went on to explain that she uses it "for songs about various forms of control." then they asked her why she'd "want to talk like that?" she looked around at all the equipment, the snot teams and said "take a wild guess."]]

3. *Culture on the Brink,* ed. Gretchen Bender and Timothy Drucker. Seattle: Bay Press. 1994. p.225.
4. Quoted by Jan van Toorn in THINKING DESIGN: ISSUES IN CULTURE AND VALUE from the exhibition catalog for *Consuming the Image: Appetite for Meaningful Design.* Western Carolina University. 1993. p 4.

"It's not what you say, but how you say it" said Ronald Reagan[3], the man whose mastery of powerful images put him in power. But are we savvy enough now to see the connection between the means of authority and the authority of the image? Just what is the link between the means and the meaning — the form and its content? "Knowledge is power" as the old adage goes. But wait, this could be read two ways. Knowledge can be "empowering," a word that evokes an image of the small and meek overcoming the mighty and powerful. At the same time, the control of knowledge makes for power that controls, consciously or not. How does knowledge come about? Where does it circulate? In what forms do we find it?

Our discussion here is about exposing the seams that sew authority and knowledge together — undressing the power dressing. As seamstresses who stitch together form and content, creating the garment in which content is clothed, graphic designers have insight into the contrivance of appearance, the patterns for knowledge. Why set ourselves to expose and undermine the means of authority, pointing to ourselves in the process? Because seamless appearances allow authority (which legitimizes knowledge) to seem "natural" in a world whose power relations are out of balance, leaving few dangling threads with which one could unravel and expose what is a constructed get-up, the emperor's new clothes. Ours is a questioning of knowledge made material through communication technologies, whether it be the book, the magazine, the Internet or language itself — the latter two through which this piece was composed.

Front cover *Fellow readers* (1994).

[right margin rotated text:]
Robin Kinross Fellow readers notes on multiplied language

bubble of meaning. Something could mean anything, and so quickly it could only mean nothing. And all of this echoed the politics of the time: when a sense of things in common was displaced by free-for-all individualism; and when individual liberty became reduced to freedom to consume — if you had the cash — watched over by forces of the state.

[[anne > louise: hey - i think this discussion we've got between these brackets should be kept in - a seam-ripping device. anne > fellow readers: since i'm in raleigh, north carolina, usa and louise is in maastricht, the netherlands, we've been writing this by e-mail whose format gives us no margins to scribble in. so instead we created these roped-off spaces to wrestle with our form and content and sometimes each other - out the most difficult opponent by far has been the authoritative voice of our discussion. after much struggle, we lived to tell the story.]]

stand in contradiction to his discussion of Enlightenment ideals, printing and typography in *fellow readers?*

[[anne > louise: a little quip about roland barthes and the health issue: for barthes, the healthy sign is that which does not attempt to mask its presence as a sign. doesn't pass itself off as natural, transparent. the cloak of neutrality is, for him, authoritarian and therefore unhealthy. it's the disease of power and control. while clean living, clean thoughts, and kinross's clean design may be somehow pure, they may not all be healthy. sanitary makes sense where the corporeal is concerned, but it masks a deception when words and images are put to paper or screen. where are the smudges, the seams?]]

In the Know

"All this fire-breathing polemic seems to lead merely to a plea for graphic designers to be allowed to make their presence known," Kinross says.(p.9) Well, yes and no. If Kinross means that we just want a bit of fame, a role in the foreground in exchange for our long hours, while we may not mind that, it's hardly worth the pages of *Emigre.* But if "making our presence known" is about initiating a critical discussion about the designer's role in shaping what constitutes knowledge, then this is hopefully more than a MERE plea for recognition.

Can this discourse take place within the formal language of graphic design and typography? The designer presence to which Kinross refers is made known through visual strategies (as opposed to mention in the colophon); typography that is somehow disruptive, refusing to recede into the background of transparent convention". In this work the form — the visual signifier — draws attention to itself via one device or another, and could be read as bringing the designer to the foreground. Kinross's interpretation is that the goal of this work is to direct one reading (the designer's) as opposed to another (the author? The reader?). But couldn't it also be read as a "deeper argument about social effects, about the place of the designer"(p.9), by revealing its own constructedness and the constructedness of any authorized reading?

Either way, the limitations of a strategy of disruption become apparent when considered in the context of our particular historical moment. The rapid circulation of forms in our culture makes it difficult for disruptive/subversive/alternative maneuvers to retain their connotation. Even the meaning of the more subtle gestures that have appeared in book and catalog design, where the reader hardly notices the form until a sly move such as a little line of type gone astray, destabilizes and thus

11. While our description here is very generalized, (Kinross neglects to show the specific work to which he is referring), we are attempting to discuss strategies as opposed to actual formal manifestations found within certain work that is pertinent to Kinross's discussion and our own. We are not concerned with critiquing the success or failure of these examples of formal motivation behind such form-making, rather discussing the way such form circulates in the culture. We would also like to point out the degree of overlap between Kathy McCoy, Jeff Keedy, et al's "fire-breathing polemic" and Kinross's "deeper arguments about social effects" (p.9)

[58]

Know Where?

[[anne > louise: i was thinking — as i was downloading your e-mail and converting it to Microsoft Word, changing the font and point size to the ones i prefer — about the irony of writing about the relationship between content and form in a medium in which the form is completely malleable and left up to the reader/receiver. (is pt. Courier, by the way — to signify work in progress — a kind of fuzzy nostalgia for the typewriter. Come to think of it, the students i'm teaching now don't really have that same connection and over time any typeset text might signify malleability, work in progress, since typesetting will no longer contain the mysteries of its production, thanks to the computer.) Our content is digital information — does it exist without a material form prior to encountering a reader/receiver? Yes, I guess, because we have the alphabet and punctuation to work with — that's our language-made-material.]]

[[louise > anne: This brings up the big question about the World-Wide Web, too — where, at least for now, everything looks more or less equivalent regardless of what it is: you end up scrolling through lists of lists of lists. Here's the jumble of design-related thoughts this brought up: If everything had the same expression, would that be considered democratic? It makes me wonder, how much of what something means comes through what it looks like? Writing this via e-mail has really revealed the complexities of form and content and where design intervenes in the meaning-giving process. This makes me think about the three gloms: 1. First you have the expressive capacity of words, then 2. you glom on the expression of ideas through structural writing form, then 3. the expression of ideas through the forms of typography/typeface and typographic layout and design. Whew! That's a heap of stuff!]]

[[anne > louise: Can we talk about these things only having 1 and 2 to work with when we're really going to be talking about 1, 2, and 3? I was thinking about this when I came across Kinross's statement on page 15 about the casual language of e-mail and the need for — I don't know what — the formality of printing? The regulated use of proper English? Here's the quote: 'One already noticeable effect is that an informal, unedited style which goes with private communication is spreading into multiplied communication. The formality that multiplication and publication demands of a text carries a social function.']]

[[louise > anne: Yeah, it keeps everybody in line.]]

brings their expectations to the fore, depends on such expectations remaining constant across all audiences. While we fellows may meet on common ground, we in no way make up a homogeneous community that remains constant over time.

Perhaps we're asking too much from form alone. For this to be more than a "fire-breathing polemic," shouldn't it be extended into the public spheres where its significance is directed? In what forms/forums could this take place? In the section "Talking in Public,"(p.20) Kinross poses these same difficult questions, with a slightly different focus from ours.

[[anne > louise: isn't this more about public education in regards to *proper typography?*]]

"While printing is a prime means of enlightenment and demystification, discussion of it has tended to be the preserve of specialists..."(p.20) Looking at several small books on typography criticism by authors such as John Ryder and Erik Spiekermann, Kinross discusses the contradiction between the public arguments put forth and the precious books in which the arguments appear.

He goes on to ask, "Could typography be a topic of regular and intelligent discussion in newspapers?"(p.20) Perhaps. Some of the ideas in this essay began, for Louise, as a letter she wrote to *The New York Times Book Review,* a call for acknowledgement of the graphic designer's role in affecting the positioning and interpretation of a text. She wrote, "While I don't want to suggest that the designer's contribution is equivalent to the writer's, I do want to offer that design, as the expression of content, is another form of authorship." But the letter was never completed, for the forms of knowledge have become so naturalized, so invisible, as we've already discussed, that the difficulty of relating this idea to the general readership of a publication such as *The New York Times Book Review* kept her from completing it. Besides, in a climate of pervasive skepticism, it seemed equally absurd to her to heap design onto what must already seem to be an overly deconstructed world. But if we are going to argue for the significance of design in giving face to that world, of shaping what we know and how we know it, then designers will need to find a way to speak visually and/or verbally to and as fellow readers.

Page *fellow readers.*

[59]

EMIGRE #34/PAGES 52-53, PAGES 58-59

designer: Rudy VanderLans; design studio: Emigre; client: Emigre; typeface designers: Zuzana Licko (Matrix Regular), Barry Deck (Arbitrary), Conor Mangat (Platelet); typefaces: Matrix Regular (body text, folios), Arbitrary (headlines), Platelet (quotes, accents)

How earth uncovered the body,
 the suffocating body of A.
How no more unjust treatment shall pervade,
 the power of A: unseen, unknown.
The body of A, alive.
How the inside shall work its way out into breathing,
 only breathing in thoughts in this future.
If this is my lung, then this is my breathing alphabet,
 my lung pulled out alive.
Tack me onto the letter alive.
Make the breathing.
Make no more words be known, but breathing, but A.
All other infantile extremities sloughed off as human waste.
Let out the C in a wild yet peaceful cough.
Fart out all F's, ultimately.
Squeeze out all the hate of H as monstrous waste piles.
Shoot any last ounce of jizm to the death of J itself.
The very nemesis core ejected in the oblivion nowhere of N.
Quit out of any Q left behind quirky.
Every last drop of urine forcibly applied to the uselessness of U.
All vile entities exorcised in the form of V-pus.
The very notion of waste scraped out with wisdom
 leaving no W behind.
Expel, without doubt, any mark of X.
Spill the boring yawn of Y.
Kill Z frankly in the infectious ferment of zero.
All other body parts singing to A,
 the lung song lifting up in marvelous puffs of breath.
All control given over to almighty lung life.
The continued extermination of the floral chart.
Other frivolous letter forms, shall be attended to,
 as necessary, by the lung proper.
Certain waste, such as shit,
 always tempting the lung as life.
The leukocytes guarding lung posts.
Shovel in hand, the dumping,
 keeps the alphabet moving, keeps the breath alive in gusts.
Sail the wordsmith smooth and horizontal.
Sail next door's lung life.
If any sound, be it the breath of A,
 be it the breath of A in all extremes.
So Cave. So Greek. So Roman. So Gothic. So Adobe.
So in the end, so A.
The sound of letters only there in A, the sound of breathing.
The breathing alphabet as continuous as life itself.
Live the alphabet in columns of A.
Inscribe the A here and live, breathing.
So complete in this life,
 the breathing A.

. . .

"Pack my box with A's breathing."
 says Goudy.
Pack the sexy box with the bodies of B, P, and R.
Pack them divine.
Two ton breathing template applied.
Live the lust of letters breathing down your neck.
Lettered body parts indicating breath ports.
No more limits to mouth opening.
My fists open.
Fists closed in waste products.
Stinky fist gone down.
Lovely fist open in the breathing port.
 let life.
Live in the A life breathing.
Sex up the breath port with the bodies of B.
Bigger P song singled out in the life long.
Goudy's eminence cut as early as Rome 114 A.D.
The breathing beginning as early.
The A lifting up only now in verse,
 in a long poem breathing the life of A.
Live a life in the box open.

. . .

EMIGRE #32/PAGE 15, PAGES 16-17
designer: Rudy VanderLans; design studio: Emigre; client: Emigre; illustrator:
Brian Schorn; typeface designers: Zuzana Licko (Matrix Regular), Miles Newlyn
(Sabbath Black), Conor Mangat (Platelet); typefaces: Matrix Regular (body text),
Sabbath Black (headlines), Platelet (folios)

Breathing Through the Body of A

A Typographical Approach for the Future

Written and constructed by
brian schorn

Introduction to A

. . .

If it is written in no language it is written in no body.

DOMINIQUE FOURCADE
(From the)

A is everything. A is all. A is the all beginning.
Here, A has become the body. A is breathing.
Look, A is alive, and A cries out.
 "I am Aism!"
A lives in the lung of language.
The lung's intellect released onto A,
 A's own language, its alphabet redefined.
Simplification: a loss of letters in flourish.
Leave now from letters says the A of breathing.
 leave all breath previously requested in primitive cultures,
 all letters unworthy of the lung of A.
Go C, go F, go H, go J, go N, go Q, go U, V, W, X, Y, and Z.
All ancients be gone,
 be born unto the dust of your own frivolous tongue flapping.
Live the document of A, the breathing body of A,
 given here as said of the ruins.
O single page dug up breathing this:
 "A corresponds to the first symbol in
 the Phoenician alphabet, where
 it represented not a vowel, but a breathing."
These words alive,
 these Goudy words,
 dug from the depth of a lung beat.
The Goudy-father of Aism.

. . .

Typography of A

. . .

Writing knows nothing of the present.
The first word breaks with the past in order to face,
 virgin, the demanding future.

EDMOND JABÈS
(From The Book of Margins)

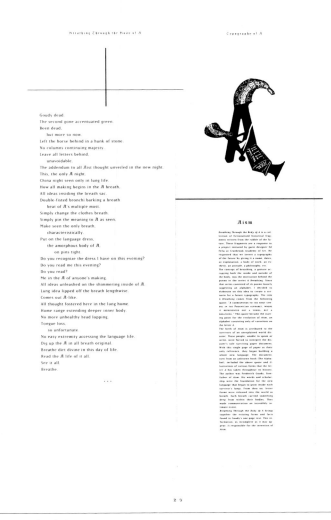

Goudy dead.
The second gone accentuated green.
Been dead.
but more so now.
Left the horse behind in a hunk of stone.
No columns continuing majesty.
Leave all letters behind.
unavoidable.
The addendum to all *A*ist thought unveiled in the new might.
This, the only *A* night.
China night seen only in lung life.
How all making begins in the *A* breath.
All ideas insiding the breath sac.
Double-fisted bronchi barking a breath
beat of *A*'s multiple most.
Simply change the clothes breath.
Simply pin the meaning to *A* as seen.
Make seen the only breath.
characteristically.
Put on the language dress.
the amorphous body of *A*.
on pins tight.
Do you recognize the dress I have on this evening?
Do you read me this evening?
Do you read?
Me in the *A* of anyone's making.
All ideas unleashed on the shimmering inside of *A*.
Lung idea lipped off the breath lengthwise.
Comes out *A*-like.
All thought fostered here in the lung home.
Home range extending deeper inner body.
No more unhealthy head lopping.
Tongue loss.
so unfortunate.
No easy extremity accessing the language life.
Dig up the *A* in all breath original.
Breathe dirt divine in this day of life.
Read the *A* life of it all.
See it all.
Breathe.

. . .

*A*ism

*Breathing Through the Body of A is a col-
lection of fictionalized historical frag-
ments written from the rubble of the fu-
ture. These fragments are a response to
a project initiated by guest designer Ed
Fella at Cranbrook Academy of Art. He
requested that we invent a typography
of the future by giving it a name, dates,
an explanation, a body of work, an es-
thetic, an attitude, a philosophy, etc.
The concept of breathing, a picture es-
caping back the inside and outside of
the body, was the motivation behind the
poems in the series A Breathing. Since
that series consisted of 26 poems loosely
suggesting an alphabet, I decided to
elaborate on this idea to create a sce-
nario for a future typography. The title
A Breathing comes from the following
quote: "A CORRESPONDS TO THE FIRST LOW-
ING IN THE PHOENICIAN ALPHABET, WHERE
IT REPRESENTED NOT A VOWEL, BUT A
BREATHING." This quote became the start-
ing point for the evolution of Aism, an
alphabet consisting only of variations on
the letter A.
The birth of Aism is attributed to the
survivors of an unexplained world dis-
aster. These people, unable to speak or
write, were forced to interpret the dis-
aster's sole surviving paper document.
With this single page of paper as their
only reference, they began building a
whole new language. The document,
torn from an unknown book (The Alpha-
bet), included the above quote and il-
lustrations of various forms that the let-
ter A has taken throughout its history.
The author was Frederick Goudy, fore-
father of Aism. His words and scholar-
ship were the foundation for the new
language that began to grow inside each
survivor's lungs. From then on, letter
forms were released into the world as
breath. Each breath carried something
deep from within their bodies. This
made communication an incredibly in-
timate event.
Breathing Through the Body of A brings
together the existing forms and facts
found in Goudy's one page text. This re-
formation, as incomplete as it may ap-
pear, is responsible for the invention of
Aism.*

In "Strukturwandlung der Oeffentlichkeit," the German philosopher Habermas sketches the historical development of the public domain in a number of European countries. He outlines an ideal model of this domain in which decisions regarding public matters are taken on the basis of arguments rather than of status, power or tradition. This is clearly a prerequisite for the functioning of a democracy. The public domain is the medium in which the arguments are formulated that ultimately underlie political action. The quality of the arguments and the number of participants in the debate are crucial in determining the democratic level of the decision-making. A specific form of communication turns out to be *sine qua non* for a democratic system.

In his historical sketch, Habermas indicates who formed the basis for this early public domain: the city burghers. They were wealthy and educated and shared the values of a certain lifestyle - bourgeois culture. So only a limited segment of the population was involved; women, the poor and children played the no role in the debate. The burghers controlled the material and other conditions for taking part in this debate. At once owners of capital, participants in a common culture and keepers of the relevant information, they turned the public debate into the exclusive preserve of a particular social group.

The question is whether the actual public domain achieved between the seventeenth and nineteenth centuries can continue to serve as a model in the twentieth century. Not only has the number of participants increased dramatically, but the nature of public debate has changed. It is no longer carried on or mainly carried on between equal citizens but between the representatives of organizations who make use of increasingly complicated information and media networks. Ownership of the economic machinery has been divorced from its management - the so-called managerial revolution. The internationalization and increased scale of the economy alone ensure that the classic model of public domain cannot be retained. But it is not only economic powers of decision that have gained independence from the Bourgeoisie: the same is true of the production of knowledge and information. Bourgeois culture has long ceased to be identical with capitalism; the bourgeois lifestyle is no longer rooted in positions of economic power. Bourgeois values such as thrift, lack of ostentation, etc. have become antique in a culture of conspicuous consumption. In his novel "Buddenbrooks," Thomas Mann shows how the early bourgeois culture yielded to the new capitalism that took over in the second half of the last century. In sociology, it was Max Weber who described the end of Enlightenment ideals: the society of rationally thinking, speaking and acting citizens ended up as a bureaucratized state/society that subjected its own citizens to its administrative procedures. In "Dialektik der Aufklärung," Horkheimer and Adorno outlined the working methods of a culture industry that constantly and professionally manipulates the behavior of the masses. In their somber view, in the twentieth century the masses who had become politically aware were robbed of this awareness by being permanently embedded in a mass culture in which entertainment and fun took the place of pleasure, culture and knowledge.

Graphic design is a young discipline. As an independent field, it is related to the rise of modern mass culture and opposed to it. Graphic design came into being as a by-product of the development of modern mass communications — as an autonomous professional function between the creation of text/image and its printing and circulation. Its object is the form in which all kinds of information are presented. As an independent discipline, graphic design is tied to the decline of the bourgeois public domain as described by Habermas.

The profession originated at the end of the nineteenth and beginning of the twentieth century. It emerged from low, rather than high, culture. As a producer of images, the poster designer gave a banal treatment to themes and techniques from painting to meet the needs of business and the entertainment industry. As the arranger of information, the graphic designer applied architectonic design methods to two-dimensional work. At the same time as this new field of commissioned work was developing, book design became the domain of those graphic designers who had made the traditional forms, typefaces and page forms of the Renaissance book, the standard.

It is remarkable that both traditional book design and the New Typography were at odds with the reality of the print media that dominated the field of communications at the beginning of the century. Dutch Traditionalists wanted to see a revival of the bourgeois culture, which had achieved its finest form in the seventeenth century. In the Dutch version of Art Nouveau (known as "Nieuwe Kunst"), a new feeling was given expression in a curious amalgam of traditional forms and a new idiom. Obvious examples include the furniture that Van de Velde designed for his own use or for high-minded clients such as Osthaus, and the design of the volumes of poetry published by Kloos and Corter. The specialized book designers retained the classic outward form of the book while trying to extend its range to include the masses (from the "Arbeiterbildung" of

20

21

CHRISTOPHER VICE was born in Raleigh, North Carolina, and attended the School of Design at North Carolina State University. After receiving an M.F.A. from CalArts in Valencia, California, he relocated to Vermont. He now resides in New York City.

CHRISTOPHER
VICE

DISCONNECTION
EXHIBIT/INVITATION
designer: Christopher Vice;
design studio: Christopher
Vice Studio; client: California
Institute of the Arts; typeface:
Bodoni

QUEER SHOW !

*

sights/sites
of ABSOLUTE PERSPECTIVE
of ABSOLUTE CONCEPTION
(and sighs)

from lesbian,
gay & bisexual positions

FUCKING SCHEDULE

ART SHOW TATUM LOUNGE	THROUGH FRIDAY
VIDEO SCREENINGS TATUM TV	WEDNESDAY NOON PROGRAM ONE
	WEDNESDAY SEVEN PM PROGRAM TWO
	THURSDAY SEVEN PM PROGRAM ONE
READINGS TATUM LOUNGE	WEDNESDAY EIGHT THIRTY PM
PARTY TATUM LOUNGE	WEDNESDAY TEN PM

CALARTS, QUEER SHOW
designer: Christopher Vice; design studio: Christopher Vice
Studio; client: California Institute of the Arts; typeface: Hard
Times

RECITE/RESIGHT/PROMOTIONAL POSTCARD
designer: Christopher Vice; design studio: Christopher Vice
Studio; client: Jager Di Paola Kemp Design; photographer:
Christopher Vice; typeface designers: Elisabeth O'Harman
(Textura Bold), Austin Putnam (Spike Light Text); typeface:
Fette Fraktur and News Gothic (front), Textura Bold and
Spike Light Text (back)

Typefaces used in this piece are digital manipulations of
existing fonts.

KATE TAMARKIN, Music Director
2 Church Street Burlington, Vermont 05401 THOMAS PHILION, General Manager
802-864-5741 FAX 802-864-5109 I CALL TOLL-FREE IN VERMONT 1-800-VSO-9293

VERMONT Symphony ORCHESTRA

2 Church Street Burlington, Vermont 05401

VERMONT Symphony ORCHESTRA

VERMONT SYMPHONY
ORCHESTRA/STATIONERY
designer: Christopher Vice; design studio:
Christopher Vice Studio; client: Vermont
Symphony Orchestra; typeface:
Garamond

THOMAS PHILION, General Manager
802 864 5741 I FAX 802 864 5109
CALL TOLL-FREE IN VERMONT 1-800 VSO-9293

VERMONT Symphony ORCHESTRA

2 Church Street Burlington, Vermont 05401

JOHN WARWICKER is an original member of the design studio Tomato started in 1991; other original members are Steve Baker, Dirk Van Dooren, Karl Hyde, Richard Smith, Simon Taylor and Graham Wood. Jason Kedgley joined three years later. Tomato draws their design inspiration and philosophy from a long and varied list of art forms, activities and aesthetics. For them—to use only a few elements—there are film and sculpture and talk and writing and paint and music and walking and drawing and memory and philosophy and composing and film as sculpture as talk as writing as paint as music as walking as drawing as memory as philosophy as composing. At the same time, film is sculpture is talk is writing is paint is music is walking is drawing is memory is philosophy is composing.

JOHN WARWICKER

TOMATO

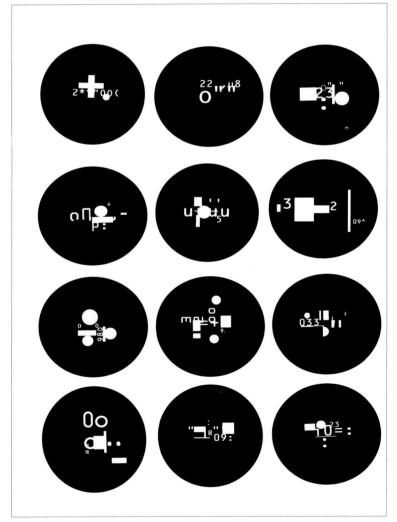

FALSE SCIENCE
designer/art director: Dirk Van Dooren; design studio:
Tomato; client: Tomato; typeface: Ocrb

BEAUTIFUL POETRY/CHEAP SENTIMENT
designers: Simon Taylor, Dirk Van Dooren; design studio: Tomato; client: Tomato;
art directors: Simon Taylor, Dirk Van Dooren; typefaces: stencil faces

Inspired by the look of an invitation, Taylor and Van Dooren used a pencil to
create these stencils.

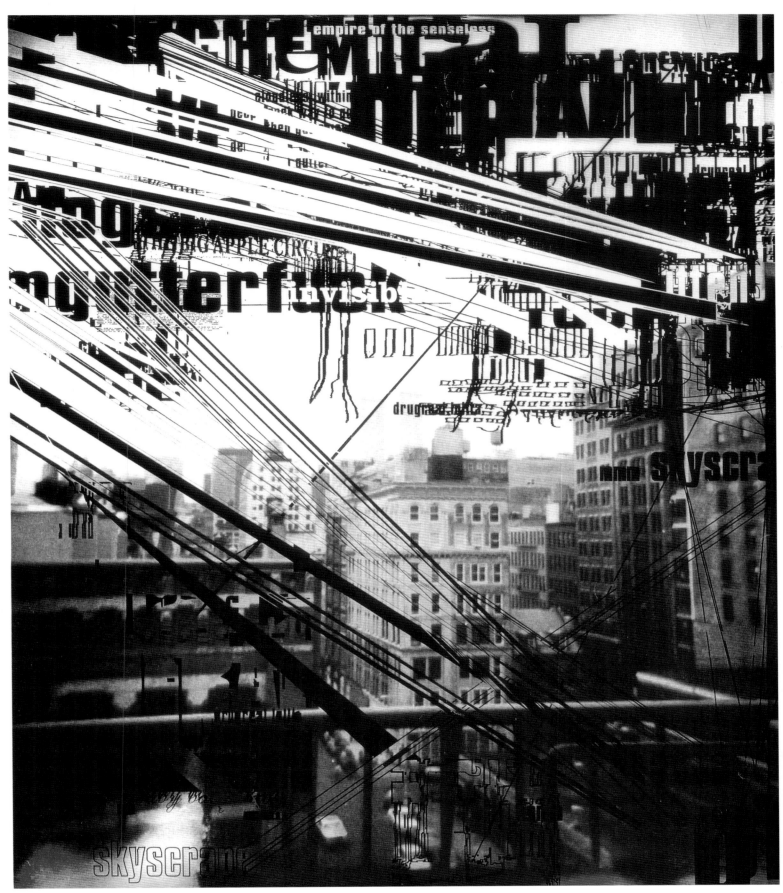

EMPIRE OF THE SENSELESS
designers: John Warwicker, Karl Hyde; design studio:
Tomato; client: Tomato; typefaces: Compacta, Shelley
Allegro, Bureau Grotesque

ADIDAS, EARN THEM (MAN), (WOMAN)
designer/art director: Graham Wood; design studio: Tomato;
client: Legas Delaney, London; photographers: The Douglas
Brothers; typeface: Bureau Grotesque

Wood created this look for Bureau Grotesque by processing
the font through chemicals.

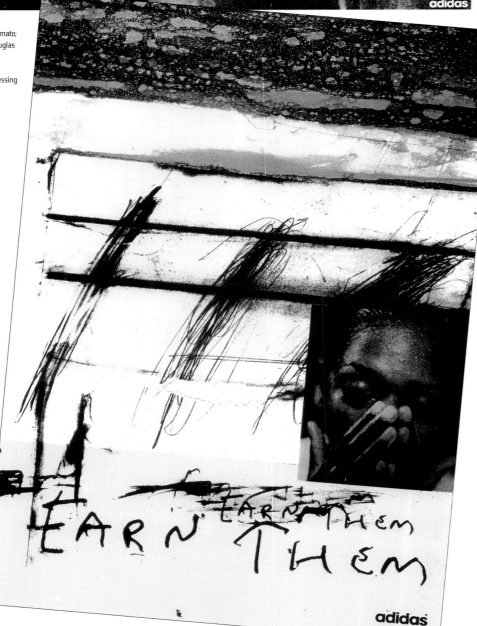

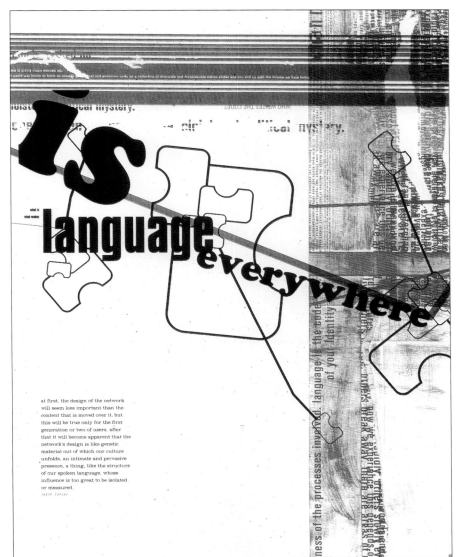

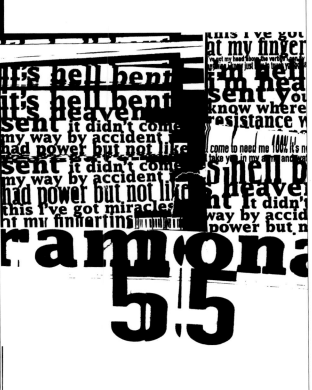

IS LANGUAGE EVERYWHERE?
designers: John Warwicker, Simon Taylor, Chris Ashworth, David Smith; design studios: Tomato (Warwicker, Taylor), Invisible (Ashworth, Smith); client: MTV Europe; typefaces: Cooper Black, Compacta Boi, Clarendon Light, Clarendon Bold

The designers were inspired by Archigram—the architectural language lab of the 1960s—to choose these fonts.

RAMONA 55, HELL BENT
designer/art director: Graham Wood; design studio:
Tomato; client: Ramona 55; typeface: Bureau Grotesque

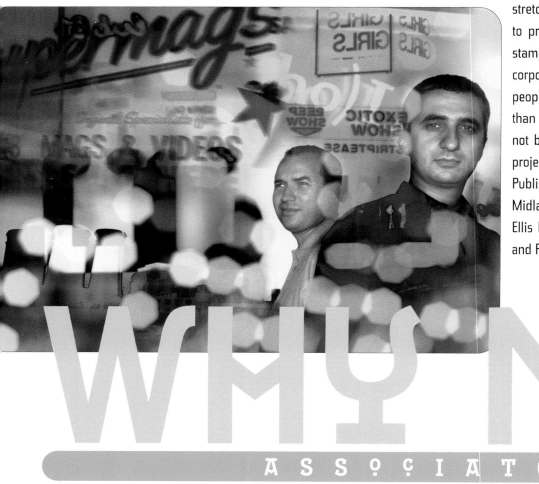

WHY NOT ASSOCIATES are Andrew Altman and David Ellis, graduates of Saint Martins School of Art and the Royal College of Art. Compared to the predictability of most design companies their work is often described as pretty wild. In reality, they share a spirit of optimistic experimentation with a long line of designers stretching back to the last century. This approach has led to projects ranging from exhibition design to postage stamps via advertising, publishing, television titles and corporate identities. If they have a goal it is to prove that people are a lot more receptive to adventurous design than they are given credit for and that such work need not be limited to the ghettos of youth culture and arts projects. Why Not's clients include The Royal Mail, Virgin Publishing, Smirnoff Vodka, The Green Party, Mazda, Midland Bank, and Wieden Kennedy/Nike. Altman and Ellis have had their work exhibited in Germany, Japan and France.

WHY NOT

ASSOCIATES

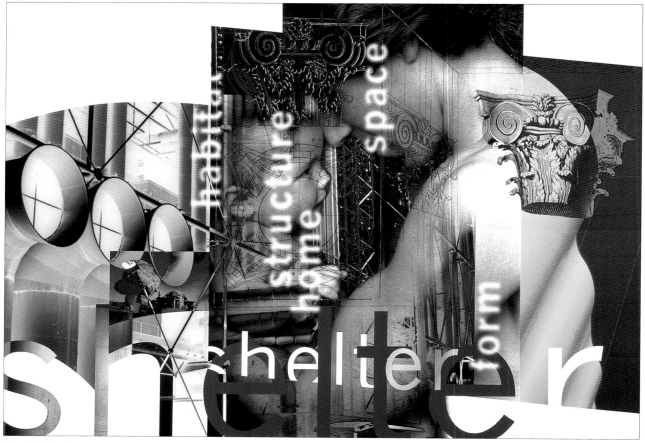

KOBE—INSTALLATION FOR MUSEUM OF FASHION
designers: Andy Altmann, David Ellis, Patrick Morrissey; design studio: Why Not Associates; client: Kobe Fashion Museum; photographers: Rocco Redondo, Richard Woolf, Photo Disc; typeface: News Gothic

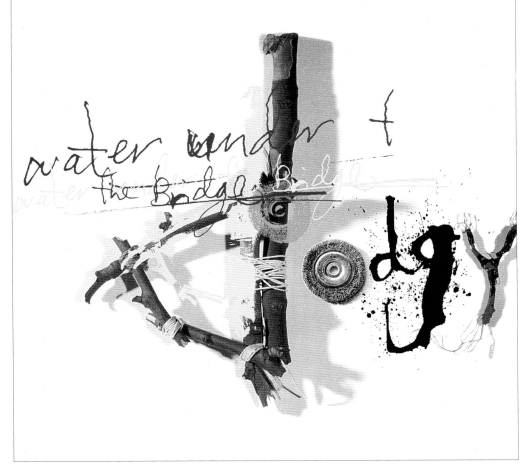

DODGY, RECORD SLEEVE
designers: Andy Altmann, David Ellis, Chris Priest; design
studio: Why Not Associates; client: A & M Records; pho-
tographer: Chris Priest; typeface: bits of wood and stuff

The designers used string, wood and other materials to
create this Winnie-the-Pooh inspired typeface.

IN SOCCER WONDERLAND, BOOK
designers: Andy Altmann, David Ellis;
design studio: Why Not Associates;
client: Booth-Clibborn Editions; pho-
tographer: Julian German; typefaces:
Franklin Gothic, Decorated, Typo
Upright

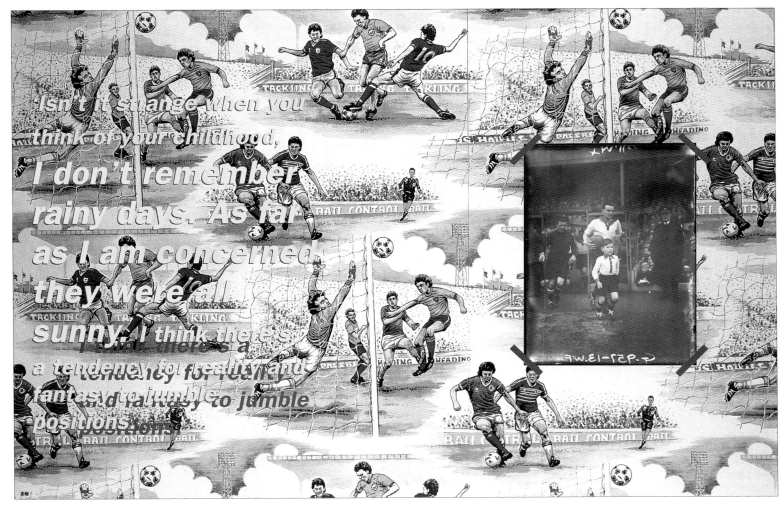

Isn't it strange when you think of your childhood, I don't remember rainy days. As far as I am concerned they were all sunny. I think there's a tendency for reality and fantasy to jumble positions.

We want every job to be as **worry-free** as possible, from **concept** meeting right through to completion.

That's where the **VTR PRODUCTION TEAM** comes in: they are there to provide clients with PROFESSIONAL ADVICE and friendly support from start.

We also have a trained engineering department on hand at all times to ensure the smooth running of our equipment.

V.T.R. LONDON/BROCHURE
designers: Andy Altmann, David Ellis, Patrick Morrissey; design studio: Why Not Associates; client: V.T.R. London; photographer/ illustrator: Photonica/Photo Disc; typeface: Meta

OPER NACH DEM FILM VON
JEAN COCTEAU

Europäische Erstaufführung

PHILIP GLASS
ORPHEE

Freiluftvorstellungen im Renaissance-Schloßhof Weikersheim/Württemberg:
31.7., 2.8., 4.8., 6.8., 7.8., 8.8.1993

Beginn: 21.00 Uhr

Musik: Philip Glass
Libretto: Nach dem Drehbuch von Jean Cocteau bearbeitet von Philip Glass
herausgegeben von Robert Brustein
Copyright 1993 Dunvagen Music Publishers, Inc.

Schirmherrin: Bundesministerin Dr. Angela Merkel

Musikalische Leitung: Dennis Russell Davies

Regie: Birgitta Trommler

Bühnenbild: Thomas Pekny

Kostüme: Barbara Löschenkohl

Streichorchester der Musikakademie Litauen

Solisten und Instrumentalisten der 38. Internationalen Sommerkurse Schloß Weikersheim

Eine Produktion der Jeunesses Musicales Deutschland, Marktplatz 12,
D-97990 Weikersheim, Telefon: 07934/280, Telefax: 07934/8526

PHILIP GLASS, ORPHEE/POSTER
designers: Andy Altmann, David Ellis; design studio: Why Not Associates; client: Lippert Wilkens; photography: Ace Photography; typeface: Doddy

Altmann and Ellis, inspired by Perpetua, created Doddy through the digital manipulation of an existing font.

YAK/POSTER
designers:
Andy Altmann,
David Ellis;
design studio:
Why Not
Associates;
client: Why Not
Associates;
typeface:
Grotesque

controlled alcohol use, a few liveners while working out ideas.
creativity stimulated by a blurred logic, a glorious relaxation of previously held beliefs, permission to explore.
"in vino veritas", creative endeavour is a truth which comes as much from the heart as the head. dull the head a little and let the heart be heard. learn to trust intuition. take out a good drop of red.
drink may be unfashionable, but who gives a toss about fashion.
you'll never get me back into flares.

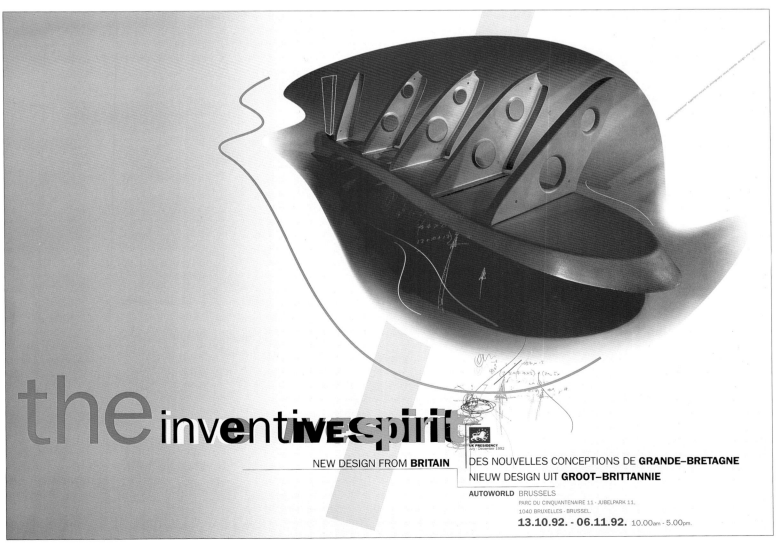

the inventivespirit

NEW DESIGN FROM **BRITAIN** DES NOUVELLES CONCEPTIONS DE **GRANDE–BRETAGNE**
NIEUW DESIGN UIT **GROOT–BRITTANNIE**

AUTOWORLD BRUSSELS
PARC DU CINQUANTENAIRE 11 - JUBELPARK 11,
1040 BRUXELLES - BRUSSEL.
13.10.92. - 06.11.92. 10.00am - 5.00pm.

THE INVENTIVE SPIRIT/POSTER designers: Andy Altmann, David Ellis; design studio: Why Not Associates; client: The Foreign and Commonwealth Office; photographer: Rocco Redondo; typeface: Franklin Gothic

FRED WOODWARD joined <u>Rolling Stone</u> as creative director in 1987; since then, the magazine has won more design awards than any other magazine in the United States. In 1993 he was named vice-president of Straight Arrow Publications and in 1995 he became creative director, overseeing the design of all Wenner Media magazines, as well as books published under the Rolling Stone Press imprint. In May 1996, he was honored by the Society of Publication Designers with its first ever "Best of Show" award, as well as five gold medals and five silver medals. Woodward has taught publication design at Parsons School of Design and has had work exhibited in Japan and New York City. Recently the music video he co-directed for Hole with photographer Mark Seliger was awarded a Clio for Best Alternative Music Video in 1995.

FRED
WOODWARD

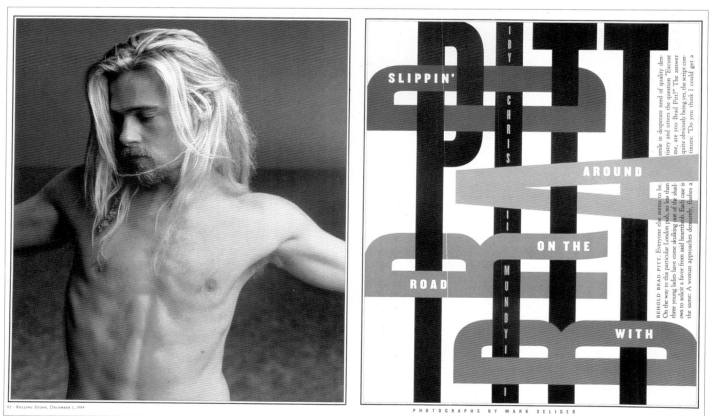

92 · ROLLING STONE, DECEMBER 1, 1994

PHOTOGRAPHS BY MARK SELIGER

BRAD PITT
art director: Fred Woodward; designers: Fred Woodward, Geraldine Hessler; client: Rolling Stone; illustrator/photographer: Mark Seliger;
typefaces: Champion (various weights; digitally altered)

Champion is a creation of Jonathan Hoefler.

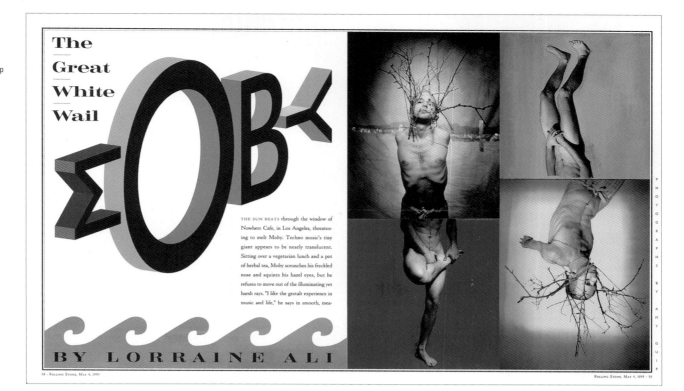

The
Great
White
Wail

THE SUN BEATS through the window of
Nowhere Cafe, in Los Angeles, threaten-
ing to melt Moby. Techno music's tiny
giant appears to be nearly translucent.
Sitting over a vegetarian lunch and a pot
of herbal tea, Moby scrunches his freckled
nose and squints his hazel eyes, but he
refuses to move out of the illuminating yet
harsh rays. "I like the gestalt experience in
music and life," he says in smooth, mea-

BY LORRAINE ALI

PHOTOGRAPHS BY AMY GUIP

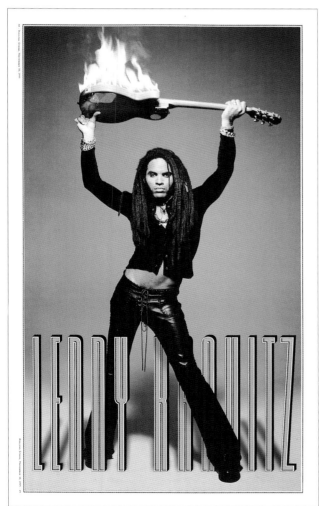

LENNY KRAVITZ
art director: Fred Woodward; designers: Fred Woodward, Geraldine Hessler;
client: Rolling Stone; illustrator/photographer: Matthew Rolston; typographer:
Eric Siry; typeface: Barcode

Comstock inlines and dimensional shadows were added to the original font.
Shadow was also digitally incorporated to merge the type with the photo.

xxxLifeAfterDeath

xxxx

CourtneyLove

xxxPhotographxx
byMarkSeligerxxx
xxxxxxxxxxxxxxxxxx

LIFE AFTER DEATH
art director: Fred Woodward; designers: Fred Woodward, Lee Bearson; client:
Rolling Stone; photographer: Mark Seliger; typeface: typewriter type

Typewriter type was digitally
altered to create this effect.

MONSTER MADNESS
designer/art director: Fred Woodward; client: Rolling Stone; photographer: Mark
Seliger; typographer: Eric Siry; typeface: Gill—manipulated

DAVID LETTERMAN
designer: Geraldine Hessler; client: Rolling Stone; art director: Fred Woodward;
photographer/illustrator: David Cowles; typeface: Champion Heavyweight

Jonathan Hoefler created this family of type.

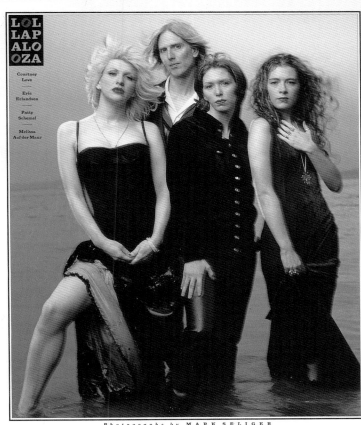

LOL LAP ALO OZA

Courtney Love

Eric Erlandson

Patty Schemel

Melissa Auf der Maur

Photographs by MARK SELIGER

While the Courtney saga continues, Hole prove that a rock & roll band is the sum of its parts BY JASON COHEN

IS A BAND

HOLE IS A BAND
designers: Fred Woodward, Geraldine Hessler; client: Rolling Stone; art director: Fred Woodward;
photographer: Mark Seliger; typographer: Eric Siry; typeface: Belizio—digitally altered

Belizio is a Font Bureau face.

TOM PETTY
designers: Fred Woodward, Geraldine Hessler; client: Rolling Stone; art director: Fred Woodward;
photographer: Mark Seliger; typefaces: Old Engraved Letters ("Tom"), Craw Modern ("Petty"),
Bellview ("This is How it Feels" and "On the Road")

The engraved backgrounds for "Tom" were altered by hand and digitally.

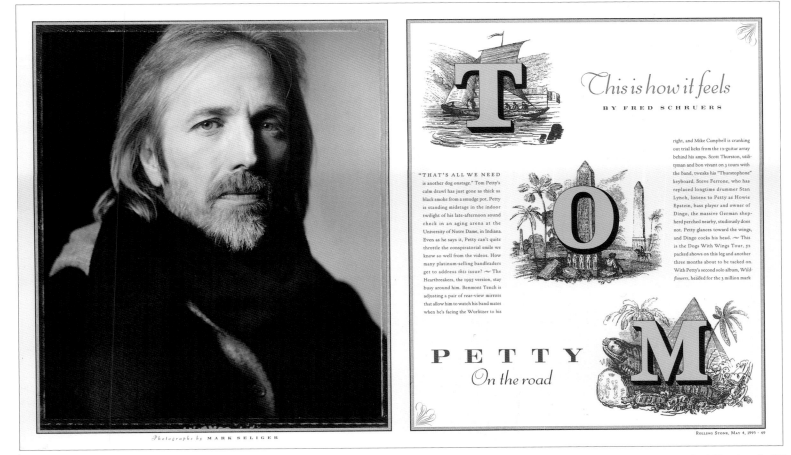

Photographs by MARK SELIGER

This is how it feels BY FRED SCHRUERS

"THAT'S ALL WE NEED is another dog onstage." Tom Petty's calm drawl has just gone as thick as black smoke from a smudge pot. Petty is standing midstage in the indoor twilight of his late-afternoon sound check in an aging arena at the University of Notre Dame, in Indiana. Even as he says it, Petty can't quite throttle the conspiratorial smile we know so well from the videos. How many platinum-selling bandleaders get to address *this* issue? ⁓ The Heartbreakers, the 1995 version, stay busy around him. Benmont Tench is adjusting a pair of rear-view mirrors that allow him to watch his band mates when he's facing the Wurlitzer to his

right, and Mike Campbell is cranking out trial licks from the 12-guitar array behind his amps. Scott Thurston, utilityman and bon vivant on 3 tours with the band, tweaks his "Thurstophone" keyboard. Steve Ferrone, who has replaced longtime drummer Stan Lynch, listens to Petty as Howie Epstein, bass player and owner of Dingo, the massive German shepherd perched nearby, studiously does not. Petty glances toward the wings, and Dingo cocks his head. ⁓ This is the Dogs With Wings Tour, 52 packed shows on this leg and another three months about to be tacked on. With Petty's second solo album, *Wildflowers,* headed for the 3 million mark

PETTY On the road

Capturing an audience of respectable measure by employing the most modern of typographic styling, has long been considered the "avant" thing to do. It is, however, my seasoned opinion that this risk-driven method of response retrieval is no longer on target. After almost two decades of beating my head against the wall, I've come to believe a "safe" approach yields the most certain communication connection.

If I've been told once, I've been told a zillion times, "they just won't get it." In hindsight, I'm amazed at how resistant I was to this insight. The enlightened audience I once designed and experimented for was, in fact, minuscule. Commerce had hypnotically numbed the sensibilities of design's potential audience, rendering the majority alert only to the vocabulary of dumb and dumber under the foil-stamped patina of straight process colors. No wonder the only audience I could speak to was other designers! Talk about circle jerkin'! Duh!

The exact moment of awakening eludes me, but when I did come out from under my avant glaze, I had gained a new-found formula to speak clearly and to be understood by additional multitudes. I call my new methodology The White Tiger. Allow me to share its genesis.

The notion came from a network television special featuring Siegfried and Roy, the flamboyant Las Vegas illusionists. Siegfried (the blond one) welcomed me to his world. Mysteriously lit by candles and wearing a crimson velvet smoking jacket, Siegfried delighted in a home video of Roy romping with one of their ferocious white tigers. Siegfried reminded me not to be fooled by the soft white fur and gentle ways, for the white tiger remains a dangerous animal! (Even though the lobotomy incisions seemed somewhat apparent to me.)

On any day along the moving walkway into the Las Vegas Mirage Hotel and Casino, the white tigers are on display in a McDISNEY world fantasy faux. The hotel guests are seduced by the barely-breathing specimens to purchase souvenirs stuffed in their likeness. This nonstop parade to the cash register showed me the key: Rather than make valued messages look too risky, edgy and new, I now know to cover them in the familiar warm and soft look of the white tiger. More to the point, who in their right, anesthetized mind wants to snuggle up to the unfamiliar?

Behavior patterns are indeed programmable. Thoughts of Zappy Meals and Ratman #4 have us salivating like dogs. The fat cats and their minion gurus have had their way with damned near everyone's common sense. The White Tiger touch remains the only way to defibrillate mass culture's heart; a Trojan horse approach of sorts.

"BUY THIS"
"YOU NEED THIS NOW"
"HURRY, TIME IS RUNNING OUT ON THESE INCREDIBLE SAVINGS"
and
"WE'VE GOT WHAT YOU'RE LOOKING FOR"

Now, doesn't the familiar sound really comfy? Too bad the message sucks.

Please take a minute to check your pulse. If your glazed-over stare upon the purple mountain majesty of the promised land seems a bit out of focus and illuminated with the orange glow of strip mall signage, marketing's mind control may have already put you under its magic spell.

Good taste in today's modern land o' bland culture is served pre-sweetened and pulp-free. Should you think you are in control of your senses, know that Mr. Big, Inc. perceives you to be really stupid. So stupid, in fact, he thinks that you're returning calls and expecting your money back. I'm sorry if I've offended you, but actually, it's much worse than that! Mr. Big, Inc. feeds off this control to the point where he's got you throwing rocks at the ground and missing!

I speak the truth. Should any among you choose to mount an offensive (or in this case a self-defensive), remember that only the warm, fuzzy and familiar can serve your effort to communicate any messages of real value. Dress those treasured messages of hope and wisdom as white tigers. If they don't look like a white tiger, no hypnotized victim of commerce will be enticed to cuddle up close enough for you to snap 'em out of it! (. . . and if it's too late and the damage is done, bite their heads off.)

—Rick Valicenti

Typefaces Available for Sale

Phil Baines: You Can (Read Me)!
Font Shop International

Jonathan Barnbrook:
Prototype
Virus Foundry
10 Archer St., Studio 15
London W1V 7HG
United Kingdom
(f) 44-171-287-3601
virus@easynet.co.uk
No telephone orders are taken.

Joshua Berger: Altered, Anvil,
Inky-Black, Stele Bevel,
Superchunk
Plazm Fonts
P.O. Box 2863
Portland, OR 97208-2863
(t) (503) 222-6389
(f) (503) 222-6356

Margo Chase: Bernhard
Modern, Box Gothic, Bradley,
Edit, Fatboy, Matrix Script,
Pterra, Triplex
Gravy Fonts
Margo Chase Design
2255 Bancroft Ave.
Los Angeles, CA 90039
(t) (213) 668-1055
(f) (213) 668-2470

Scott Clum: Burn Font, Flo
Motion, Virtual, Room 222,
Mason
Ride Design
417 N. Second St.
Silverton, OR 97381
(t/f) (503) 873-6402

Luc(as) de Groot: Bolletje
Wol, FF Jesus Loves You All,
FF Nebulae, TheMix, TheSans,
TheSans Expert, TheSerif
TheTypes, Amsterdam
(t) +31 (0)20 4208611
(f) +31 (0)20 4209537
thetypes@xs4all.nl

Elliott Peter Earls: Calvino
Hand, Dyslexia, Dysphasia,
Mothra Paralax, Penal Code
Bland, Troopship Blanched
The Apollo Program
2 View St.
Greenwich, CT 06830
(t) (203) 861-7075
(f) (203) 861-7079
apollofont@aol.com

Edward Fella: Out West on a
15 degree Ellipse
Emigre Fonts
4475 "D" St.
Sacramento, CA 95819
(t) (916) 451-4344
 (800) 944-9021

Tobias Frere-Jones: Epitaph,
Reactor
Font Bureau
175 Newbury St.
Boston, MA 02116
(t) (617) 423-8770
(f) (617) 423-8771

Jonathan Hoefler: HTF
Requiem
The Hoefler Type Foundry
611 Broadway, Suite 815
New York, NY 10012-2608
(t) (212) 777-6640
(f) (212) 777-6684
info@typography.com

HTF Gestalt
MUSE
611 Broadway, Suite 815
New York, NY 10012-2608
(t) (212) 777-6640
(f) (212) 777-6684
muse@typography.com

i/o 360°: Gigafont 1.0, Zygote
free to download at
 http://www.I0360.com

Jeffery Keedy: Hard Times,
Jot
Font Shop International
Keedy Sans: Emigre Fonts
4475 "D" St.
Sacramento, CA 95819
(t) (916) 451-4344
 (800) 944-9021

Max Kisman: FF Cutout, FF
Fudoni, FF Jaque, FF Network,
FF Rosetta, Linear Construct
Font Shop International, Berlin

Pete McCracken: Colony,
Erosive
Plazm Fonts
P.O. Box 2863
Portland, OR 97208-2863
(t) (503) 222-6389
(f) (503) 222-6356

Modern Dog: Imperfect
available through [T-26]

Carlos Segura: Boxspring,
Stinky Movement, Tema
Cantante
(t) (312) 649-5688
(f) (312) 649-0376

Mark T. Smith: Smith Bold
Condensed, Smith Extended,
Smith Outline, Smith Scribble
Type
(t) (212) 679-9485

Rick Valicenti: Commerce,
Cyberotica, Give and Take,
Mother (free), OOGA BOOGA
(t) (847) 824-0333
thirstype@aol.com

Rudy VanderLans: Arbitrary,
Democratica, Matrix Regular,
Platelet, Sabbath Black,
Triplex Serif
Emigre Fonts
4475 "D" St.
Sacramento, CA 95819
(t) (916) 451-4344
 (800) 944-9021

Why Not Associates: Doddy
(t) 0171-494-0762